Museum Studies for a Post-Pandemic World

Museum Studies for a Post-Pandemic World demonstrates that digital literacy, creativity, and resilience, as the COVID-19 pandemic has so vividly illustrated, are now vital components of the classroom and of the curator's toolbox.

Museum studies students are increasingly asked to engage with new team dynamics and collaborative models, often relocated to the virtual world. Authored by academics, cultural heritage partners, students, and alumni, the chapters in this volume move beyond a consideration of the impact of digitisation to envision new strategies and pedagogies for fuller, more sustainable approaches to cultural literacy, exhibition, and visitor engagement. International case studies present models of collaborative practices between teams of diverse sizes and professional backgrounds. The volume demonstrates that the COVID-19 pandemic has forced the use of a variety of pedagogically and culturally significant hybrid and virtual models that provide innovative learning modalities to meet the needs of future generations of digital native patrons. This book offers meaningful strategies that will help academic and cultural heritage institutions engaged in museum studies to survive—and even thrive—in the face of future disasters by expanding programme accessibility beyond the physical confines of their buildings.

Museum Studies for a Post-Pandemic World will be of interest to students and researchers engaged in the study of museums, the arts, cultural management, and education. It should also be of interest to museum practitioners around the world.

Leda Cempellin (Research Doctor, Università degli studi di Parma) is a Professor of Art History, Coordinator of Museum Studies minor, and current Associate Director of the School of Design at South Dakota State University. She published *The Ideas, Identity and Art of Daniel Spoerri* with Vernon Press (2017).

Pat Crawford is a Professor of Landscape Architecture and the Director of the School of Design at South Dakota State University. She earned her Master's in Landscape Architecture from Kansas State University and her PhD in Environmental Design and Planning from Arizona State University. She co-authored several APLU reports on employability skills for the series *From Academia to the Workforce*.

Museum Studies for a Post-Pandemic World

Mentoring, Collaborations, and Interactive Knowledge Transfer in Times of Transformation

Edited by
Leda Cempellin and Pat Crawford

Routledge
Taylor & Francis Group

LONDON AND NEW YORK

First published 2024
by Routledge
4 Park Square, Milton Park, Abingdon, Oxon OX14 4RN

and by Routledge
605 Third Avenue, New York, NY 10158

*Routledge is an imprint of the Taylor & Francis Group, an
informa business*

British Library Cataloguing-in-Publication Data
A catalogue record for this book is available from the British Library

ISBN: 978-1-032-49216-2 (hbk)
ISBN: 978-1-032-49322-0 (pbk)
ISBN: 978-1-003-39319-1 (ebk)

DOI: 10.4324/9781003393191

Typeset in Times New Roman
by Deanta Global Publishing Services, Chennai, India

Contents

List of Contributors viii

Introduction: Adaptive, Collaborative, Interdisciplinary, and
Inclusive Online and Hybrid Strategies to Inspire the Post-
Pandemic Museum Studies Classroom 1
LEDA CEMPELLIN AND PAT CRAWFORD

PART I
Why We Gather: Connecting and Sharing **7**

1 Belonging and Being Human: Developing a Framework to
 Teach Museum and Heritage Studies Online During a Crisis
 and Beyond 9
 CHIARA O'REILLY AND ANNA LAWRENSON

2 Gathering Online: A Collaborative Project with Graduate
 Museum Education Students During COVID-19 17
 BRILEY A. RASMUSSEN AND CARISSA DICINDIO

3 Museum Studies in Our Own Backyard:
 We Have an App for That! 23
 LISA MAROTZ AND KATHRYN PLANK

PART II
Pivoting Our Pedagogical Skills to Affect Change **29**

4 Remote Internships During Intersecting Pandemics:
 Recognising the Significance of Social and Emotional
 Learning for Adults 31
 MARTHA M. SCHLOETZER

5 Lessons Learned from a Pandemic: How COVID-19 and the
 Racial Justice Crisis Impacted University of San Francisco's
 Social Justice-Focused Museum Studies Curricula 39
 JAVIER PLASENCIA, PALOMA AÑOVEROS, PAULA BIRNBAUM,
 KAREN FRASER, EYAL SHAHAR, KARREN SHOROFSKY, AND
 STEVEN TULSKY

6 The Next Evolution of Museum Studies: Museum
 Masterclasses in Augmented and Virtual Reality 56
 HEATHER MCLAUGHLIN AND LAURA-EDYTHE COLEMAN

7 Perspectives on Virtual Internship Programming from a
 Collegiate Museum Practices Programme, Host Museum, and
 Post-Graduates 65
 ADRIANA R. DUNN, LESLIE LUEBBERS, NEECOLE A. GREGORY,
 RACHEL WILSON, AND CANNON FAIRBAIRN

PART III
**Creative Tensions: Bridging the
Academic—Workforce Gap** **75**

8 Redefining the Museum Placement in a
 Post-pandemic World: Challenges and Opportunities
 Presented by the Virtual Model 77
 MARGARET MCCOLL AND DELIA WILSON

9 Digital Storytelling and Digital Skills in Museums 90
 ANRA KENNEDY

10 Immersive Digital Learning: Transforming an Onsite
 Simulation into a Powerful Virtual Learning Experience 97
 MEGAN GATELY, COLLEEN HILL, JESSICA JOHNS,
 AND ANTHONY PENNAY

11 Collaborative Conservation E-Course across Borders:
 Interpretation and Presentation of an Uncomfortable
 Heritage Site in Berlin 107
 ALEXANDRA SKEDZUHN-SAFIR, KATELYN WILLIAMS,
 STEVEN COOKE, AND IAIN DOHERTY

PART IV
The Impact of Space and Architecture in Transforming Museum Studies

119

12 Mapping Memories and Making Meaning:
Community-Engaged Heritage Studies and Research 121
HANNES ENGELBRECHT AND MARTINA JORDAAN

13 Re-Imagining Museums from the Screen:
The Challenges and Opportunities of Pandemic Learning 131
DALIA HABIB LINSSEN AND MARTINA TANGA

14 From Streets, to Galleries, to Internet:
Defining "Contemporary Museum Space" in
Chinese Art Exhibitions Pre- and Post-Pandemic 137
SHAOQIAN ZHANG

Conclusion: Ready for Change: The New Resilient Cultural
Heritage Professional in the Post-Pandemic Era 144
LEDA CEMPELLIN AND PAT CRAWFORD

Index *149*

Contributors

Paloma Añoveros (BA Art History, *Universidad Complutense*, Madrid, Spain; Conservation, *Escuela Superior de conservación*, Madrid, Spain; MA Museum Studies, JFKU; post-graduate, Strauss Center for Conservation, Harvard University) teaches museum collections management and preservation at USF. She is a consultant specialising in strategic planning and management of Museum Collections and Exhibitions.

Paula Birnbaum (PhD, History of Art, Bryn Mawr College) is Professor of Art History and Academic Director of the Museum Studies MA Program at USF. She is a specialist in modern and contemporary art and exhibition practices, and is the author of *Sculpting a Life: Chana Orloff between Paris and Tel Aviv* (2023), among other titles.

Leda Cempellin (Research Doctor, Università degli studi di Parma) is Professor of Art History, Coordinator of Museum Studies minor, and current Associate Director of the School of Design at South Dakota State University. She published *The Ideas, Identity, and Art of Daniel Spoerri* with Vernon Press (2017).

Laura-Edythe Coleman earned her PhD in Information Science with a focus on Museum Informatics from Florida State University and is Assistant Professor and Director of the Responsible Cultural Leadership Certificate Program at Drexel University. She is Fulbright Specialist in Library and Information Science.

Steven Cooke (PhD) is Associate Professor, Course Director for Cultural Heritage and Museum Studies, and Member of the Alfred Deakin Institute for Citizenship and Globalisation at Deakin University. He publishes extensively on the spatialities of difficult histories, including three highly commended books on the memory of war and genocide.

Pat Crawford is Professor of Landscape Architecture and Director of the School of Design at South Dakota State University. She earned her Master's in Landscape Architecture at Kansas State University and her PhD in Environmental Design and Planning at Arizona State University. She coauthored several APLU reports on employability skills for the series *From Academia to the Workforce*.

Carissa DiCindio is Associate Professor in Art and Visual Culture Education and co-directs the Graduate Museum Studies Certificate Programme in the School of Art, University of Arizona. She holds an MA in art history and a PhD in art education from the University of Georgia.

Iain Doherty (PhD) (SFHEA) has 20 years' experience in teaching and learning leadership spanning three different countries and institutions. Iain's skill set ranges across strategic and operational management along with managing people and culture. He remains active in course design, learning design, and teaching as well as being active in research.

Adriana Dunn serves as Assistant Director of the Art Museum of the University of Memphis. Prior to this, she completed a Master of Arts at the University of Memphis in Art History and a Museum Studies Certificate. She teaches museum studies courses at the University of Memphis.

Hannes Engelbrecht is Heritage and Cultural Tourism Lecturer in the Department of Historical and Heritage Studies, University of Pretoria. His teaching is inspired by practical, multidisciplinary, collaborative approaches that move beyond the classroom. His research interests include media-induced tourism, digital and textualized heritage, and tourism landscapes.

Cannon Fairbairn is a PhD student at the University of Birmingham, having completed her Masters in Art History—Egyptian Art and Archaeology and her graduate certificate in Museum Studies at the University of Memphis. She has interned at museums with diverse collections of contemporary art and anthropological objects.

Karen M. Fraser (PhD, Stanford University) is Professor of Art History & Museum Studies at the University of San Francisco. She is a specialist in the history of Japanese photography, with additional research interests in museum history. She teaches both undergraduate and graduate classes that incorporate exhibition practices.

Megan Gately is Director of Learning and Engagement at the Ronald Reagan Presidential Foundation and Institute (USA). She holds a BA in History/Education from the University of Arizona and an MA in Educational Leadership and Policy from Arizona State University.

Neecole A. Gregory serves as Adjunct Professor teaching numerous courses related to art, Coordinator at the Fogelman Galleries of Contemporary Art at the University of Memphis, and Collections and Special Projects Coordinator at the Morton Museum of Collierville History. Her professional interests pertain to the arts and technological advancements in museums.

Colleen Hill is Associate Director of Education at Ronald Reagan Presidential Foundation and Institute. She has a BA in Liberal Arts and Music from California Lutheran University and a Museum Studies Certificate from Northwestern University.

Jessica Johns is Lead Educator at Ronald Reagan Presidential Foundation and Institute (USA). She earned a BA degree in Liberal Studies from California State University, Chico. After spending several years in the classroom as a substitute teacher and a science specialist, she found a home in museum education.

Martina Jordaan (PhD in History, University of Pretoria) is Head: Community engagement research and postgraduate students at the University of Pretoria, Mamelodi campus. Previously she was a senior lecturer responsible for the compulsory undergraduate module, the Community-based Project Module (JCP) of the Faculty Engineering, the Built Environment and Information Technology, University of Pretoria.

Anra Kennedy works with museums and heritage organisations internationally to help them successfully navigate the impact of digital transformation. Her specialisms are digital leadership, literacies, and skills in the context of resilience, social impact, and values-led practice. Anra leads Culture24/ Audience Agency programmes, co-chairs Creswell Heritage Trust, and is a founding partner of One by One and Digital Culture Compass.

Anna Lawrenson (PhD, Australian National University) is Degree Director, Art Curating and Lecturer, Museum and Heritage Studies at the University of Sydney. Her career has spanned critical museology and applied practice, having worked in academia and the arts sector. Her research examines how the funding and administration of museums inform public engagement.

Dalia Habib Linssen is Director of Academic Engagement at the Museum of Fine Arts, Boston, and teaches in the Department of the History of Art and Architecture at Boston University. Her research focusses on art education, museum studies, cultural heritage, and object-based learning across disciplines. She holds a PhD in Art History from Boston University.

Leslie Luebbers is Director of the Art Museum of the University of Memphis and Director/Co-founder of the Interdisciplinary Graduate Certificate in Museum Studies. She earned an MA and PhD in art history from New York University. She teaches Museum Practices and Museums and Communities at the University of Memphis.

Lisa Marotz BS, Family Consumer Sciences Education, minors Early Education and English, 1989 South Dakota State University. Certified Fund-Raising Executive degree 2021, Indiana University—Lily School of Philanthropy, Indianapolis. Lisa is the Director of McCrory Gardens at South Dakota State University.

Heather Grace McLaughlin received a BA in sculpture from Temple University's Tyler School of Art and earned her MS in Arts Administration & Museum Leadership at Drexel University's Westphal College. She is Adjunct Professor at Drexel University.

Margaret McColl (PhD from the University of Glasgow) is Senior Lecturer in Museum Education and Art Education and Director of the MSc Museum Education and the International Master of Education in Museums and Heritage (Erasmus Mundus) at Glasgow University (UK).

Chiara O'Reilly (PhD, University of Sydney) is Director of the Museum and Heritage Studies postgraduate programme at the University of Sydney. Her research examines cultural institutions (Galleries, Science and Social History Museums) to critically consider their history, collections, and role with a particular emphasis on exhibitions and audiences.

Anthony Pennay, formerly Chief Learning Officer at the Ronald Reagan Presidential Foundation and Institute, is VP for Strategic Growth at New Horizons (the United states). He holds an MA in English-Creative Writing from the University of Hawaii at Manoa, and a BA in Literature and Film Studies from Claremont McKenna College.

Kathryn Plank BA, History, minors Global Studies, Religion, Museum Studies, 2020 South Dakota State University. Graduating in 2024 with a Museum Studies Master degree from Indiana University—Indianapolis. Kathryn's focus is on public and education programming that emphasises community collaboration and multicultural appreciation.

Javier Plasencia is a seasoned arts administrator and the current programme manager for the Museum Studies MA Programme at USF, where he teaches the programme's internship course. Javier received his MA in Visual Arts Administration from NYU and his BA in English Literature from Columbia University.

Briley Rasmussen is an independent scholar and museum consultant. She holds a PhD in Museum Studies from the University of Leicester, an MSEd Leadership in Museum Studies from Bank Street College of Education, and an MA in History of Art from the Courtauld Institute of Art.

Martha M. Schloetzer is the author of *Applying for Jobs and Internships in Museums: A Practical Guide* (Routledge). For over ten years she served as Programme Administrator for Internships and Fellowships at the National Gallery of Art in Washington, DC.

Eyal Shahar is Chief New Media Exhibits Engineer at the Exploratorium in San Francisco. He teaches the Museums & Technology Practicum at USF. Eyal has a BSc in electrical engineering from Tel Aviv University and an SM in Media Arts and Sciences from the MIT Media Lab.

Karren Shorofsky, (BA Art History, Brown University; MA Art History, San Francisco State University; JD Yale Law School) is an Adjunct Professor in the University of San Francisco's Museum Studies Graduate Programme and in the School of Law. She also directs the Office of Career Services at the law school.

Alexandra Skedzuhn-Safir trained as a conservator in Italy and holds an MA in World Heritage Studies and a PhD (Dr Phil) in Architectural Conservation from BTU Cottbus-Senftenberg, where she is a Assistant Professor at the Chair of Architectural Conservation. She investigates marginalised topics in heritage conservation and interpretation.

Martina Tanga is a curator, educator, and art historian with over a decade of museum field experience. She earned her BA and MA in the History of Art from University College London and a PhD in the History of Art and Architecture from Boston University.

Steven Tulsky, Adjunct Professor, is a financial executive and nonprofit finance consultant whose first love is teaching. He specialises in making financial concepts intelligible to students who fear numbers. Mr Tulsky received his BA degree from Duke University and his MBA from the University of North Carolina at Chapel Hill.

Katelyn K. Williams is Academic Coordinator for the Council on International Educational Exchange in Berlin and is a PhD candidate in Heritage Studies at Brandenburg University of Technology Cottbus-Senftenberg. She gained several years of professional museum experience working in public programming and communications at the New-York Historical Society and the Brooklyn Historical Society.

Delia Wilson studied at the University of Glasgow, achieving a BSc in science and a Master of Education. She is Senior Lecturer in the University of Glasgow, School of Education, which she joined in 1999. Her work involves museum education with a particular focus on museums and the science curriculum.

Rachel Wilson is Education and Programming Coordinator for Ducks Unlimited. She holds an MA in Art History and graduate certification in Museum Studies from the University of Memphis. She has experience working with diverse collections, including Ancient Egyptian artefacts, prehistoric tools, waterfowling collections, and contemporary works on paper.

Shaoqian Zhang is Associate Professor of art history at Oklahoma State University. She earned her BA in traditional Chinese architecture from Beijing University; her MA and PhD in art history are from Northwestern University. She received the 2017 OSU College of Arts and Sciences Junior Faculty Award for Scholarly Excellence.

Introduction

Adaptive, Collaborative, Interdisciplinary, and Inclusive Online and Hybrid Strategies to Inspire the Post-Pandemic Museum Studies Classroom

Leda Cempellin and Pat Crawford

What do the cultural heritage institutions of the future look like? How will they continue to offer vivid and meaningful educational experiences to patrons, visitors, and interns amidst natural and human-made disasters? How can institutions meet growing expectations for meaningful virtual engagement with future tech-savvy digital natives? The digital expansion pre and during COVID-19 has impacted academic and museum fields alike: collections, programming, outreach, and museum studies curricula. Videoconferencing systems to facilitate synchronous connections at a distance have long existed; with the new millennium, they have been widely deployed in education (Mitchell et al., 2022, pp. 9–10). When COVID suddenly arrived in spring 2020, many institutions, large and small, swiftly moved part of their programming online in asynchronous formats as well. The American Alliance of Museums was linked to hundreds of online tours and programming developed by museums nationwide to share resources.

How has the Museum Studies classroom taken into account the needs of cultural heritage institutions to bridge the cultural and digital savvy which was accelerated by the 2020 pandemic? The pandemic shutdowns prompted academia to design transformative pedagogical approaches, innovative networks, and outreach experiments to discover the potential of new technologies and incorporate them meaningfully within the classroom to transform their educational paradigms.

Museum studies programmes, grounded in academic theory and professional practice and based on interactions with actual objects in place, present unique challenges and have been hit harder than other classroom endeavours. Within cultural heritage institutions, new and emerging technologies, including augmented and virtual reality, have broken the no-touch barriers and facilitated close examination through simulations. The reconstruction of contexts surrounding the object, new insights on the processes adopted by various museum professionals in handling the objects from storage to exhibition, and a variety of online platforms and storytelling strategies help connect the object to the visitor at cultural and emotional levels. Academics, learning designers, and professional partner institutions working in the Museum

DOI: 10.4324/9781003393191-1

Studies classroom have responded in many ways to the need to compensate for the lack of the physical object by acting at many levels, from small assignments to courses, to entire programmes.

Before the pandemic, Museum Studies bridged the gap between academic knowledge and professional practices, with classrooms as knowledge repositories and cultural heritage institutions as future workplaces. The pandemic disrupted this, leading to collaboration within a unified virtual space. This book's perspective is pedagogical. Traditional research involves critical reflection on teaching and learning processes, including the design of an intervention, qualitative and/or quantitative data collection, results interpretation, and future practice recommendations. This occurs within a controlled environment with an iterative process over multiple semesters. However, the departure point of this book is a dramatic change of context that required an immediate, disruptive response. The critical reflection is done *a posteriori*, identifying triggers and reconstructing adaptive strategies as problem-solving. Critical reflection is the departure point, as opposed to the finish line.

Our anthology is divided into four cross-sectional themes, telling stories of resourcefulness, problem-solving, and resilience at various scales, from assignments and classes to pre-professional practices and entire curricula.

Why We Gather: Connecting and Sharing

Classrooms are places for intellectual discourse with respect towards cultural heritage, involving reflection and idea exchanges through voices, body language, talking, listening, writing, questioning, and watching videos. Cultural heritage institutions are physical spaces hosting material objects and shaping experiences. Both environments are necessary to form well-rounded cultural heritage professionals. When suddenly both spaces shut down, workplaces and artefacts became inaccessible, family routines were shaken, and mental health was a concern. Digital technologies enabled isolated individuals to remain connected, with Zoom emerging as the main virtual place to facilitate interactions.

In this context, students, faculty, and cultural heritage professionals found novel ways to connect and share personal experiences and reflections on cultural heritage. Professionals, altering their presence in the institution to care for the artefacts, designed and posted online tours and videos showcasing individual pieces from the museum collection and provided anecdotes to keep curiosity alive. Using these resources, sharing widely on websites and social media, and integrating Zoom with learning management systems and collaborative platforms like Moodle and Miro, the museum studies' virtual classroom welcomed novel forms of interaction among faculty, classmates, cultural heritage professionals, artefacts, and community members.

A more humanised and intimate virtual classroom emerged as the answer to the convergence of a pandemic of epic proportions, civil unrest, and increased political polarisation. The classroom, bound by behavioural etiquette, became a model of intellectual cultivation, emotional restoration, and equality aspirations. Everyone—faculty, students, cultural heritage professionals, guests, community collaborators—enjoyed the same real estate in the Zoom gallery view, professional attire was optional, and comfort pets were welcomed.

Anna Lawrenson and Chiara O'Reilly envisioned a framework for continuity during this transition, applying three principles in their online teaching: predictability, flexibility, and care. Briley Rasmussen and Carissa DiCindio explored collaborative practices to share students and resources from two universities for developing online exhibition experiences. Lisa Marotz transformed an app originally designed for visitors' *in situ* experiences into a learning tool that refocused students' attention to their immediate surroundings, thus moving the classroom into open spaces (Marotz and Plank).

Pivoting Our Pedagogical Skills to Affect Change

While technology removed personality-filled handwriting from digital files way before COVID-19, the pandemic enabled educators to showcase technology's humanising power. The removal of geographical barriers allowed faculty to increase global connections, invite additional virtual speakers without adding travel costs to the programme budget (Plasencia et al.), test new technologies like virtual reality without fear of failure (Coleman and McLaughlin), expand the typology of cultural institutions for a more varied and inclusive internship experience (Plasencia et al.), and integrate socio-emotional components of learning to reshape an entire internship experience as a mentoring model focused on developing emotional intelligence skills (Schloetzer).

The virtual classroom also removed the smart desk, creating a more equitably accessed and shared space. Students and alumni, previously the subjects of qualitative and quantitative studies, are given a direct voice and have become co-authors with faculty to help paint a multi-faceted picture of this new learning environment and the mentoring experience (Adriana Dunn, Cannon Fairbairn, Neecole Gregory in Adriana Dunn et al.).

Creative Tensions: Bridging the Academic-Workforce Gap

As the physical distance between classes and cultural heritage institutions (the two complementary components of Museum Studies) collided in the Zoom screen, Anra Kennedy served as a consultant to help institutions discover and deploy digital platforms as educational tools. She explained the digital skillset needed to transform traditional storytelling into a more open-ended constructivist environment that invites collaboration. The Reagan Foundation, known

for forming future leaders, proved resilient and resourceful in the face of massive layoffs—an unfortunate side effect of colleges, cultural institutions, and even businesses previously thriving on in-person interactions and exchanges. The Foundation's leadership programme, primarily catering to K-12 students, was successfully adapted to the virtual format through the design of immersive decision-making situations, thus becoming a model integrating adaptive content and processes.

The digital environment's removal of physical barriers enabled geographically distant academic institutions to create meaningful interdisciplinary collaborations across oceans and time zones. Through video technologies and digital brainstorming platforms, two higher education institutions, one from Europe and one from Australia, engaged their students in a project involving a disputed area of the Berlin Wall. Future cultural heritage professionals, thriving online under the pandemic's challenges, are trained to deal with controversial sides of history (Skedzuhn-Safir et al.). Margaret McColl and Delia Wilson managed to place two American students in Scottish museums remotely to develop online resources; they explained the skillset learned by students and the adaptive strategies devised to incorporate key elements of professionalism, such as meaningful interactions with the museum staff, in the remote internship experience.

The Impact of Space and Architecture in Transforming Museum Studies

The COVID-19 pandemic has led to a more multi-faceted notion of classroom *space*, which has inner emotional components, expanding beyond the classroom and into our immediate surroundings, and invites us to collaborate on various platforms that expand and defy traditionally experienced notions of space and time.

After days in isolation, students, faculty, and professionals better navigated virtual spaces. A mandated in-person, hybrid, or phased return to our communities required us to integrate these digital resources and skills with previous ways to experience cultural heritage. Dalia Habib Linssen and Martina Tanga focused their students' attention on the critical examination of museum architecture and the accessibility of online museum programmes. This helped bridge the gap between real and virtual spaces. Hannes Engelbrecht and Martina Jordaan from the University of Pretoria partnered with the Historical Society of Mamelodi to design a virtual platform that turned community members into content co-creators, honed students' skills, and led to a product that transcended the local community's geographical boundaries. Shaoqian Zhang's essay provides a snapshot of the pre-and post-pandemic tensions between Chinese artists and the state's cultural politics, with creatives finding alternative exhibiting spaces both on-site and online.

Within the framework of this book, academics, partners, students, and alumni shared their stories. These included synchronous and asynchronous course redesign at micro- and macro-scales, classroom management strategies weaving personal well-being with intellectual curiosity, academic partnerships at national and transnational scales, and novel approaches to community outreach. We hope that the resourcefulness and adaptive strategies represented in this anthology will inspire readers to look into the future with hope: humanity can turn challenges into opportunities for innovation, leading to a more mature society.

Reference

Mitchell, A., Moehring, T., & Zanetis, J. (2022). *Museums and interactive virtual learning*. London: Routledge.

Part I
Why We Gather
Connecting and Sharing

1 Belonging and Being Human

Developing a Framework to Teach Museum and Heritage Studies Online During a Crisis and Beyond

Chiara O'Reilly and Anna Lawrenson

In March 2020, Australia went into a harsh lockdown. Our geographic isolation was quickly leveraged as international and state borders closed and planes were grounded (Commonwealth of Australia, 2022). Worlds shrank to small circles, radiating from our homes, determined by government-imposed travel limits. Universities, cultural institutions, and the routines of daily life experienced long periods of strict lockdown. In the Museum and Heritage Studies (MHST) postgraduate degree programme at the University of Sydney, teaching quickly shifted online and remained that way for nearly two years. Students dealt with unstable work and housing, anxiety, and isolation, so our key priority was supporting them to maintain strong engagement while continuing to offer high-quality learning. Staff also faced instabilities, increasing work, and personal demands along with the technical limitations of their home offices. Therefore, any "solution" needed to be manageable for staff and accessible for students. The experience provided a rare opportunity to reflect on teaching strategies and implement changes that responded to the crisis while helping to form new collaborative frameworks that could be carried into the future.

We designed an approach focused on three key principles: predictability, flexibility, and care. These principles shaped our teaching and how we sought to support students and one another. We established predictable learning routines via careful communication and clearly articulated expectations to balance the unpredictability of daily life and the overwhelming 24-hour news cycle of pandemic reportage. Synchronous and asynchronous content gave students flexibility—without penalising how they participated—allowing them to juggle other responsibilities. Finally, care was core to our approach; we were genuinely worried about the welfare of our students. As a result, cohort building was one of our primary aims, with a particular focus on students outside of Australia, whom we wanted to ensure felt included.

We begin this chapter by establishing the context of the MHST programme. Next, we unpack the pedagogical foundation of each principle and demonstrate how we applied them in practice. We argue that by taking this approach, we were able to effectively support students, sometimes more so than in previous face-to-face scenarios. Moreover, the rapid pivot to online learning created unforeseen benefits that have become an enduring and positive legacy of

DOI: 10.4324/9781003393191-3

the experience: the opportunity to engage with industry across Australia and the world, a renewed focus on community, and a drive to support students and staff through a culture of care. These benefits will stand our students in good stead to become empathetic cultural leaders who value the interconnectedness that was afforded throughout this difficult time.

Context

The MHST programme is a postgraduate coursework degree taught by a small team at the University of Sydney (University of Sydney, 2022). Students come from various undergraduate disciplines, are highly motivated, and enroll with diverse career ambitions. Prior to COVID-19, the curriculum was designed to build collegiality via in-person attendance and was enthusiastically taken up. The programme had never been taught wholly online but did use an online learning platform (Canvas) for announcements, resources, "catch-up" lecture recordings, and assignment submission. This meant that students and staff had some technical competence and familiarity, which aided the 2020 reactive and rapid transition (Manca and Delfino, 2021) to online learning. Nevertheless, we were mindful that online learning was forced upon MHST students, all of whom had enrolled in a face-to-face degree programme. Despite the challenges, the rewards were significant. The connections we built between staff and students—especially valuable during the isolation of lockdowns—allowed us to work across real and virtual borders by making the most of digital platforms to engage, share, and collaborate.

Predictability

Given the rapidity of the shift online and the chaotic nature of the early pandemic, academics were keen to ensure there was a continuity of learning and engagement for students. We sought to allay anxiety by deploying educational design to articulate a coherent, predictable structure that mirrored in-person learning and pivoted on clear communication and expectations. Badley (2022) argues that clarity "gives students a sense of control" and builds "self-efficacy," thus maximising their chances of performing well (p. 84). We were aware of the limitations of the online classroom whereby, as Robinson et al. (2017) argue, students can become anxious as opportunities for interpersonal connection and reassurance become limited, meaning that "effective communication with online students is critical" (p. 39). Creating a predictable structure and communication strategy provided certainty for students: a familiar routine within a rapidly changing, uncertain world.

We implemented this strategy in a unit in March 2020 that involved asynchronous content—recorded lectures, electronic readings and resources, student presentations, and discussion boards—alongside a one-hour synchronous

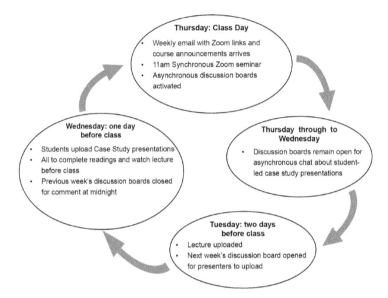

Figure 1.1 Predictable Cycle of Engagement and Communication in MUSM7035 Ethics of Cultural Property.

seminar each week. When redesigning the unit for online delivery, we used the original in-person class time as the starting point for a weekly cycle of engagement and communication as seen in Figure 1.1.

We provided this diagram to students at the outset so that they knew what to expect each week, thus empowering them to plan and control their schedules. With the university changing plans very quickly, it was important not to bombard students with information. To complement the predictable class structure, we scheduled a single weekly email "announcement" containing all relevant information for that week to arrive just before each synchronous class. The announcement included a summation of the previous week's discussions, introduction to the current week, and links for the synchronous Zoom and discussion board along with general announcements and reminders. This predictable strategy established a clear expectation of how and when information would be communicated. Predictability also extended to the design of the online learning space, which used a single page template for each week's class to ensure that information was clearly structured and easily accessible . Each week's page began with a short low-tech video of the lecturer introducing the topic, conveying announcements, and reiterating expectations about weekly contact times. The casual tone sought to allay anxiety and provide a human

face to the subject. This was followed by links to the readings, the recorded lecture, further resources, and discussion board links.

Students appreciated the certainty embedded in the structure of this unit, a comforting routine during a difficult time, as expectations on how and when they needed to engage were clearly outlined. This strategy can be valuable in face-to-face settings as well.

Flexibility

Alongside predictability, it was important to offer flexibility to allow students agency and choice, ensuring we remained responsive to changing needs. Such an approach was recognised by Huang et al. (2020), who posited that in order to "promote easy, engaged and effective learning" during the pandemic, it was vital "to reconceptualize flexible pedagogy as a learner-centered educational strategy" allowing students to choose the when and where of their learning and how they would seek out support (p. 2). We thus offered asynchronous and synchronous components that allowed students to take control of their learning based on their circumstances.

The foundational asynchronous element was the weekly recorded lecture. It allowed students choice in how they listened and supported a slower mode of engagement than a traditional face-to-face lecture: students could pause to look up concepts, consult the readings, or simply have a break. To leverage this, we rethought lectures, creating a more individualised digital experience by using a conversational tone, incorporating further digital content, like videos produced by cultural institutions, and introducing more extensive case studies that students could explore in their own time. Further resources including press coverage of topical events like the museum sector's response to BLM were posted on the weekly e-learning page, thus building a rich library of content that provided new ways to explore core thematic issues.

The importance of flexibility extended to collaborative learning opportunities through asynchronous online discussion boards. These were formal learning spaces where students uploaded presentations, recorded in PowerPoint, analysing course readings, and relating them to current examples, to which peers responded. Presenters moderated the discussion board, which was open for a week, with the instructor providing oversight. The depth of engagement was striking, with students engaging in sustained collaborative conversations around the presentations within these digital forums. As a shared resource, the discussion boards provided an opportunity to develop critical and analytical skills, which documented learning. At the end of the unit, students were encouraged to consult the discussion boards in preparation for final assessments, as a shared notebook, which charted their learning journeys.

The asynchronous content provided a foundation to support live discussions that took place in Zoom seminars designed as welcoming spaces of

collaboration and connection, allowing students to augment understanding through dynamic discourse. Students were encouraged to have their cameras on, if they felt comfortable to do so. The class format was a mix of whole group discussion and smaller breakout rooms where students undertook specific tasks that were shared back to the larger group. This flexibility and responsiveness encouraged a sense of belonging, which ensured that attendance remained strong. Students enjoyed the live Zoom sessions because they maintained social connections, and shared ideas to develop a deeper knowledge of the course content despite the loss of face-to-face discussion.[1]

In addition, the live seminars became key spaces to manifest support and care. For example, the Zoom chat function dynamically fostered peer support and generated community via casual conversations. Unlike formal discussion boards, the Zoom chat was used by students and staff alike for more informal, social conversations about the mundane aspects of life in the pandemic—what people were cooking, reading, or watching. This ensured that the weekly synchronous class was also a valuable social space, particularly during extended periods of lockdown. We say more about our pedagogy of care in the "Caring" section.

In combination, the asynchronous and synchronous points of engagement built in flexibility and ensured that student voice remained at the heart of the learning community. These points of engagement created diverse opportunities to connect and share both in terms of formal learning and social support. Students commented that they enjoyed the opportunities to build rapport between peers and lecturers despite being online.[2]

Caring

A culture of care has always been central to teaching in the programme. The pandemic, however, intensified that need as students and staff were collectively challenged. As Ikpeze and Schultz (2022) noted, the challenges of the pandemic meant that "issues of care, empathy, and emotional/psychological support for students" were vital (p. 239). Lemon (2021) concurred that the pandemic presented "an opportunity for a pause and a self-awareness" in which "humanity and self-kindness" could be prioritised (p. 161). Care was thus a demonstration of compassion, central to our approach to online learning and the nurturing of this new online community. There was an intimacy present because of the incursion of home life that was unavoidable as lectures were recorded there, and live sessions allowed a literal glimpse into people's homes. This intimacy generated a familiarity that humanised lecturers and celebrated the collective experience as we all delighted in the interruptions of pets, children, and partners. This echoes Banki's (2021) assertion that there is value in "expressing care for our students, particularly in relation to the importance of establishing trust" and that they "appreciate the chance to see the personal side of their lecturers" (p. 69).

14 *Chiara O'Reilly and Anna Lawrenson*

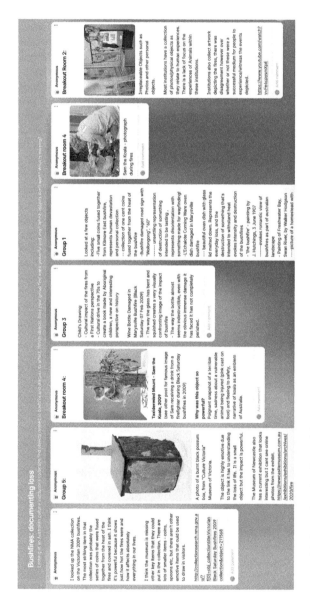

Figure 1.2 Group-based Padlet Activity *Bushfires: Documenting Loss* in MHST6904 Museums and Heritage: Objects and Places.

Care was also manifested in the relationship-building aspects of courses. The use of small-group activities during live seminars became an important way to build community *and* support learning. Simple, non-assessable tasks were designed to help students apply theoretical concepts by researching examples dynamically during class. These tasks were undertaken in breakout rooms which provided private spaces where students could speak freely or invite lecturers in if desired. Groups were kept small, five or six members, to enable discussion and ensure everyone could speak. Each group documented their discussions using Padlet, an online collaborative whiteboard, which became an enduring record of learnings over time and a conscious strategy to build a sense of cohort digitally. Breakout rooms delivered an unanticipated positive of online learning: randomly assigning participants to groups throughout the semester allowed students to form a wider network of contacts among their peers exposing them to different ways of thinking and communicating. Peer socialisation can be difficult in face-to-face situations where existing social relationships often dominate. The random constitution of breakout rooms democratised discussions and the use of Padlet enabled students to take the lead in documenting their own learning. Thus, both strategies helped to create more inclusive, student-led learning environments (Figure 1.2).

Another advantage of the shift to online learning was that it allowed us to overcome geographic and physical barriers in new ways. Guest speakers from across Australia and internationally were suddenly possible as the democratising effects of Zoom-based classes became evident. This wider pool of contributors broadened course content—we had speakers from North America, the Pacific, regional, and interstate Australia. This benefited students by exposing them to a greater breadth of firsthand accounts than possible in person. Furthermore, these guest sessions were more accessible for students, who used the Zoom chat as a space to pose questions and share documents.

The pandemic presented a rare opportunity that forced a quick and radical rethink of teaching. Applying the principles of predictability, flexibility, and care enabled us to redesign how we worked during a time of global crisis while maintaining quality. The legacy of the experience for teaching staff has been a renewed focus on connection and care—the fostering of a sense of belonging and being human as central pillars of teacher and student relationships in the tertiary space. Strategies around flexibility, a focus on making teaching predictable, and a meaningful support structure for learning are not new but are likely to become increasingly important. The tools we adopted— pre-recorded lectures, Padlet activities, short-format introductory videos, and discussion boards for presentations—may not remain the same, but the need to innovate, embrace change, and deploy strategies that allow flexibility and the tailoring of the educational experience are all likely to remain vital into the future.

Notes

1 Unit of Study Survey, MHST6904, Semester 2 2020.
2 Unit of Study Survey, MUSM7030, Semester 1B 2020.

References

Badley, K. (2022) *Engaging College and University Students: Effective Instructional Strategies.* Routledge.

Banki, S.R. (2021) '"Learning Alone-a with Corona": Two Challenges and Four Principles of Tertiary Teaching', *Journal of Research in Innovative Teaching & Learning*, 14(1), pp. 65–74. Available at: https://doi.org/10.1108/JRIT-12-2020-0081

Commonwealth of Australia. (n.d.) *COVID-19: A Chronology of State and Territory Government Announcements (Up Until 30 June 2020).* Parliament of Australia. Available at: https://www.aph.gov.au/About_Parliament/Parliamentary_departments/Parliamentary_Library/pubs/rp/rp2021/Chronologies/COVID-19StateTerritoryGovernmentAnnouncements (Accessed: 21 October 2022).

Huang, R.H. et al. (2020) *Handbook on Facilitating Flexible Learning During Educational Disruption: The Chinese Experience in Maintaining Undisrupted Learning in COVID-19 Outbreak.* Smart Learning Institute of Beijing Normal University.

Ikpeze, C.H. and Schultz, S.M. (2022) 'School Interrupted: Issues and Perspectives From COVID-19 Remote Teaching', in L. Czop Assaf, P. Sowa, and K. Zammit (eds) *Global Meaning Making.* Emerald Publishing Limited (Advances in Research on Teaching), pp. 225–242.

Lemon, N. (2021) 'Illuminating Five Possible Dimensions of Self-Care During the COVID-19 Pandemic', *International Health Trends and Perspectives*, 1(2), pp. 161–175. Available at: https://doi.org/10.32920/ihtp.v1i2.1426

Manca, S. and Delfino, M. (2021) 'Adapting Educational Practices in Emergency Remote Education: Continuity and Change from a Student Perspective', *British Journal of Educational Technology*, 52(4), pp. 1394–1413. Available at: https://doi.org/10.1111/bjet.13098

Robinson, H.A., Kilgore, W., and Warren, S.J. (2017) 'Care, Communication, Support: Core for Designing Meaningful Online Collaborative Learning', *Online Learning*, 21(4). Available at: https://doi.org/10.24059/olj.v21i4.1240

University of Sydney. (n.d.) *Museum and Heritage Studies - Faculty of Arts and Social Sciences.* Available at: https://www.sydney.edu.au/arts/schools/school-of-art-communication-and-english/museum-and-heritage-studies.html (Accessed: 13 December 2022).

2 Gathering Online

A Collaborative Project with Graduate Museum Education Students During COVID-19

Briley A. Rasmussen and Carissa DiCindio

The COVID-19 pandemic forced all of us to live in new ways. For those of us teaching museum-related courses, it also compelled us to not only teach through different formats but also to consider what museums are if we are unable to visit them in person because of closures and limitations due to the pandemic. This chapter discusses a project we created and implemented in our respective art museum education courses that asked students at both universities to collaborate with one another and develop asynchronous virtual tours exploring collections on both campuses at The University of Texas at Austin and the University of Arizona. In so doing, we questioned the traditional forms of coming together in museums and created programmes grounded in purpose.

In late fall of 2020, when we knew that we would not be teaching in person in spring 2021, we began conversations about how we would teach our courses virtually. We would both be teaching art museum education courses that focused on practice. Our original intention, before pandemic closures, was to hold many of these classes in campus art museums, model teaching practices, and have students develop their own teaching and lesson development skills. Prior to the start of the semester, we realised that this was not going to be possible at any point during the spring.

Planning

Because our respective courses shared many goals, and because our teaching methods align well, we decided to create a collaborative project for our classes. We already had similar projects planned for this course wherein students would prepare and execute a lesson with museum collections. We saw great benefits in having our students meet and work with art museum education students at another university, including the ability to expand our communities during these intense periods of isolation. Such a project would enable us to teach the skills and methods of collaboration, project management, and network building as part of one's professional practice grounded in visitor-centred experiences.

DOI: 10.4324/9781003393191-4

As we planned our collaboration, we were aware that we were managing our own trauma and anxiety during this time of isolation in a global health crisis. We therefore considered similar mental health challenges that our students would face. The world seemed to be changing by the day. The museum education that we knew and had practised for decades did not feel effective or valid in these new times. These were all issues we were considering and questioning as we approached creating this collaboration between our classes. It often felt like we were trying to fix the shutters in the middle of a hurricane.

As we tried to plan teaching online, we faced obstacles and limitations of the types of experiences we could offer students about museum education when we were unable to physically visit museums. Like so many of our colleagues around the globe, the question quickly became, "What do we do now?" On a positive note, the inability to physically access museums or collections for our classes forced us to question and reconsider the deeper purpose of what we were doing as university instructors and as museum educators—but how do we do this remotely without museums or museum collections? This led us to deeper conversations about the purpose of teaching in art museums.

Framework

This line of inquiry took us to Priya Parker and her book *Art of Gathering: How We Meet and Why It Matters* (2018). In this book, Parker argues that we seek to understand the deeper purpose of our gatherings, both formal and informal. She expands on this idea, stating, "when we don't examine the deeper assumptions behind why we gather, we end up skipping too quickly to replicate old staid formats of gathering, and we forego the possibility of creating something memorable, even transformative" (p. 3). Over time, she states, "category can masquerade as purpose" (p. 8). In our case, we realised that the category of a museum tour has often been confused or conflated with its purpose. When we plan museum tours, we often focus on logistics, which objects will be included on the tour, and the participatory elements we will weave into the experience. We take for granted that this tour will follow the same format and structure that we have all come to expect on tours. However, when we think about the purpose of the tours, it shifts our perspective to consider what changes we could make to the tour that would better serve its purpose. Our thinking about museum teaching was liberated by this idea. During the pandemic, we were not held to the same formats of museum teaching we were used to; rather, we had the opportunity to focus on why we were gathering together around works of art: To consider them and to share our ideas with each other. This focus on purpose became the centre of our collaboration.

Project Implementation

Through this project, students considered how art museums can serve as sites for intentional gatherings through asynchronous digital experiences. We focused these experiences on building community and social connections. Students worked together to engage with their university art museums through experiential learning opportunities centred on care and wellness. They thought about how art experiences could offer openings for connections with works of art and each other, ways that objects could serve as intermediaries for dialogue, and how they could use works of art in mindfulness and wellness practices.

The project was comprised of four components: Engagement with an individual work of art and tour stop plan; the full tour plan, called the arc of teaching, that resulted in the cross-university collaboration; a presentation of the tours through videos and discussion; and a final paper that allowed students to evaluate their work and reflect on the experience of the project (Figure 2.1). For the first assignment, engaging with an individual work of art, we asked students to choose a work of art from their university collections using museums' public digital online databases or public outdoor art on campus. For the first half of the semester, each student engaged individually with the art they chose through a series of assigned activities and prompts designed to encourage long looking. They also posted responses using the online sharing platform Padlet. For example, for a long-looking response using writing, we asked students to write one to two paragraphs from the perspective of a work of art, as if they were the art. In another, we asked students to create soundtracks that matched their works of art. These individual prompts and responses were designed to give students opportunities to spend time with a work of art, provide examples of ways they could frame activities on tour stops, and give them space to share their experiences with classmates.

Figure 2.1 A Diagram We Shared with Students to Illustrate the Progression of Assignments. Credit: Briley Rasmussen.

For the second half of the semester, each student designed a tour stop either based on the same work of art they used for long looking activities or another work if they were ready for a change or had found a work of art better suited for the project. The guidelines for these tour stops were open because we wanted students to be able to develop the type of experiences they wanted to facilitate, but we asked them to focus in some way on health, care, or connection. We asked students to stay within approximately four to six minutes, include one or more works of art, incorporate a participatory element, and serve as a resource for university students.

Working in cross-university groups synchronously over Zoom and asynchronously through email, students created complete versions of their tours by combining their individual tour stops. Using a rubric as a framework to include a consistent structure in the tours, they developed unified themes, or big ideas, that connected the tour stops together, worked together to incorporate these themes into introductions and conclusions, and designed comments and questions between tour stops to transition to the next one. In some cases, the works of art in each group were quite diverse in terms of media, time period, subject matter, location, and culture, but groups all found connections that unified these tour stops through a big idea.

Groups used their plans to create video tours. They also developed accompanying written guides to their video tours that included activities and discussion questions centred on their themes and designed to further engage visitors. For example, some students designed writing and drawing activities to engage participants, and others included additional works of art and contextual resources about the artist or theme of their tours. Students presented and discussed their work through video screenings of their tours during the last class over Zoom. Their final reflective papers at the end of the semester had them looking back on the project and describing the successes and challenges of putting together videos of asynchronous collaborative tours.

Realities of the Project

Even with a detailed plan in place, issues arose during our collaborative project that were familiar to us after having already taught our courses online for a year. Students at both universities expressed anxiety over the ambiguity of the project. Because we wanted the assignments and final tours to be led by students' ideas and did not want to restrict creative interpretations of the project, we kept the project design very open-ended. However, without perimeters, students were concerned whether they were completing the assignments correctly and producing what we wanted to see. Although we set up a Padlet site for students to ask questions and share ideas, students seemed to want to talk openly with us and classmates rather than typing questions and waiting for responses, and most of these discussions happened during class when we checked in with each other synchronously over Zoom.

Students were also living in different time zones, making it challenging to find time for groups to meet over Zoom and to gather both classes together. As we kicked off the project, we asked everyone to meet to talk about the assignment and get to know their group members. This was difficult, with some students meeting over Zoom while working jobs to fit it into their schedules. When we began the project at midterm, Arizona and Texas had a one-hour time difference. After this initial meeting, daylight savings time started, and Arizona's time does not change, but Texas' time does. The two-hour time difference proved to be much more challenging for students to meet in their individual groups. At the end of the semester, we tried to get the classes back together for final presentations, and it was not possible to find a time that fit everyone's schedule.

Finally, students had to deal with new technologies to record their videos and collaborate online, usually asynchronously. Rasmussen worked with a teaching assistant who had experience in this area, and he helped both classes. Other students who knew more about video editing were able to help the rest of the group record and combine their tour stops. Although confusing or malfunctioning technology caused frustration, it also gave students spaces to collaborate and share knowledge.

Benefits of the Collaboration

The collaborative project gave students experience designing activities with art museum collections and collaborating with their peers to create engaging online video tours. Through this collaboration, students engaged in participatory practices and multimodal learning opportunities. They also gained multiple perspectives into gallery teaching and professional experience that they can take with them in the field. In reflecting on this project, we see benefits to this type of collaboration that far exceed the challenges. These include:

- Working digitally: Students learned how to translate gallery activities into a digital format, use new technology, and facilitate activities asynchronously. This presented benefits and challenges. Students had to respond to images of works of art rather than physically engage in the space with the actual works of art. However, because they were working digitally, they were able to incorporate videos, images, and music into their tour stops seamlessly through their video productions.
- Collaboration: Students collaborated with classmates, museums, and peers from another institution. They experimented with ways to engage audiences through their tour stops and problem solved together to create a unified tour. They were able to share their knowledge and learn from each other.
- Professional networking: This project gave students space to get to know each other as emerging professionals in the field that will hopefully set up opportunities for continued connections in the future. Art museum education is a relatively small field, and building a network of peers is valuable for collaborating and supporting each other in the future.

Conclusion

Cross-university partnerships can build opportunities for peer learning, collaboration, and experimentation through new perspectives and voices. This project took a lot of time and planning, but when it concluded, we felt that it was worthwhile. Virtual programmes will continue to be a part of museum education even now that museums are physically open, and giving students space to experiment with ways in which this type of programming can be incorporated into teaching gives them valuable tools for their professional practices. We see this project as one that can be incorporated in in-person classes as well.

References

Parker, Priya (2018). *Art of Gathering: How We Meet and Why It Matters*. New York: Riverhead Books.

3 Museum Studies in Our Own Backyard

We Have an App for That!

Lisa Marotz and Kathryn Plank

Introduction

Gardens and the cultivation of plants have been in existence for thousands of years with the first examples dating to around 3,000 years ago in ancient Egypt and Mesopotamia. There are approximately 3,700 botanical gardens around the world, drawing 750 million visitors every year (Botanical Gardens Conservation International, no date). In its essence, a public or botanic garden is a mission-based institution that maintains collections of plants for education, research, conservation, and/or public display. By definition, a botanical garden must have a mission statement; plant collections; materials or programmes for education, research, and display; and professional staff. It must also maintain plant records and be open and accessible to the public (Rakow & Lee, 2011, p. 3).

McCrory Gardens

McCrory Gardens of South Dakota State University in Brookings, SD, USA, is a 70-acre botanical garden and arboretum. Our mission statement is, "Connecting people and plants through education, research, discovery, and enjoyment of the natural and built landscape."[1]

Education, being named first, is a top priority for McCrory Gardens. The gardens are filled with traditional passive education tools such as wayfinding signs and plant ID labels. They are helpful means of communicating to a visitor where they should walk or move about, what they are seeing, and even how they can locate a store in which to purchase the plant, tree, or shrub of interest. Not unlike other types of museums, botanical gardens face challenges and opportunities regarding efforts to make themselves a welcoming place for all. What can we do to ensure that every visitor is able to experience the gardens in a meaningful way, regardless of social status, physical ability, distance from the property, and even the weather? How do we encourage usability and barrier-free access?

DOI: 10.4324/9781003393191-5

We Have an App for That!

In 2016, McCrory Gardens was awarded a $50,000 3M EcoGrant to develop the McCrory Gardens Explorer interactive web-based mapping application (McCrory Gardens, 2017). By using a collections management database, staff at McCrory Gardens also developed a website to host the application. Accurate scientific nomenclature and taxonomy for specific perennials, trees, and shrubs within the formal gardens, as well as their defined GPS location, is of utmost importance. In addition to serving as a living collections management system, the heart of the application is to enhance visitor experiences prior to, during, and after their time at McCrory Gardens. All who interact with the application have an entire botanically diverse living museum of curated plants for the northern plains at their fingertips and are barrier-free.

Technology, particularly a collections mapping application such as McCrory Gardens Explorer, benefits both new and seasoned gardeners. For example, by knowing which hardiness zone one resides in, such as zone 4b (US Department of Agriculture) in which McCrory Gardens resides, gardeners can discover through the Explorer app which plants, shrubs, and trees they too could select for their own personal dwelling sites. The app lists growth habits and needs of the plant as well as images of what it looks like in our varying seasons. Little did the McCrory Gardens Education Coordinator anticipate that the painfully tedious work of developing the application would result in our capacity to carry forth educational endeavours amid a global pandemic.

Introduction to Museum Studies Course[2]

During the spring semester of 2020, early in the COVID-19 pandemic, Museum Studies students at South Dakota State University were scheduled to come to McCrory Gardens on three consecutive dates. We had originally planned to introduce the McCrory Gardens Explorer application to students and demonstrate it in a classroom setting. Then, students would be assigned a plant, tree, and shrub to locate within the 25-acre garden using the app on their phone or computer. The final assignment was to identify areas of McCrory Gardens that are not in the app yet and add them.

Unable to interact in-person with the students due to the pandemic, I translated our former class experience into an online platform, offered students opportunities to build an increased hands-on character, and provided for a more independent approach to learning. We looked at the current situation not as a loss for us, rather as an opportunity to experience learning in a new form and to further our positive class climate by working together through the situation. This is learning, too.

For our first class session together, I integrated a pretest to learn about the student's level of understanding of a botanical garden. Through a PowerPoint presentation via Zoom, we discussed the history of botanical gardens and demonstrated the importance of a robust plant database. In the following class

session, we introduced the McCrory Gardens Explorer application. Again, through Zoom and screen sharing, students observed how I navigated the site as I discussed how they would need to work through the app in order to successfully complete their final assignment. This layering effect of instruction aided me as someone new to the higher education classroom, in relating to the students who were new to the application.

The final assignment for the students required them to complete the following steps:

1. Take a photo of an outdoor space surrounding your current dwelling that could be used to plant a garden;
2. Provide contextual information about the space selected;
3. Using knowledge gained from previous class time and also self-discovery using the McCrory Gardens Explorer application, create a collage using the following:
 a. The photo of the space you've selected;
 b. Images of plants, trees, and/or shrubs you've discovered by using the application's search shortcuts;
 c. A brief synopsis of your choice of space and plant materials. Was it driven by science or aesthetic considerations?

Learning outcomes of the final assignment were that students would demonstrate familiarity with the professions within a botanical garden and proficiency in the technological application used in the work of McCrory Gardens. Since the students were unable to visit the gardens in person, teaching through an inquiry-based approach seemed most fitting. As mentioned earlier, the gardens' mission statement includes education, research, discovery, and enjoyment. These words exude activity and a sense of adventure. Through the assignment, students were prompted to investigate, explore, study, and search for answers in their own backyard.

The idea of having the students create a collage was brought about as I reminisced over activities I had done in art classes of my school days. I recalled it being fun to search discarded magazines and clip out images of dream houses, adorable pets, and sparkling jewellery. With endless restraints that the COVID-19 pandemic was imposing, it felt fitting to allow everyone the opportunity to freely use their imaginations to create a beautiful, safe place for themselves or others. After the students received their assignment, they moved swiftly through the process of wondering and researching. They were not evaluated along the way, but were welcomed to reach out to me if they needed help.

The manner in which one student, Kathryn Plank, took on the challenge of the assignment and created a design simply astounded me (Figures 3.1 and 3.2). It was exceptionally thoughtful and wisely developed based on a dream garden for her mother. Not only did she work through the requirements of the project, but Kathryn also proved what a fairly novice user of the McCrory Gardens Explorer application could accomplish from home.

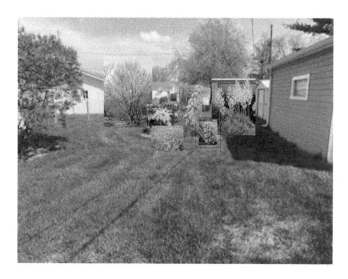

Figure 3.1 Collage developed by Kathryn Plank for her assignment using the McCrory Gardens Explorer App, 25 April 2020.

My backyard in Nebraska already has a flowerbed, butterfly bush, apple and flowering pear tree so I tried to work with those in mind. I replaced the central flower bed to got with my audience (mom) favorites. I chose Rocky Mountian [sic] Blazing Star to a tall purple butterfly flower to be the back center attraction but also compliment [sic] the butterfly bush in the yard. Lavender chives to be in the front of the flower bed to provide easy access for use of the herb. The Redbud tree is on the left side to spread out the visual because the apple and pear are on the right side. When they bloom the trees should provide an array of white, red, purple shades. I added a hyacinth preferably pink, white, or purple (unlike the picture which is blue). This flower is very fragrant and one of my mom's favorite smells. The Monarda and Yucca on opposite sides add a blending white color between the overall aesthetic. All these plants are full sun because the flower bed is in the middle of the yard. The Redbud tree additionally will provide a unique yellow color in fall so give the backyard year round interest and it will compliment the red of the apples on the tree. Multiple flowers in the collection include butterfly, hummingbird, and bee attracting plants. Bringing addition visuals and cheer. Overall the theme and purpose of the garden would be to bring joy to it audience my mom.

(Kathryn Plank's assignment, 25 April 2020)

Summary

Public gardens have evolved from their early inception as gathering places for people to learn about and enjoy plants, to centres of study, and celebration of biodiversity and human culture. As they continue to develop, the primary objective for public gardens today is to maintain relevance in a rapidly changing, connected, and global community (Redman, 2011, p. 327). Does technology diminish the value of the personal, live, and on-site immersive experience? Or do technology's capabilities enhance the visitor experience and expand the learner's and educator's resources? Based on the outcome of utilising the McCrory Gardens Explorer application as a classroom tool during this time of crisis, it has proved to render an accessible-to-all platform.

Notes

1 https://www.sdstate.edu/mccrory-gardens.
2 This introductory course, AHSS 110, which was offered for the first time in-house at South Dakota State University during the spring of 2020, included a leadership team with the Museum Studies minor's Coordinator and members from five partner institutions: South Dakota Art Museum, South Dakota Agricultural Heritage Museum, SDSU Archives and Special Collections at Briggs Library, McCrory Gardens, Children's Museum of South Dakota.

References

Botanic Gardens Conservation International. (n.d.) *Botanic Gardens and Plant Conservation*. Available at: https://www.bgci.org/about/botanic-gardens-and-plant-conservation/ (Accessed July 3, 2023).

McCrory Gardens Explorer. (2017) Available at: http://mccrorygardensexplorer.sdstate.edu/ecmweb/ECM_Home.html (Accessed July 3, 2023).

Rakow, D. (2011) 'What Is a Public Garden', in Rakow, D. and Lee, S. (eds), *Public Garden Management: A Complete Guide to the Planning and Administration of Botanical Gardens and Arboreta*. Hoboken, NJ: John Wiley & Sons, Inc., pp. 3–14.

Redman, P. (2011) 'The Shape of Gardens to Come', in Rakow, D. and Lee, S. (eds), *Public Garden Management: A Complete Guide to the Planning and Administration of Botanical Gardens and Arboreta*. Hoboken, NJ: John Wiley & Sons, Inc., pp. 327–338.

United States Department of Agriculture Plant Hardiness Zone Map. (n.d.) Available at: https://planthardiness.ars.usda.gov/ (Accessed July 2, 2023).

Part II

Pivoting Our Pedagogical Skills to Affect Change

4 Remote Internships During Intersecting Pandemics

Recognising the Significance of Social and Emotional Learning for Adults

Martha M. Schloetzer

In summer 2020, in response to COVID-19, the National Gallery of Art transitioned to 100% remote internships. This was a significant decision because remote internships were relatively new. Previously, the institution had hosted only one virtual intern, a student participating in the US State Department's Virtual Student Federal Service programme. After communicating with supervisors and interns and confirming the switch to remote internships, it became clear we would need to think about the 2020 summer programme differently. A significant challenge emerged: How to keep interns engaged and a part of our workforce culture when they are teleworking. The pandemic forced interns into remote work and made it impossible for them to engage with their supervisors and co-workers in person. More recently, studies have shown the isolation and stress experienced during the pandemic may have impacted this cohort's interpersonal skills and left them feeling lonely. Regrettably, the negative conditions of the pandemic appear to be impacting their transition into the workforce. In May 2023, ResumeBuilder.com published the results of a survey that found 74% of managers believe Generation Z is "more difficult to work with than other generations" (Resume Builder, May 2023). The survey's findings suggest that GenZers would benefit from more training in professional skills, such as interpersonal communication, to succeed in today's workforce.

In 2020, experiencing the impact of social isolation during COVID-19 lockdowns, I felt a responsibility to provide the interns with a programme, but at the same time, felt emotionally overwhelmed and expected they did, too. I recognised it would not work to start the summer as usual. It was important to acknowledge how I was feeling and likewise give the interns an opportunity to process their feelings and express themselves. Our approach to the challenge of remote internships was to surround the interns with support in the form of relationships and camaraderie. Social and emotional learning[1] is not something the internship programme previously focused on. In 2020, we worked differently by offering the following activities:

DOI: 10.4324/9781003393191-7

1. Personal reflection for professional development;
2. Mentorship programme;
3. Weekly asynchronous and synchronous social networking opportunities;
4. End-of-programme celebration.

In this chapter, I argue that connecting with interns on a social and emotional level, which we were not really doing prior to COVID-19, should matter to practitioners because self-awareness (the ability to understand the perspective of and empathise with others) is key to a person's long-term success and provides psychological benefits, including less stress and anxiety (London et al., 2023, p. 265). The purpose of an internship is to gain real-world experience, network, and receive helpful, actionable performance feedback. Because the focus is on work and the learners are mature (college-aged and up), prior to the pandemic we tended to prioritise professional accomplishments. In 2020, I developed creative ways to integrate social and emotional learning into the internship programme.

Peter Felten (Executive Director of the Center for Engaged Learning at Elon University) and Sarah Rose Cavanagh (Senior Associate Director for Teaching and Learning at Simmons University) positively influenced my thinking about social and emotional learning for adult learners. I learned how relationships lead to better student outcomes in terms of students feeling supported and engaged in a learning community and are a powerful factor for identity development (Conley, 2015, pp. 198–199). Likewise, emotions are critical for learning. Positive emotions, such as creativity, curiosity, wonder, and joy, motivate and drive learning success. On the other hand, negative emotions such as anxiety, anger, stress, and sadness distract learners and lead to disengagement (Osika et al., 2022).

Personal Reflection for Professional Development

The summer intern programme started on 1 June 2020, coinciding with the peaceful protests and riots happening across the United States and the world in response to George Floyd's murder. Many cities were under curfew, including my hometown, Washington, D.C. After months of feeling scared and trapped due to the pandemic, many of us were experiencing a new type of fear and anxiety. I knew that if I was feeling this way, the eight summer interns, enrolled in graduate programmes and living in cities and towns across the United States, were too. Therefore, it was important to address any negative emotions that could inhibit learning.

One method I introduced to help interns slow down and process their thoughts and feelings was personal reflection for professional development. During orientation, the interns and I talked about the significance of recording their experiences this summer as a way of learning more about themselves. I asked them to carry a notebook and write notes about the meetings they

attended, contact information for people they met, questions they had, and notes to themselves. I also shared some mindfulness exercises to help them focus on the present, reflect on internal and external experiences, and cultivate a curiosity towards their thoughts, emotions, or physical sensations. I made sure to tell them why reflection is a worthwhile practice. Reflective learning allows learners to step back from their learning experience, helping them to develop critical thinking skills and improve on future performance by analysing what they have learned and how far they have come.

I had two important sources as I worked to integrate reflection into the summer internship programme: Jennifer A. Moon, an author and expert on reflective learning techniques, and Lorena Bradford, my colleague in the Education Division at the National Gallery. Moon has written extensively about the significance of journal writing and learning. In Chapter 13 of *Learning Journals*, she offers a wide variety of reflective activities geared towards students and early career professionals (Moon, 1999). Along with writing exercises, Moon includes forms of non-verbal journaling. Drawing an image or free drawing, recording dreams, and cartooning may appeal to creative people drawn to a career in museums. One of my favourite exercises is writing a letter you do not intend to send. This can be an effective way to explain something about the internship experience in detail. One could even write a letter to their future self.

Lorena Bradford is the manager of Access Programmes at the National Gallery. We had a memorable conversation about reflection where she recommended an exercise to quiet the editorial voice inside one's head: ten minutes of freewriting. The directions are, do not stop writing, even if you cannot think of what to write. If that is the case, simply write, "I don't know what to write." Keep writing for the full ten minutes. This exercise originated from a study by Dr. James Pennebaker, a pioneer of therapy writing. Dr. Pennebaker conducted and published research on the relationship between emotional release writing and improved physiological and psychological functioning (Pennebaker & Smyth, 2016). I have done the freewriting exercise with interns. After the ten minutes, I ask them, "What one thing surprised you after this exercise?" Interns have shared that initially they think ten minutes is an impossibly long time to write. Upon reflection, they are surprised at how much they have to say and how the process of writing brings to the surface thoughts and feelings they did not realise were there. An extension of this exercise is to tear it up and throw away the writing, which reinforces the fact that we are not creating a precious piece of writing; instead, we are developing the skill of critical reflection. Freewriting is about the process, not the product.

Reflective activities promoted intern learning in an online learning environment and are a tool I plan to use in the future even when we transition back to traditional internships. Over the course of the summer, the result of having interns reflect on their experience helped them organise their thoughts and connect what they had previously learned in the classroom with the working world of a museum and create personal insights. This was evident in their

high level of participation, as well as the questions they asked in our weekly meetings.

Omnidirectional Mentorship Programme

One of my main concerns for remote interns was that they would be working from home, isolated from co-workers, and missing social connections. As a result, the second significant component that was added to the remote internship programme was mentorship. We identified the following goals for the programme:

1) Build community: In addition to the intern cohort, departmental supervisors, and teams, we wanted interns to be regularly connected to a museum staff member. In order to get a larger view of our professional community, we made sure that mentors and mentee pairs were not in the same department or division.

2) Provide support and guidance: For example, one of the summer interns had just graduated from college and was coping with a lot of transitions. They wanted a mentor who could be a friend and support during the summer, someone they could count on for conversation or a caring text message or email. Other interns are committed to job searching and value having a mentor who can provide career insights and assistance in preparing for interviews.

3) Network: This goal is connected to building community but also has a practical element—to help increase professional connections. Mentors can help connect their mentees with influential people in their network. This can open up opportunities that would be harder to come by otherwise. For instance, we matched a senior member of the horticulture staff with an intern in the department of northern European paintings. When meeting with her cohort, the intern spoke fondly about leaving her office space to meet with her mentor in the greenhouses on the campus of the museum, which were filled with beautiful plants and trees. In addition to the change of scenery, she valued learning from a seasoned professional outside of art history who provided his own unique perspective on navigating the working world.

There are many mentorship models out there, such as traditional one-on-one mentorships, reverse mentoring, and group mentoring. Based on our goal of focussing on the whole person, not just the interns' future careers, we introduced omnidirectional mentorship, which fuses traditional top-down mentorship with "mentoring-up" and "lateral mentorship" experiences. National Gallery Education Assistant Marie-Louise Orsini identified this topic for us, originally introduced by Edward Clapp, Ed.D, Principal Investigator at Harvard University Graduate School of Education. Clapp wrote:

By fusing *top-down, mentoring-up,* and *lateral mentorship,* Omni-Directional Mentorship naturally builds on the greater know-how of a larger web of professionals. In doing so, it does not deny the directionality of traditional mentorship, it simply turns one-way mentoring into recipro-cal multiway exchanges that are beneficial to all stakeholders.

(Clapp, 2010)

The omnidirectional model worked well for the internship programme because it encouraged a free exchange between mentors and mentees and empowered mentees to be active participants by sharing fresh ideas and challenging their mentors to consider new perspectives. Feedback from mentors revealed that they saw themselves benefiting from the mentorship programme as much as their mentees.

There was not a lot of time in 2020 to prepare for the first mentorship cohort. To make the matching process more efficient, I sent targeted mes-sages to staff who are former National Gallery interns asking them to be men-tors. All the professionals I approached were interested and enthusiastic about serving as mentors. That first summer, I made the matches myself based on my familiarity with the staff and knowledge of the intern cohort. In 2021, we refined the matching process by circulating a "call for mentors" to all staff and a mentorship questionnaire to the interns. This helped democratise the pro-gramme beyond my staff contacts and allowed us to better match the interns and staff based on their goals and common interests.

The expectation was that the pairs would check in once a week during the nine-week internship. Other than providing some resources (such as goal-setting documents, conversation starters, and a mid-point check-in), we did not provide much structure. Instead, we introduced the omnidirectional model and stressed how the mentorship should be tailored to each intern's needs. The post-programme survey responses demonstrate how mentors added much to the interns' experience by providing guidance and support, as well as making interns feel part of the organisation. Interns appreciated the casual nature of the conversations, which alleviated work-related stress. Mentors not only shared insights into workplace culture but also facilitated informational interviews with museum professionals, providing diverse perspectives. The weekly meetings not only allowed mentees to take a break from their work but also helped them forge lasting connections for future career advice and informal chats. Overall, the mentorship programme was a highlight, fostering meaningful relationships.

The mentorship programme provided the support and networking we were hoping for that summer. Interestingly, the virtual nature of the programme may have contributed to its success. At home, mentees may have felt more comfortable and secure compared to the workplace. As a result, it could have been easier for them to communicate openly and honestly.

Weekly Asynchronous and Synchronous Peer Networking Opportunities

Unlike the mentorship component that we added in 2020, peer-to-peer mentorship has always been a part of the summer internship programme, and I wanted to be sure this happened in a remote environment. What worked well for the National Gallery's programme during COVID-19 was designating an intern to lead these efforts. 2020 summer intern, Bridget Girnus, posted weekly activities related to the collection on the interns' Microsoft Teams channel. Examples include creating personal art alphabets using the letters in their names, participating in a virtual scavenger hunt, and writing poems based on art in the collection. Asynchronous writing activities also allowed for collaboration across time zones. One afternoon a week, Bridget led a social hour on Zoom for the intern cohort. It is worth noting that staff did not participate in either of these intern-led activities. During this social time, the interns played games, completed crafts, and got to know each other on a personal level. Trust is a key component of long-term networking; it takes time to build up trust with others. By consistently showing up on a weekly basis and building meaningful connections, the interns were able to get to know one another and build strong relationships that go beyond immediate transactional benefits. The power of long-term networking is uncovering hidden opportunities that may not be immediately apparent. Over time, access to upcoming or unadvertised opportunities, exclusive insights, and industry trends can often arise through long-term trust and collaboration. Interns enjoyed being in a cohort, as it provided an informal outlet to bond over similar personal and preprofessional challenges.

In post-programme survey responses, interns shared how being in a cohort affected their experience. They emphasised the significance of connecting with other interns who were at similar stages in their careers, discussing the learning process in the context of new circumstances, and seeking support. Despite the virtual setting, being part of a cohort proved immensely beneficial, offering a supportive community and an informal outlet. The camaraderie formed within the cohort and the regular interactions with fellow interns became a highlight of the internship, contributing positively to the overall learning process.

The cohort's weekly meetups afforded socialisation that would have happened naturally during an in-person internship. With a bit of advanced planning and a designated leader, Bridget, it was gratifying to see interns bond during the summer. Forming peer relationships is critical because the lateral networking interns do can help them attain career success through job leads and recommendations.

Closure and Celebration

Related to her work planning social time for the cohort, Bridget's final task was to organise a virtual farewell for the summer programme. Because the event was hosted on Zoom, we were able to have a large guest list that included supervisors and staff working with interns, mentors, and other staff who supported the programme. Bridget approached the planning for the farewell by taking advantage of Zoom's features, for instance, arranging a number of group activities for the attendees. Using the polling feature on Zoom, we played a quarantine-themed game of Would You Rather—for example, "Would you rather have a cuddly puppy or a beautiful plant as a quarantine co-worker?" She also used breakout rooms for small-group conversations. In breakout rooms, participants introduced themselves and shared with everyone the object that has brought joy, excitement, or happiness while working from home. Each person had two minutes to talk, and the next person had to find a way to connect their object to the previous presenter's item and ask the previous presenter one follow-up question. This continued until everyone had a chance to share. The farewell combined fun and thanks in the virtual setting and allowed us to commemorate the end of the programme.

Conclusion

The shift in thinking about internships and social and emotional learning matters because it contributes to the interns' emotional well-being and enables them to engage and reap the benefits of experiential learning more fully. It is important that this focus on relationships remains now that we are establishing a new normal. For instance, going forward, I strongly encourage supervisors to schedule time on the calendar to get to know their interns on a personal level. Asking about hopes, dreams, and worries, rather than just work assignments, is critical. If we want happy, productive, engaged interns, we need to continue spending time developing personal relationships: peer-to-peer, supervisor-to-intern, mentor-to-intern, and museum staff-to-intern.

Note

1 Social and emotional learning (SEL) is an integral part of education and human development. SEL is the process through which all young people and adults acquire and apply the knowledge, skills, and attitudes to develop healthy identities, manage emotions and achieve personal and collective goals, feel and show empathy for others, establish and maintain supportive relationships, and make responsible and caring decisions. "CASEL'S SEL Framework—CASEL." CASEL, 2020, casel.org/casel-sel-framework-11-2020/?view=true.

References

'CASEL'S SEL Framework - CASEL'. CASEL, 2020. casel.org/casel-sel-framework-11-2020/?view=true.

Clapp, E. P. (2010). 'Omni-directional mentorship: Exploring a new approach to inter-generational knowledge-sharing in arts practice and administration'. In D. Schott (Ed.), *A closer look 2010: Leading creatively* (pp. 66–79). San Francisco, CA: National Alliance for Media Arts and Culture.

Conley, C. S. (2015). 'SEL in higher education'. In J. A. Durlak, C. E. Domitrovich, R. P. Weissberg, & T. P. Gullotta (Eds.), *Handbook of social and emotional learning: Research and practice* (pp. 197–212). New York, NY: The Guilford Press.

London, M., Sessa, V. I., & Shelley, L. A. (2023). 'Developing self-awareness: Learning processes for self- and interpersonal growth (January 2023)'. *Annual Review of Organizational Psychology & Organizational Behavior*, 10(1), pp. 261–288.

Moon, J. A. (1999). 'Activities to enhance learning from journals'. In *Learning journals: A handbook for academics, students and professional development* (2nd ed., pp. 141–157). Abington: RoutledgeFarmer.

Osika, A., MacMahon, S., Lodge, J. M., & Carroll, A. (2022, March 18). *Emotions and learning: What role do emotions play in how and why students learn?* THE Campus. www.timeshighereducation.com/campus/emotions-and-learning-what-role-do-emotions-play-how-and-why-students-learn.

Pennebaker J. W., & Smyth J. (2016). *Opening up by writing it down: The healing power of expressive writing* (3rd ed.). New York: Guilford.

ResumeBuilder.com. (2023). *3 in 4 managers find it difficult to work with GenZ*. https://www.resumebuilder.com/3-in-4-managers-find-it-difficult-to-work-with-genz/.

5 Lessons Learned from a Pandemic

How COVID-19 and the Racial Justice Crisis Impacted University of San Francisco's Social Justice-Focused Museum Studies Curricula

Javier Plasencia, Paloma Añoveros, Paula Birnbaum, Karen Fraser, Eyal Shahar, Karren Shorofsky, and Steven Tulsky

Creative Pedagogical Pivots

In order to understand the ways in which the University of San Francisco's Museum Studies MA Programme adapted as a result of the pandemic, it is imperative to contextualise these programmatic pivots in relation to the broader framework of the institution's mission and the types of opportunities students were afforded before the pandemic. As a private Jesuit university with a strong social justice mission, University of San Francisco (USF) is:

> committed to educating hearts and minds to cultivate the full, integral development of each person and all persons; pursuing learning as a life-long humanizing and liberating social activity; and advancing excellence as the standard for teaching, scholarship, creative expression, and service (University of San Francisco, 2023).

The Museum Studies MA programme's learning outcomes mirror this ethos, and its faculty members strive to educate students through a lens of equality, diversity, and human rights.

In addition to a strong focus on human rights and social justice, the university's location in the heart of San Francisco provides students with invaluable professional and internship opportunities. Whether through site visits, guest speakers, or internships, students in the programme expect enriching in-person educational experiences. However, as the reality of the pandemic set in—especially after the matriculation of the programme's first entirely remote cohort—the faculty and staff searched for innovative ways to deliver on what students expected from their now-virtual educational experiences.

This chapter details the creativity of the programme's faculty in repositioning their curricula to engage students, keeping true to the learning outcomes promised them, and developing new pedagogical approaches that reinforced the programme's identity as progressive and social justice-minded.

DOI: 10.4324/9781003393191-8

Faculty also address the pros and cons of online instruction, as well as student reactions to these new modes of teaching. Finally, we explore student performance within the realm of professional practice—specifically through their online internships and final Capstone papers or projects.

At the start of the pandemic, many museum professionals in the San Francisco Bay Area were generously accommodating to academic classes that otherwise would have been left stymied and bereft of guest speakers due to social distancing requirements. USF faculty found quick solutions by simply picking up the phone and inviting trusted colleagues or cold-calling new ones to serve as virtual guest speakers. For instance, at the onset of the pandemic, Professor Paula Birnbaum called the Director of the California Academy of Science (CAS), Scott Sampson, to Zoom into her classroom. Sampson spoke candidly to students about leadership during a time of crisis and answered their questions about how CAS, a leader among US science museums, was responding in real time to the pandemic. In addition to enjoying an intimate conversation with the museum's director, students virtually "toured" the museum's rainforest exhibit with a biologist on staff. Students also explored CAS's rich archive of virtual programmes created pre-pandemic, noting how technology allows for scalable museum programming and how software like Zoom can make museum experiences accessible for those unable to visit physical spaces due to geographical or physical barriers.

As the semester progressed, other novel and hitherto untenable educational opportunities arose for students, particularly in relation to museum advocacy. Given social distancing requirements, the American Alliance of Museums (AAM) was forced to shift its annual, in-person Museums Advocacy Day online. Held in Washington, D.C., this event provides museum professionals and students the opportunity to advocate for museum legislation in front of their respective congressional representatives. AAM's shift to an online programme allowed USF to enroll our entire cohort in the event—providing students a professionally enriching extracurricular opportunity previously inaccessible due to cost and logistics. At the event, students met virtually with their local congressional representatives and spoke about their experiences as emerging museum professionals during the pandemic.

While each of these experiences came with their own set of logistical challenges, creative pivots to online pedagogical approaches provided our students enriching and mission-driven opportunities to engage with pertinent museum work and also modelled creative and crucial problem-solving skills for emerging museum professionals.

Centering Students' Needs in the Classroom

As the pandemic set in and the devastating psychological and emotional effects on students across the country, and specifically within the programme, became apparent, our faculty reconfigured their priorities. Not only did they

need to address changes in content and delivery, but they also needed to consider students' rapidly evolving socio-emotional needs. In this sense, class sessions were sometimes simply about checking in and helping vulnerable students get through the emotional burden of this time.

Professor Steven Tulsky, who teaches the Museum Management course, described his transition to virtual learning while keeping the students' emotions about the pandemic and feelings about the course content in mind:

> Many of our students come from the arts, humanities, and other creative backgrounds so the fact that we cover quantitative topics like accounting can intimidate, if not outright scare, many of them. I am always trying to create personal connections with them, and I'm aware that the more I can acquaint myself with their individual skills and make them comfortable, the more likely I will be able to get them to open up to and appreciate the topic I'm teaching. My own teaching style is very hands on; I'm constantly moving around the classroom and looking for visceral feedback that tells me what's working and what isn't and where there may be anxiety. Where might an "aha!" moment be happening?
>
> (2021)

The transition to online instruction disrupted teaching styles predicated on intuiting comprehension by observing student behaviour in the physical classroom. In response, instructors like Professor Tulsky had to find alternate ways to pick up the subtle signals of understanding they were used to receiving from being in the physical presence of their students. As they learned about what students needed during this brutal period of time, instructors emphasised the need for predictability and set very clear ground rules and expectations within the classroom, such as requiring that all students' cameras be on during class.

Acknowledging that students were deprived of the types of social engagement typically associated with graduate school, our faculty proactively sought to create community-building environments focused on social interactions among students. In his second year teaching his Museum Management course online, Professor Tulsky was more intentional with planning student interactions and group work. Whereas in a live class he assigned small-group tasks based on simple prompts, in the virtual class such work needed to be more specific and include written instructions and deliverables, with students more formally reporting back to the full class on what they had discussed.

Technology played a significant role in the development of new instruction and assignment methods. One pre-pandemic assignment, for example, changed from an individual task to a collaborative breakout room exercise which involved students working on a budget model that Professor Tulsky built for them. Students were challenged to reach an agreement on making adjustments and additions to the budget to achieve a specific end-result. This breakout room session worked extremely well because they could remotely share and manipulate an online spreadsheet; students worked in groups of

three or four on the computer model, and the level of collaboration and communication in these groups was heartening from the instructor's standpoint.

Finally, instructors were more intentional about varying their slide decks and embedding compelling visuals and videos to maintain student interest throughout their three-hour sessions. In addition to providing aesthetic variety to these PowerPoints, professors linked to YouTube videos or other multimedia that museums were producing at the time—providing additional professional perspectives and content for the students. Including images from pop culture or other cultural reference points the students could relate to also generated excitement and clear interest from them. Other little tricks like playing music at the start of class or including silly internet memes in the slides were ways of injecting small moments of joy into the Zoom classroom.

Student-driven Virtual Exhibitions

While most of this case study centres on graduate students' experiences during the pandemic, this section confronts the difficulties and successes of the three exhibition-related practical classes on both the graduate and undergraduate level: two undergraduate classes and one graduate practicum course.

Prior to the pandemic, students in USF's undergraduate Art History and Museum Studies programme organised a juried exhibition of student artwork every spring semester at the on-campus Thacher Gallery, located in the heart of USF's Gleeson Library. This exhibition, known as the Thacher Annual, is tethered to an undergraduate academic course (Thacher Practicum), and the exhibition of jury-selected work is the culmination of students' efforts in the course. Another undergraduate course (Museum Studies) organises a smaller-scale and more intimate exhibition each spring semester in the university's Rare Book Room, also located in Gleeson Library. The third course, the graduate-level Curatorial Practicum, takes place in the fall semester, and the students' coursework and research culminate in the production of an exhibition at Thacher Gallery each December. Throughout the course of the pandemic, the university had five exhibition-related classes impacted, each of which required a shift to online instruction: two undergraduate courses in the spring of 2020, one graduate course in the fall of 2020, and two undergraduate courses in the spring of 2021.

When the pandemic first hit in March of 2020, one of the most significant challenges concerned the fact that the undergraduate Thacher Practicum and Museum Studies courses were already deeply involved in the planning of their respective on-site exhibitions. For instance, students in the Thacher Practicum had already chosen the title, Chrysalis, for their exhibition, and they had already solicited entries from their peers. Many of the planning pieces were already in place, so adjusting the content of the exhibition would not have been feasible. As a result, the students and instructor needed to figure out how to transition from what would have been an in-person exhibition to an online exhibition (Figure 5.1).

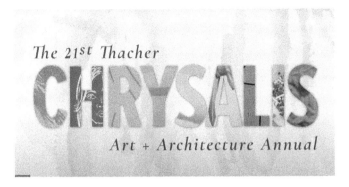

Figure 5.1 Banner Image for *Chrysalis*, USF's Undergraduate-led Exhibition of Student-submitted Artwork. Source: Image Courtesy of Thacher Gallery.

Similarly, students in the undergraduate Museum Studies course were midway through an exhibition that would have focused on artists' books and prints of the California coast. The instructor of the course, Professor Karen Fraser, described how painful it was to sacrifice this exhibition and recounted how she even contemplated going to the Rare Book Room to take high resolution photos of the selected works to somehow make the exhibition work. Unfortunately, she quickly realised how unfeasible this would be and made the painful decision to completely reinvent the project. In thinking through relevant ways to change course on the exhibition in a meaningful and student-centred way, Professor Fraser decided to shift the focus of the exhibition to the theme of pandemics. She stated:

> the students—and the faculty for that matter—were stressed and feeling unsettled by all of the catastrophic things happening around them, so this new approach was partly me thinking, "Ok, I'm going to try to provide my undergraduate students some comfort by helping them see that many societies have lived through these types of moments before."
>
> (2021)

The exhibition, thus, transformed into one focussing on the history of pandemics through the lens of material and cultural objects. While this thematic shift was well received by the students, there were several logistical hurdles that arose from this change of plan. For instance, while students would have normally designed the exhibition—given the tight turnaround time—they were asked to research content and present on objects, while Professor Fraser built out the website on which to present the students' work and research.

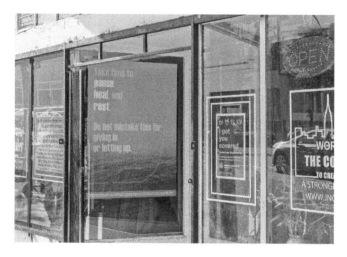

Figure 5.2 Related Tactics, from *The future now* (2021), Third Street Corridor of San Francisco's Bayview Neighbourhood. Source: Photo Courtesy of University of San Francisco.

One of the major challenges for these exhibition-related courses and for the professors teaching them concerned the integration of appropriate forms of technology for best displaying exhibition content, especially since none of the instructors were technology specialists. Despite the steep learning curve, students in the graduate Curatorial Studies Practicum, under the supervision of independent curator, Astria Suparak, and in coordination with Thacher Gallery, were able to creatively and successfully take the art "out of the gallery" in their online exhibition, *Become The Monuments That Cannot Fall.* The class accomplished this by partnering with Related Tactics, a Washington DC and San Francisco-based art collaborative that creates thought-provoking work about race and culture.

The exhibition had two parts: a web-based survey of Related Tactics' works, including individual members' artistic practices, as well as a thrilling public art project titled, *The future now*, in which colourful posters were installed in multiple storefronts in the Bayview neighbourhood of San Francisco, a neighbourhood recently designated as an African American arts and cultural district by the city of San Francisco. The posters themselves harkened to pertinent political content emerging from the racial justice protests of summer 2020 (Figure 5.2).

As the pandemic wore on, both students and faculty became savvier with Zoom and other online platforms and event software. This presented greater learning opportunities for students and provided them with some

Figure 5.3 Student-created Postcard for Quarantine Connections: Sharing Art in a Time of Isolation. Nancy Estrella BA'23, *Change*, 2021. Source: Image Courtesy of the Artist.

exhibition-design work they had missed out on in previous virtual semesters. One of the platforms utilised to great effect during this time was Kunstmatrix, an online virtual gallery platform with which students were tasked to design, curate, and programme exhibitions and events.

One example of the programme's effective use of Kunstmatrix was conceived in the winter of 2020 as part of a departmental effort to build community across our undergraduate and graduate programmes. Faculty and staff designed an extracurricular project that asked students to reflect on their experiences during quarantine and to create a postcard that answered the simple question, "Where are you?" Students were asked to interpret the question broadly and to be creative in their design of their postcards. The department received more than 150 postcards from students all around the country. In the spring of 2021, Professor Kate Lusheck's Museum Studies undergraduate course utilised these postcards as the basis for their class project, which was the creation of a digital exhibition based on the postcard submissions (Figure 5.3).

According to two of the student-curators in the class, their initial objectives with these submissions were:

to [get to] know our objects and the many complex themes they expressed. This object-based study resulted in long discussions about our exhibition's "big idea": building empathy between students either struggling or thriving during a time of isolation by sharing their highly personalized

art. After further deliberation and selection of the works to be exhibited, we decided to organize them around themes that showed the paradoxes of our collective experiences: Isolation and Connection, Home and Yearning, Stasis and Transformation, and Struggle and Hope. This thematic structure gave us the foundation we needed to build a virtual gallery on the Kunstmatrix.com platform, as well as an opening presentation that would properly convey our primary message.

(Hoisington and Smith, 2021)

Not only did the pandemic impel these exhibition-based courses to quickly incorporate new content and adapt to new circumstances, it also forced students in these classes to develop technological and exhibition design skill sets that will continue to benefit them in a museum landscape that is more technologically focused post-lockdown. In sum, curricular pivots, technical challenges, and decisions about what kind of technology and platforms to incorporate into the classroom were throughlines for the department and for the instructors of these exhibition-related courses during the pandemic.

Novel Approaches to Collections Management

In addition to these exhibition-related courses, our graduate Museum Studies Programme requires students to take a comprehensive Collections Management course. This class explores issues of preservation and access through different lenses, and—much like the Curatorial Practicum for graduate students—this seminar-style course convenes in small groups and necessitates a great deal of hands-on work. Students typically touch and handle objects and spend time throughout the semester discussing issues of stewardship and care. Moving online for this course raised interesting questions about how students could meaningfully engage with objects while remote.

Many of the workarounds for this course during the pandemic involved the course instructor, Professor Paloma Añoveros, engaging directly with generous colleagues in the field who were active participants as guest speakers and as co-collaborators, reworking the hands-on activities students typically do in the classroom and adapting them to a remote model. For example, Professor Añoveros contacted Amanda Hunter Johnson, Paper Conservator at the San Francisco Museum of Modern Art (SFMOMA), to develop kits for the students that included various types of papers pertinent to museum work. Professor Añoveros then mailed these paper kits to the students so that they could do paper testing with her in the Zoom classroom and in their own homes. Another annual guest speaker in the course, Alisa Eagleston, Conservator at the SFO Museum, accommodated behind-the-scenes virtual tours, walking around the museum with her iPad while showing students the museum's conservation and storage rooms.

While the individual project for the Collections Management course typically involves students choosing an object from a museum for analysis and inspection, Professor Añoveros shifted the assignment, allowing students to choose objects in their own lives (family heirlooms or historical objects, for example) that they analysed and on which they reported. The assignment was a rich research and critical analysis experience for the students, for many did not have much information available from reputable sources about these objects; they had to rely on their own powers of observation and critical thinking to make compelling arguments about the objects they chose.

The pandemic also served as a launching point for the class to revisit topics critical to collections and issues of preservation. What are museums preserving? Why are they preserving these objects? Who do these objects represent? These questions go hand-in-hand with issues of social justice, and the class analysed these questions actively in relation to cataloguing objects and thinking about issues of representation and access. Access, specifically, is an issue that many cultural institutions needed to reckon with during the pandemic. The fact that museums were not physically open during the pandemic not only demonstrated the sheer importance of digitisation efforts, but also, unfortunately, laid bare the inequities present in the field. Larger organisations had the structures and funding to provide greater digital access to their collections, while smaller organisations lagged in this regard. These were important lessons for the students to learn.

Another positive, though not surprising, outcome of the pandemic concerned the students' responses to group work which is embedded into the fabric of the course. According to Professor Añoveros, the students provided very positive feedback on group projects even though they had never met each other in person. Their enthusiasm for collaborative work could most likely be attributed to their desire for socialisation at such an isolating time.

While the inability to work directly with objects in situ proved difficult, the Collections Management course still provided students the opportunity to work hands-on with objects and archival paper, to engage in substantive and socially enriching group work, and to think critically about the ties between collections and issues of access and social justice.

Harnessing Technology for Communication and Student Success

Unlike the more exhibition-centred courses within the programme, which necessitated swift and drastic changes to their curricula once the pandemic began, other classes in the Museum Studies Programme, such as the Museums and Technology Practicum, were well equipped to handle a transition to remote instruction by virtue of their structure and course content. Exploring how technology shapes a wide variety of cultural institutions (from collections

management systems and portable museum guides to virtual reality and social media), the Museums and Technology Practicum gave students the opportunity to develop valuable skills, which became even more applicable and relevant as a result of the pandemic. Over the course of the semester, students were tasked with conceiving fictitious museums and creating brand identities and products around those museums. Students developed technical skills by learning HTML and CSS for website creation.

Equally important to the technical skills the students learnt in the course are the communication skills they established. They developed technological vocabulary and learnt how to talk about technology with technologists. With this learning outcome in mind, the third project of the semester was to conceive of an interactive experience using digital design tools such as wireframes, storyboards, and flow charts. The students were also tasked with describing their work and creating a proposal for the interactive project.

According to the course instructor, Professor Eyal Shahar, teaching the class online presented quite a few opportunities in breaking geographical barriers within a class that relies heavily on guest speakers.

> There's a wide variety of topics that we cover, and I am not an expert in all of them, so it's a good opportunity to bring people who are more well versed in these topics than I am. But since we were all on our computers, the restriction of hosting only local speakers was lifted, and now I was able to bring speakers from all over the country, which is something I really hope to continue as we move forward into a more hybrid future
>
> (2021).

In addition to the logistical benefits that virtual learning provided the Museums and Technology Practicum, the pandemic also provided students with examples of how museums were adapting to the pandemic in real-time. As museums ramped up their online presence, the class had a chance to discuss some innovative uses of web and social media that they were seeing take place; up to that point, such applications were limited or hypothetical. This generated interesting discussions during class and on the online threads.

On the other hand, the pandemic presented quite a few challenges for the course. In-person field trips, for example, which are a critical (and fun!) part of the course, were not possible. The biggest challenge of running the technology class, however, concerned lab time. Many of these students are new to coding, and usually lab is a carefully planned time where students sit down at a computer with peers and actively engage and brainstorm together. During lab, the instructor "floats" among students answering questions, oftentimes pausing, asking everyone to break from their work, and presenting an individual student's problem as a case study for the whole class. Replicating the dynamic of lab culture was difficult in a virtual classroom, although there were several tools Professor Shahar used to overcome this,

including using technology to create multiple channels of communication and support for the students. Labs were conducted over Zoom, and rather than having the students conceive of and work on their fictitious museum projects individually, Professor Shahar structured the assignment as a pair activity, enabling them to have a built-in support system. Most students said that the process was effective and that they were happy with their collaborative end products.

In addition to having the students support one another by working in pairs, there were many technological functions on Zoom that enabled Professor Shahar to address any coding or content issues. During lab, each pair of students was sent to their own Zoom room, and they could call the instructor to them by using the "raise hand" function. While in the room, the instructor could utilise the "remote control" function in Zoom to operate the students' computer remotely and help the students solve any issues they might be facing. Outside of class, students were encouraged to use a special "help desk" thread on the course website, where their preliminary designs could be reviewed and their technical questions answered not only by the instructor but by their peers as well. In addition, recorded video tutorials were posted to the course site for the students to watch at their own pace. These recordings are assets that can be used in future classes, whether online or in person. Finally, students were encouraged to come with questions to virtual office hours, which will remain in place as museums (and universities around the world) adapt to hybrid learning models.

Navigating Internship Placements and Tempering Expectations

In addition to the coursework students complete while in the graduate Museum Studies programme, an integral part of their educational experience concerns their summer internships, where they engage in hands-on projects that are crucial to developing their professional skill sets. The students greatly look forward to this component of the programme. Over the years, the programme has established solid working relationships with a wide range of museums, cultural organisations, historical societies, and nonprofits for internship placement. However, once the pandemic struck, the internship landscape fundamentally changed, as did the programme's approach to placing students.

During winter 2020, when students began to think about their internship placements for summer 2021, museums were operating at a skeletal level, actively cutting staff and reducing programming. Museum Studies Programme Manager and one of the Internship course instructors, Professor Javier Plasencia, described the internship landscape he confronted in the spring of 2021 in these terms:

General morale across the country was low. In particular, the prospects for museums were not looking great. To provide some context, I went back to this American Alliance of Museums survey, and it said that during November of 2020, nearly 30% of museums were still closed, and at that time had no plans to reopen anytime soon. More than half of museum respondents to that survey had to furlough or lay off staff, and 30% of staff from those organizations who responded were out of work.[1] So, understandably, at this time, many museums were focused on survival, and internships weren't at the forefront of their minds.

(2021)

It was not until April of 2021 that many organisations began to reopen and consider taking students as interns. This left students with a diminished timeframe of two months in which to find internships.

Given this short timeframe and the dearth of museums offering internships at this time, the programme actively expanded the list of organisations with whom they typically communicated for internship placements. Additionally, Professor Plasencia advertised more idiosyncratic and atypical organisations to students, organisations that were not museums but that still had valuable museum-related work for students to complete. Specifically, he pointed students to art fairs, historical societies, science and humanity societies, cultural and educational nonprofits, libraries, labs, hospitals, halls of fame, parks, and larger corporations that maintain collections.

Additionally, Professor Plasencia required students to fill out an internship questionnaire at the onset of their search asking them about their academic and professional strengths, geographic or familial constraints that would limit their placement options, and current trends in the museum world which piqued their interests. This questionnaire served a dual purpose: assisting Professor Plasencia in winnowing down options for the students' internship placements while simultaneously encouraging the students to think more broadly about the types of organisations and institutions that would best serve them in their professional futures. While the students were not always placed at sites that were "perfect matches" the questionnaire served as a helpful baseline from which to draw important information and to initiate important conversations between the students, Professor Plasencia, and the potential internship sites.

Upon receiving these completed questionnaires, Professor Plasencia provided students with lists of organisations that aligned with their capabilities and that were good academic and social fits for them. In addition to providing students with lists of potential organisations and encouraging them to send out letters of inquiry, Professor Plasencia made calls and wrote emails on their behalf, edited resumes and cover letters, and consoled students who did not get internships on which they had their hearts set. In order to temper expectations, Professor Plasencia continuously reiterated that internships would most likely be virtual, but also tried to convey that working at an organisation

during this time would be a great experience that would equip them with skills to thrive in this newly hybrid world.

The last—and perhaps one of the most important—lessons the programme learned throughout the pandemic was the importance of flexibility and adaptability. As the deadline for students securing internships rapidly approached, three students had not been placed. The students were told that, should they not find something for the summer, the programme would be able to restructure the internship course for them in the fall. This reassurance alone provided many of the students a great sense of relief. Thankfully, through endless phone calls and the coordinated hard work of the students, staff, and faculty, the programme was able to place all 22 students at a mix of organizations for their summer internships. Unsurprisingly, these were not the larger museums in which furloughs and layoffs took place, but rather smaller, more nimble organisations, as well as regional historical societies and arts nonprofits.

Despite the stressful uncertainties of placing all of the Museum Studies students in their summer internship, the entire search process proved fruitful in surprising ways. The process equipped students with the skills to search for, apply for, and secure jobs in their professional futures.

Adapting an Internship Curriculum for Relevancy

Once Museum Studies graduate students secure a summer internship, they become simultaneously enrolled in a concurrent, four-unit, online internship course. The course meets several times over the summer and allows students to critically analyse their internship experiences within an academic setting. While at their sites, the students complete a major project for their respective organisation; as such, the internship is more than just an administrative summer job, but rather a solid opportunity for students to work on a substantive museum-related deliverable.

After the students were placed at their sites, the instructor for the Internship Course that summer, Professor Karren Shorofsky, realised that rethinking the syllabus would be vital for the students in that they needed a different framework by which to address the unique set of challenges that confronted them. To that end, Professor Shorofsky incorporated reflections and essay assignments into the syllabus that specifically addressed COVID-19 and the effects it had on the administrative and financial arms of their respective internship organisations. Essay prompts, similarly, were structured on issues including digitising collections, financial and staffing issues, and disaster preparedness—all things that students were seeing and hearing about first-hand at their own internship sites.

The internship course is unique in that it is the only course in the USF programme that has always been offered completely online. Students are so geographically scattered and their hours so variable that forcing them all to sit in a physical classroom at the same time would be impractical and unrealistic.

Despite the fact that the course is online, the programme does organise in-person site visits with the students completing local internships and their supervisors as a way of establishing community and providing room for care. Given that these site meetings were no longer possible because of the pandemic, these meetings with students and their supervisors were relegated to Zoom.

Compounding the emotional duress that many students were facing—especially earlier in the pandemic—was the murder of George Floyd and the civil unrest that followed the police brutality of that summer. Professor Shorofsky describes how important convening as a class was during that time:

> Given that the class meetings for the internship are more professionally focused, the class Zoom meetings were an opportunity for the cohort to meet together as a group, to feel joined, and to provide some room to care for one another, hear from one another, and be there for one another. That was crucial. In response to the protests, I quickly added some timely materials and readings about how museums were responding to that moment, and that became very important for us to process together as a group in terms of embracing the unique opportunities this moment in time presented us.
>
> (2021)

The pandemic and the racial justice reckoning had profound effects on the types of projects that students completed. For instance, one student from India interned for the Rubin Museum in New York City. During her time with the museum, she helped organise and run the online mindfulness meditation programme. The programme was so successful that it was written up in many national publications for its responsiveness to the moment. The programme also catapulted this smaller museum into the national spotlight and conveyed how museums could respond to community at a time of need. Another student worked at a small historical society, helping the organisation move both their major fundraising events and their membership programmes into an online space. The society surpassed their fundraising goals, and the student was instrumental in helping them creatively rethink their programmatic ventures.

Students also chose to work on internship projects that highlighted the university's commitment to social justice and accessibility. For instance, one student who was placed at the Museum of Craft and Design in San Francisco worked on an "artmobile," a van that went out into different Bay Area communities and delivered art materials to different households. Some of the artwork created with these materials was then put on the museum's website as an online exhibition. Another student worked at a small museum with a storefront. Rather than have people come in, the museum curated a show from the windows and provided interpretive material for their audience outside. Promoting these types of community-based initiatives has been a cornerstone of USF's Museum Studies programme since its inception; the pandemic saw

dramatic increases to these types of programmes, and fortunately, the students in the internships were well equipped to take on such projects.

Rather than feel sour or embittered by their internship experiences during the pandemic, many of the students maintained a positive outlook throughout the class. Professor Shorofsky described how making necessary pivots in the class:

> really made a difference to these students. Instead of seeing themselves as beleaguered, they saw themselves as lucky. They were some of the very few that were on the ground floor, not only watching history, but actually participating in it. As museums were learning, they were learning with them.
>
> (2021)

At the end of their internship experience, students were required to submit a final portfolio highlighting the work they completed at their respective site. Students appreciated the benefit of working on the front lines during such a pivotal moment for museums and seeing themselves as agents in a field that was rapidly changing right before their eyes.

Timely Capstone Topics[2]

In their final semester, students in the Museum Studies Programme must complete a capstone paper or project on a topic of their choosing. This paper or project is the culmination of a semester of research, and oftentimes (but not always) reflects work that they have completed while in their internships. Unsurprisingly, the pandemic and racial justice movements of 2020 were prevalent themes that students explored during virtual instruction. One student worked with Professor Añoveros on a collections-themed paper on the impact of the pandemic on preservation and access to collections. The student interviewed a number of leading collections managers to ask them how they were handling loans during this period and how they were changing their practices to respond in real time to the crises facing their institutions. The result was a marvellous piece of scholarship and a fascinating institutional survey of different approaches many collections managers took at a time of crisis and uncertainty.

Another student used her capstone project to address racial inequalities through social justice education in US art museums. Using the American Alliance of Museums' listserv, the student reached out directly to museum educators throughout the country and conducted interviews about how museum education departments were or were not engaging in social justice pedagogy. The final paper encapsulated the programme's philosophy of using museums as agents for social change; it was so successful that it was expanded into a poster which the student presented at a major museum conference in Portland, Oregon.

Another student worked with Professor Birnbaum to take on the hot topic of deaccessioning in museums—a topic that could not have been timelier. The American Association of Museum Directors (AAMD) changed its policy while the student was working on his project. As a result of the pandemic, AAMD allowed museums to use funds from deaccessioned works for "direct care" like staff wages; this policy was in stark contrast to their previous position on the matter, which only allowed museums to use funds from deaccessioning for new acquisitions. The student attended a large symposium about deaccessioning in the field, and his experience there became fodder for his paper. The broader ramifications of this topic dovetail nicely to questions of social justice and best practices for museums, using deaccessioning or operating budget funds to meet social justice priorities.

In sum, the pandemic provided students with source material that was timely, highly relevant to the field, and oftentimes wedded to issues of social justice.

Conclusion

While emotionally and pedagogically strenuous, both the pandemic and the country's reckoning with racial injustice provided students with engaging and unique experiences. Faculty and staff in the Museum Studies Programme also saw a deeper engagement among students, who tackled issues pertaining to social justice and anti-racism in both the curriculum and in their personal lives. For example, students and faculty had candid and oftentimes difficult conversations about ways they had experienced, or perhaps inadvertently contributed to racism and colonialism within the field. As within the larger museum field, these topics remain timely and continue to be of great importance within post-quarantine classroom discussions.

In addition to pivoting syllabi and curricula to address pertinent issues that students were experiencing, faculty also needed to learn new technologies, address students' diverse socio-emotional needs, develop new modes of social interaction, and rethink pedagogical strategies to fit the unique circumstances of the moment. Faculty tackled all of these issues with creative problem-solving, teamwork, and an eye toward the care of the whole student. The lessons our programme learned during the pandemic have informed the way we operate post-quarantine. While the pandemic was a terribly difficult time, it made our faculty and staff more adaptable and keener to address the issues our students will face in this starkly different post-pandemic world.

Notes

1 https://www.aam-us.org/2020/11/17/national-snapshot-of-covid-19/.
2 Permission to quote student work in this essay—anonymously and in anecdotical form—obtained by the Director of Ethics Research Review Board (IRB) at University of San Francisco.

References

American Alliance of Museums. (2020, November 17). "National Snapshot of COVID-19 Impact on United States Museums." Available at: https://www.aam-us.org/2020/11/17/national-snapshot-of-covid-19/

Birnbaum, P. (moderator), P. Añoveros, K. Fraser, J. Plasencia, E. Shahar, K. Shorofsky, and S. Tulsky (2021, November 16–19). "Lessons Learned from the Pandemic: How COVID-19 and the Racial-Justice Crisis Impacted University of San Francisco's Social-Justice Focused Museum Studies Curricula." In *Museum Studies International Symposium Virtual Dialogue: Museum Academics and Professionals on Challenges and Opportunities in the Post-COVID World*. South Dakota State University.

Hoisington, M., and J. Smith (2021, May 20). "Greetings from Quarantine! USF Museum Studies Students Foster Connection During Pandemic Through Virtual Postcard Exhibition." *USF's Museums Blog*. Available at: https://usfmuse.wordpress.com/2021/05/20/greetings-from-quarantine-usf-museum-studies-students-foster-connection-during-pandemic-through-virtual-postcard-exhibition/

University of San Francisco | Our Mission and Values. (2023). Available at: https://www.usfca.edu/who-we-are/reinventing-education/our-mission-and-values

6 The Next Evolution of Museum Studies

Museum Masterclasses in Augmented and Virtual Reality

Heather McLaughlin and
Laura-Edythe Coleman

Remote education is not a new concept in academia, and the disability community has long fought for distance learning accommodations (Wattenberg, 2004). An early adopter of remote education, the Arts Administration & Museum Leadership (AAML) graduate programme at Drexel University has offered online classes for remote and working professional students for over a decade. In 2020, however, the global scale of the COVID-19 pandemic created a new set of challenges for the hands-on learning that usually takes place during the AAML graduate programme's required 20-week practicum. This chapter discusses the pros and cons of shifting to virtual reality instruction methods to teach the next generation of museum professionals about material culture. In particular, we focus on the role of new instructional methodologies in creating an equitable and inclusive education for museum students in a post-pandemic world.

Problem Statement

Unsatisfied with the limitations of video lectures, we embarked on a journey to create "The Next Evolution in Museum Studies," a series of educational materials delivered through augmented and virtual reality. To develop the series, the AAML programme collaborated cross-departmentally with the Virtual Reality & Immersive Media (VRIM) programme at Drexel University with the intention of creating a working prototype of a virtual reality lesson for Museum Studies students. The completed pilot episode, "How do you handle objects?" is intended to teach students through a virtual reality (VR) interface about object handling, identifying prior restorations, and transporting objects within a museum (Figure 6.1).

History of AR/VR

The American Alliance of Museums describes augmented reality (AR) as a technology wherein "the visible natural world is overlaid with a layer of digital content," and virtual reality (VR) as technology that "places the experiencer in another location entirely" and that "entirely occludes the experiencer's

DOI: 10.4324/9781003393191-9

Figure 6.1 An in-headset view of the virtual Masterclass, in which a Drexel Professor is standing in a storage room holding a green bowl for inspection. There is 3D rendering of the same bowl superimposed over the video for learners to interact with.

natural surroundings" (American Alliance of Museums, 2018). In creating an AR/VR lesson for Museum Studies students, we must consider the use of AR/VR in educational settings and the use of AR/VR in museums. This project integrates the subject content of museums into the educational environment, effectively combining the two into a new form of educational delivery.

Universities have long used AR/VR in educational settings, especially in engineering, medicine, and art history. Virtual learning environments present an opportunity for students to gain experience handling dangerous or delicate processes, as is the case with *MiReBooks*, a mixed-reality textbook used in mining studies (Daling et al., 2020). At Colorado State University, an immersive reality training lab is used to mitigate costs by simulating expensive biomedical equipment (Dick, 2021). VR is also being used in humanities at the University of Virginia and Lafayette College to closely study unique works of art or distant cultural heritage locations (Newman, 2017; Wilson, 2021).

Several museums have adopted varying levels of virtual reality in their public-facing programmes, ranging from simple overlays to entirely virtual museums. For example, the Smithsonian National Museum of Natural History has developed an app called *Skin and Bones* that augments and enhances the Bone Hall exhibits and that can be used either at the museum or from home on an Apple device (Smithsonian National Museum of Natural History, no date). This use of AR is unique in that it works both on- and off-site. Building on this idea, the Victoria and Albert Museum also used a blend of VR in their 2021 "Alice: Curiouser and Curiouser" exhibit (Victoria and Albert Museum, no date). To create the exhibit, V&A partnered with HTC Vive Arts to develop

an immersive VR experience based on *Alice's Adventures in Wonderland*, which could be experienced at the museum during the show's run or at home any time through a personal VR headset. There are also fully virtual museums with no physical location, such as the Kremer Collection, a digital collection of 17th-century Dutch and Flemish works of art (The Kremer Collection, no date). Although museum studies bridge the academic and professional worlds, there is currently a gap in the use of AR/VR in museum studies education. That gap is what we aim to address with this project, and the result has the potential to reach distance learners and students with different accessibility needs in unprecedented ways.

Methodology

As museum studies professors, we are familiar with the subject content of our lessons but found ourselves ill-equipped to produce, from a technical stand-point, the AR/VR delivery of our lessons. To develop the series, the AAML programme collaborated cross-departmentally with the undergraduate pro-gramme in Virtual Reality & Immersive Media (VRIM) at Drexel University. Under the guidance of Professor Valentina Feldman, freshman undergraduate students enrolled in the course VRIM 110 completed their learning objectives for the 2022 spring quarter by scanning real museum objects and rendering them for the planned virtual museum classroom. In addition to the materials and equipment used by the students, the production relied heavily on Prof. Feldman and her expertise at Night Kitchen Interactive, an AR/VR development company (Night Kitchen Interactive, no date).

Concurrent with the work of the VRIM 110 students, AAML graduate student Lauren Hoffman along with Professors Laura-Edythe Coleman and Heather McLaughlin conducted research on the uses of AR/VR in higher education to create a literature review aimed at strengthening the argument for creating the Museum Masterclass Series. McLaughlin and Coleman submitted an innova-tion grant proposal to a museum; however, it was rejected. Undeterred, we partnered with Professor Derek Gillman and the Drexel Founding Collection, a donation-based collection that is "the University's flagship collection of art—(and) was founded alongside the University in 1891" (Drexel Founding Collection, no date). The completed pilot episode would feature objects and items from the Drexel Founding Collection and the expertise of Prof. Derek Gillman and Drexel Founding Collection Director Lynn Clouser.

As the final product, an episode titled "How do you handle objects?" is intended to teach students about object handling, identifying restoration, and transporting objects within a museum. To accomplish these goals, Prof. Derek Gillman authored a script for the episode detailing the objects and the actions that would occur in each scene. As the objects involved in each scene are of great value, care was taken to describe the motions and the direction of indi-viduals within each scene (Figure 6.2).

Figure 6.2 An Example Image from the Video Production of Museum Masterclass.

From a pedagogical point of view, Prof. Gillman wanted to address a long list of subjects in the video. However, it quickly became apparent that only a few concepts could be taught well within a ten-minute episode. For example, Prof. Gillman wished to address Renaissance China and related economic history, but this topic was too broad for the pilot episode. Instead, Prof. Gillman focused on the handling of objects and the conservation of broken objects. As educators, we pondered our ability to simulate the physical environment within the virtual classroom. In particular, we wondered how we would imitate the weight of objects and the role of gravity when moving objects carefully through a collection's space. We desperately wanted to allow our students to interact with objects within the virtual environment. However, we found that the VR filming tools we were using were inadequate to create gamified interactives, such as touching the objects virtually. We struggled with the desire to create 3D printable files of each object in the hopes that future students would be able to print copies of these teaching objects to hold during virtual classes. However, despite our hopes, the time required to 3D scan (for printing purposes) was greater than the allotted time to produce the VR film.

In addition to our technical goals, Prof. Gillman wanted to address several educational goals that concern interpretive practice for museum professionals.

In particular, he wanted to present material that posed questions for the Museum Studies student on *how* they should handle objects, *when* to move objects, and *why* they must use certain practices over others. In the pilot episode, we addressed these critical thinking skills that we believe all museum professionals should have when handling objects.

Presentation of the Project's Evolution

A key aspect of this project is incorporating feedback from our peers, both in the academic and museum communities. Over one year, we presented our research and prototype both virtually and in person at several conferences focussing on education and museum studies. The presentations featured a brief PowerPoint presentation followed by a demonstration of the prototype Masterclass. To accommodate different conference formats, the demonstration was accomplished through either a hands-on with an Oculus Rift Headset, a live "Point of View" demo, or a self-guided exploration of the Masterclass using the attendees' personal smartphone devices (Figure 6.3).

We presented our research and pilot episode at multiple conferences, including the 26th International Council of Museums Committee on the Training of Professionals; the European Network of Cultural Administration Training Centres allowed us to receive feedback from a broad range of cultural educators. In addition to these educational conferences, we also presented at

Figure 6.3 An Image of Conference Presentation using AR/VR Museum Masterclass.

the 15th International Conference on the Inclusive Museum. We dialogued with our peers concerning the role of AR/VR technologies in creating more inclusive and equitable education for museum professionals. Teaching museum studies students—students who are pursuing a career in museums. The presentation at the Association of Arts Administration Educators focused on the pedagogical considerations in teaching arts administration educators, such as students who are pursuing a career in arts management. Presenting at the European Network of Cultural Administration Training Centres allowed us to receive feedback from a broad range of cultural educators. In addition to these educational conferences, we also presented at the 15th International Conference on the Inclusive Museum to explore virtual education's role in providing more inclusive and equitable educational experiences.

What We Learned

In the production of this pilot episode, we learned more than expected. For example, when we began this project, we had no idea how many students, both undergraduate and graduate, would take part in developing this prototype episode. As a result of our collaboration, we engaged more students from undergraduate programmes outside of AAML than might have been possible under regular teaching conditions. In addition to learning core skills of immersive media production, freshman students in the VRIM programme learned to work with objects, handle art, and work within the small confines of art storage areas. In part, the COVID-19 pandemic forced us to move beyond our ivory tower siloed walls and work with colleagues in other programmes on a shared goal.

During the development of the episode, we realised as educators that while we knew the subject content (ceramics and paintings), we would need to script our every move, turn, and action. For professionals and educators, this became an exercise in mindfulness as we wrote out the script for our filming partners in the virtual reality class. We also discovered that filming requires more than access to objects and galleries; it also requires a relatively empty and quiet space. For this reason, our professors and students filmed this pilot episode in the evenings and night hours when the building was devoid of students, faculty, and staff.

After filming, we were amazed at the work of the undergraduate students to produce a VR experience in less than ten weeks' time, the length of a quarter term. The final product included a script for the lesson, 14 minutes and 35 seconds of instruction to be viewed in 360°, and 3D renderings of the objects being discussed in the video. One unfortunate aspect of this project was that once the term ended, the VRIM students dispersed and were not available to polish the VR film. Despite the rough quality of some sections of the VR film, it remains a formidable prototype for the work we wish to

do. Along with superficial finishing touches, we would also like to address some of the critical baseline accessibility features that we were not able to include in the first prototype, such as closed captioning. The lack of accessible content in this project was unintentional, and yet provided a learning opportunity for students and educators. It is our responsibility as educators to ensure that new teaching tools are built accessible from the start, and not as an afterthought.

A few things became readily apparent in presenting the finished VR film to our colleagues at conferences. For example, as we presented the Oculus Rift experience in person at the 15th International Conference on the Inclusive Museum, we noticed that educators and museum professionals alike were very curious about the concept and novelty of the project. However, participants were hesitant when it came time to try on the Oculus headset itself. There was an almost primal fear of wearing the headset, which effectively blinds the wearer to their actual surroundings. In addition, it was difficult to troubleshoot from outside the headset, and many people declined to use it or only used it very briefly. Those who did use the headset reported disorientation and dizziness but also joy and awe at the experience. We did receive positive feedback about the content of the Masterclass, especially from participants who watched and engaged with the full length of the episode.

We found that the different conference formats—virtual, in-person, and hybrid—garnered significantly different feedback on the features and content of the pilot episode. If we had not been limited by COVID-19 restrictions and required to do virtual and hybrid presentations, we might not have benefitted from these additional perspectives. For example, in doing completely virtual presentations, one author would wear the headset and essentially share their screen with the participants online, while the other author moderated. This allowed the participants to call out directions they desired the author to focus on while not being encumbered by the headset itself and resulted in feedback that focused on the content and concept. In in-person presentations, both authors were free to assist participants with the VR Headset while they navigated the Masterclass. In most cases, it was the participant's first-time using VR equipment, and much of the feedback that we received was about the interface and novelty of the experience.

Ultimately, the best interactions occurred when participants were instructed to use their personal mobile devices and navigate to the VR video on YouTube. A smartphone can manage our VR Masterclass interface in one of two ways. The first, and simplest, is to watch the 360° video flattened into 2D, and use finger pinches on the screen to direct the user's point of view. The second way more closely approximates a true VR experience by fitting their phone into a phone holder with two lenses that creates a stereograph effect and can be navigated by turning their head to "look" around. Using personal devices enabled participants to comfortably encounter the VR video and pause the experience at will.

Conclusion

As universities adapt to a peri-pandemic world, educators must build for the future from a base of equity and accessibility. For emergent instructional technology to be considered truly innovative, it must dismantle barriers to education. To ensure that exclusionary practices in higher education are not re-rendered into the virtual classroom, the AAML programme is completing a comprehensive study on theoretical and practical considerations regarding the accessibility and inclusivity of AR/VR models of museum studies instruction. While our prototype seemed successful in being used for distance education, we were not able to include the accessibility features that we envisioned due to limited time and resources. We continue to seek AR/VR models of museum studies education that are cost-effective, accessible, and comfortable for all students. While we are currently limited by the technology available, we believe that museum studies education will only become universal when we employ cutting-edge technologies to bridge the divide between communities with great access to collections and those with significantly less access to museums and their objects. In the future, we aspire to create museum studies classes that allow greater interactivity and 3D printing of teaching objects.

References

American Alliance of Museums. (2018) 'Immersion in Museums: AR, VR, or Just Plain R? [PDF]', *Center for the Future of Museums*. Available at: https://www.aam-us.org/wp-content/uploads/2018/10/Immersion-in-Museums-primer.pdf (Accessed: 15 November 2021).

Daling, L. et al. (2020) 'Mixed Reality Books: Applying Augmented and Virtual Reality in Mining Engineering Education', in V. Geroimenko (ed.), *Augmented Reality in Education*. Cham: Springer International Publishing (Springer Series on Cultural Computing), pp. 185–195. Available at: https://doi.org/10.1007/978-3-030-42156-4_10.

Dick, E. (2021) *The Promise of Immersive Learning: Augmented and Virtual Reality's Potential in Education*. Information Technology and Innovation Foundation. Available at: https://itif.org/publications/2021/08/30/promise-immersive-learning-augmented-and-virtual-reality-potential (Accessed: 13 November 2021).

Drexel Founding Collection. (n.d.) *Home | Drexel Founding Collection*. Available at: https://drexel.edu/drexel-founding-collection/ (Accessed: 4 February 2023).

Newman, C. (2017) *How Virtual Reality Is Changing This Art History Class at UVA, UVA Today*. Available at: https://news.virginia.edu/content/how-virtual-reality-changing-art-history-class-uva (Accessed: 16 November 2021).

Night Kitchen Interactive. (n.d.) *Night Kitchen Interactive | Digital Experiences Since 1997, Night Kitchen Interactive | Digital Experiences Since 1997*. Available at: https://www.whatscookin.com/ (Accessed: 4 February 2023).

Smithsonian National Museum of Natural History. (n.d.) *Bone Hall*. Available at: https://naturalhistory.si.edu/exhibits/bone-hall (Accessed: 15 November 2021).

The Kremer Collection. (n.d.) *The Kremer Collection, The Kremer Collection.* Available at: https://www.thekremercollection.com/ (Accessed: 15 November 2021).

Victoria and Albert Museum. (n.d.) *Curious Alice: The VR Experience, Victoria and Albert Museum.* Available at: https://www.vam.ac.uk/articles/curious-alice-the-vr -experience (Accessed: 15 November 2021).

Wattenberg, T. (2004) 'Beyond Legal Compliance: Communities of Advocacy That Support Accessible Online Learning', *The Internet and Higher Education*, 7(2), pp. 123–139. Available at: https://doi.org/10.1016/j.iheduc.2004.03.002.

Wilson, S. (2021) *Virtual Michelangelo, Lafayette News.* Available at: https://news .lafayette.edu/2021/09/09/virtual-michelangelo/ (Accessed: 16 November 2021).

7 Perspectives on Virtual Internship Programming from a Collegiate Museum Practices Programme, Host Museum, and Post-Graduates

Adriana R. Dunn, Leslie Luebbers, Neecole A. Gregory, Rachel Wilson, and Cannon Fairbairn

Virtual Internships Within a Museum Studies Degree Programme

In 2023, the University of Memphis' Interdisciplinary Graduate Certificate in Museum Studies enters its third decade of preparing students holding or pursuing an advanced degree in any discipline for professional careers in museums. In fall 2019, the certificate programme went online for its class offerings but continued to require on-site internships that could be arranged with any museum in the country. COVID-19 dealt a swift and seemingly deadly blow to that important aspect of the Museum Studies programme.

On-site internships offer undeniable benefits to interns—immersion and participation in the professional culture of museums and, tangentially, the potential for initiating professional relationships. For U of M Museum Studies students to complete requirements during COVID-19, we were compelled to initiate virtual internships, and we quickly experienced the advantages these offer to both students and institutions, including our own, the Art Museum of the University of Memphis (AMUM), where we were able to evaluate remote experiences from the perspectives of the certificate programme and the host museum. COVID-19 closed or reduced activity in many museums, but alternatively, some museums like ours experienced an opportunity to focus on behind-the-scenes tasks of physical and digital collections management, programme evaluation and planning, and innovation of online public content creation and delivery. AMUM, interns were able to assist with researching collections, entering collections data into PastPerfect, and to create and publish online exhibitions. Because of limited space and staff in the best of times, AMUM can accommodate only one or two interns on-site. The COVID-19 experience taught us that remote or hybrid internships enable the museum to develop successful experiences while minimising stress on physical resources.

DOI: 10.4324/9781003393191-10

In ours and other institutions, museum studies interns during the pandemic had varied and valuable experiences. One assisted in developing a strategic plan for a museum on the cusp of relocating to a new campus, another worked on a large Museums for America grant application through the Institute of Museum and Library Services (IMLS), and another conducted collection research on Native American pottery. In every case, meetings were held on Zoom and work was self-paced. In some situations where object evaluation was necessary, on-site research was essential. Overall, the museum studies programme response to the COVID-19 crisis demonstrates that remote work can be beneficial to all.

The internships discussed in this chapter were part of the University of Memphis Interdisciplinary Museum Studies certificate programme, and two represent many of the internships organised by Adriana Dunn, former curator of the West Tennessee Delta Heritage Center (WTDHC) in Brownsville, Tennessee. As a recent graduate of our certificate programme, she had intimate knowledge of its objectives and requirements, and she also understood how to provide valuable experiences for the students and knew that these talented and committed aspiring museum professionals could provide much-needed programmatic or administrative services for her small, ambitious museum.

The Original Vision: Adriana Dunn's Path to Virtual Internship Programming

I landed my first full-time position as curator of the WTDHC in February 2020; around this time, the world faced a debilitating pandemic. Thankfully, I was able to keep my position and fully transition into the role. Though I thought that the pandemic would soon dissipate and no longer be a threat to the safety of our staff, visitors, and potential interns, I soon learned that this was not going to be the case, and serious adaptations to virtual programming were the answer to these obstacles.

Originally, the museum intended to serve as a host museum to interns who were looking to gain hands-on experience. This programme would require interns to report to the museum on agreed-upon days with their assigned supervisor to complete a project geared towards museum education, collections, or curation of an exhibition. However, because of the restrictions brought on by COVID-19, the museum reevaluated the feasibility of remaining a host museum for incoming interns. After extensive research, internship description planning and writing, and programme development, the museum reinstated itself as a host museum to a series of collections, curatorial, and educational internships. The museum's internship programming transitioned to being offered virtually to university students in order to meet the needs of its community during COVID-19. With contemporary technological advances, the integration of online education has been made possible and popular among aspiring professionals pursuing upper-level degree programmes. Between fall

2020 and summer 2022, the WTDHC hosted a total of ten interns working in collections, curation, and education virtual programmes.

Examples of Virtual Internships

The following examples provide museums with models to design their own virtual collections and curatorial internships (Dunn, 2022, pp. 2–3). In a collections internship, the intern is assigned a data entry project using the museum's web-based cataloguing software. The intern can either be given direct access to the software or can fill in object-related information on an Excel spreadsheet that can be transferred to the software. The intern is also responsible for condition reporting of an object or small group of objects with the use of a webcam over any video conference call programme (e.g., Zoom, Microsoft Teams, FaceTime, and Google Team). The intern plays the role of curator or collections registrar as the museum supervisor assists with the holding of the camera around the object during the condition reporting process. This requires interns to be thoroughly trained through assigned readings and videos, to be given blank condition reports to fill out, and to have the proper condition reporting nomenclature in front of them to work from during the condition reporting process.

Curatorial interns create virtual exhibitions featured on the museum's website. Duties include organising a series of virtual programmes (events hosted on Facebook Live and/or Zoom) to promote the exhibit and engage the community. We also provide the option of a conference call to set up an exhibition for virtual curatorial internships. In this scenario, the museum supervisor plays the role of preparator working in the museum, and the intern takes on the role of curator directing the set-up of their exhibition.

Educational Programming

Students fulfilling an educational programming internship write a series of lesson plans that reflect the museum's objects and exhibitions for school groups based on the state's education core curriculum standards. Interns also create an audio tour of objects featured in the museum's exhibitions. Audio tours provide museum visitors who have visual impairments an alternate method of education and engagement with objects in the collections.

Museum supervisors can also assign interns to write scripts for free, easily accessible audio tours that guests could access during their visit to the museum using sites.google.com featuring digitally embedded videos created by the intern and hosted on YouTube. Developing the audio tour is simple. One need only access the website, create a Google Drive account, and then set up the institution's webpage. Next, the intern creates tour stops writing a description for each stop and records a short video that is then uploaded to the museum's YouTube channel. Museums are able to create tours showcasing

specific aspects within the museum that guests can access using QR codes placed within the museum using their smartphones.

Benefits of Virtual Internships for the Host Museum

Integrating virtual internships is the perfect solution to the ongoing pandemic. The virtual internship programme extends the museum's ability to reach prospective interns who do not have direct physical access to the museum. This provides an efficient pathway to successful execution of the museum's mission to educate and engage its local and long-distanced community. While virtual components of each internship are time consuming for the museum staff and interns, it puts the interns completely in charge of their projects, just like a professional curator, educational director, or collections registrar. This element gives dedicated emerging museum professionals a stronger internship experience.

A Recent Alumna's Perspective: Neecole

The COVID-19 pandemic forced the world to a halt in 2020, and society had to adapt professionally and personally to a digital setting. In the field of museums, this meant exciting new ventures in public engagement and information storage. Online platforms enabled museum professionals to stay connected with their audiences in ways that outperformed traditional practices of engagement and entertainment (Agostion, Arnaboldi, & Lamis, 2020, p. 366). As with any field, obstacles began to arise when certain positions had a difficult time transitioning online. Internships had partial success during the pandemic, especially when it became apparent that museum professionals could conduct their work from home. However, many museums were forced to close because of health and safety concerns and government mandates (Juarez & Blackwood, 2022, p. 84). Before internships would be offered again at these institutions, a period of adjustment had to be made, so the museum staff could adapt their institutions to working digitally.

As I entered the second year of my Masters programme in 2020, I was limited in my options for internships because all museums in the Memphis area were closed. Luckily, I was able to connect with Adriana Dunn, a former classmate who had taken a curatorial position at the West Tennessee Delta Heritage Center (WTDHC), which had developed a hybrid museum internship requiring minimal visits to the physical institution. Over the semester, I developed an exhibit about Hoodooism in West Tennessee for the museum when it reopened in June of 2020. My work included acquiring objects for the exhibition, writing condition reports for the objects, and developing public programming to promote the exhibition. The hybrid setup was ideal for my life as a graduate student and a course instructor as I could set my own hours.

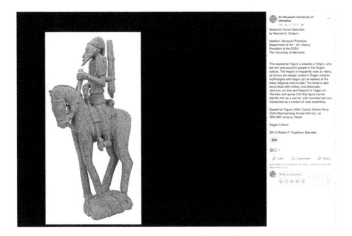

Figure 7.1 A "Research Corner" Post Featured on the Art Museum of the University of Memphis' Facebook Page in February of 2021.

The museum organised multiple outreach opportunities for me to engage audiences virtually. This internship ensured that I would have hands-on experience in the many facets of curatorial work, especially when working with a living culture and folklore that need to be handled with care.

The following semester, and the beginning of 2021, would come with the same challenges as before. Again, I faced a professional field that was ravaged by COVID-19 and still recovering. Though some of the Memphis institutions were starting to open, the few internships they offered were quickly taken by candidates as desperate as I was. Luckily, I was accepted by the Art Museum of the University of Memphis (AMUM) to be an intern with curatorial duties. I was charged with creating a digital exhibit of the museum's African objects, primarily from the Dogon people. My duties spanned photographing the objects to data collection and submissions into the PastPerfect programme and creating an online exhibit. My internship with AMUM did not involve as much interaction with potential audiences as the exhibit would be permanent on the museum's Omeka online programme. However, I was able to engage in virtual outreach by developing weekly postings on the museum's social media platforms to showcase the African collection (see Figure 7.1).

At first, I did not realise how important my experience working in a virtual internship would be in the museum world. During the pandemic, health, safety, and financial sustainability were the primary concerns for both museums and those who were employed at these institutions. Adaptation to virtual interaction was a positive result of this situation, and more museums became aware of

how innovative and effective this type of interface could be. Gaining experience through virtual internships has expanded my prospects to more than just traditional roles within museums. Museum opportunities that were once thought to be inaccessible because of location are now a lot more feasible to accomplish, no matter where they are located, because of virtual programming. Participating in these virtual internships during my graduate programme has made me capable of excelling in a diverse range of web-based platforms that I never would have been able to learn without this online education experience. This new method of programme facilitation allows for more accessibility to explore and interact with technological advancements in the field of museums.

A Recent Alumna's Perspective: Rachel Wilson

In the fall of 2020, I was one of many students who found herself starting a graduate programme in the midst of a global pandemic. I spent my time in lockdown searching for a museum that was still opening its doors for interns. Unfortunately, the pandemic had put a halt to all in-person work. Adriana Dunn, the former curator at the Western Tennessee Delta Heritage Centre (WTDHC), informed me that she was creating a new virtual internship programme in museum collections, curation, and education. I applied and was granted a Collections Internship.

Although the lockdown had been lifted by the start of my internship, pandemic restrictions still affected institutions such as universities and museums. As one of several virtual interns in this new programme, I was able to meet with the others via Zoom, where we could discuss individual goals. I also had regular virtual one-on-one meetings with the curator to touch base and discuss active projects and any questions or concerns I might have. This communication was an important part of ensuring the success of a virtual internship, allowing me to stay connected with Adriana and helping maintain my goals.

Working in collections presented unique challenges for a virtual internship as it required access to the objects in the collection. The curator had recently established an online database for the WTDHC; my primary focus was on researching the objects in the Hatchie River Region collection and updating the database. Given that an image of an artefact does not replace seeing it in person, the internship was established according to a hybrid in-person/remote, with the occasional visit to the museum required to complete certain projects.

My goal in researching the Hatchie River Region collection was to apply my findings to varying audiences within the museum. I provided several scholarly sources on each object in the collection for those who may wish to do more formal research. However, I primarily focused on writing new descriptions for the objects that were more accessible to the public and would interest a wider audience. It is important for all museums to emphasise the relevance of their collections to the community. This can be achieved by presenting

some of that research using social media. During my internship, the museum created a video presentation as part of a virtual series, in which I came into the museum to do an interview with the curator and discuss my research and some of the objects in the collection. During the pandemic, it became increasingly necessary to use social media to stay connected to the community. Social media platforms are always evolving, and museums are finding effective ways of using it to connect with their audiences, even in a post-pandemic world. Using an online platform to build and maintain a stronger community presence, with internships to build upon that presence, makes a museum more accessible to the public while also encouraging visitation.

The learning curve of a hybrid-virtual internship benefitted me a great deal. One of the biggest skills it helped me cultivate was time management. Being virtual means self-governing, even more so with multiple projects and other responsibilities. With virtual classes and my master's thesis to write in addition to my virtual internship, it was imperative to manage my time for all of my projects and to focus on my goals with limited supervision. At the start of each week, I had to plan and allocate each hour to a particular task and maintain the schedule. Working virtually provided flexibility; however, with only one of my virtual classes taking place at a particular time. I was able to decide which projects earned priority while still addressing my other responsibilities. This practice, modelled after observation of my professors' time management skills, is vitally important for working in the museum and education fields, where initiative and discipline are required.

I found that the flexibility of my working environment was both a benefit and a challenge. While I could work from home at all hours, I could also choose to work wherever I was most comfortable or focused. Keeping pandemic restrictions in mind, this included going to a local coffee shop or the library. While these environments can provide stimulation or a comfortable workspace, they can also be challenging as they are not necessarily delegated working environments. Working at home, however, risks compromising the life-work balance. I felt somewhat disconnected from the museum as a whole as well as its other staff and missed having an inclusive workspace at the museum for the full experience. Working virtually and living an hour away from the museum meant inconsistent access to the objects, as well as lack of access to any potential hard copies of files on the objects. That being said, working virtually was also a great way of eliminating barriers. Virtual internships as a whole will offer a much wider range of possibilities to students who may not have direct access to a museum.

A Recent Alumna's Perspective: Cannon Fairbairn

During the pandemic lockdowns, I found myself looking for an internship in order to complete my Interdisciplinary Graduate Certificate in Museum Studies at the University of Memphis. During the Fall 2020 semester, when

many museums were closed or had only recently reopened, I reached out to the Brigham Young University Museum of Peoples and Cultures in Provo, Utah, and arranged to do a hybrid in-person/remote internship with their collections and education teams. As lockdowns and restrictions were still in place, the museum had me start remotely with plans for me to come into the museum on a limited basis, once regulations and policy permitted. As the first intern to complete this type of internship at the museum, it was a growing experience for all involved as we learned how to ensure that I was able to work on projects of real importance to the museum, while meeting the requirements of my internship.

My remote hours were spent working with the education team and included the following assignments:

- Adapting ongoing educational materials to an online or COVID-19-safe format and developing new programmes;
- Arranging and hosting internal events for museum staff to help cope with isolation during the pandemic;
- Creating a video to accompany educational resources offered by the museum.

Once pandemic restrictions began to lift, I was approved to come into the museum to work with the collections manager by entering object information into the museum database, creating mounts for various objects, photographing and measuring artefacts, and researching in the museum archives. Due to pandemic guidelines, these were largely independent tasks that could guarantee social distancing and safety.

Challenges

Some aspects of the hybrid internship were difficult or impossible to transfer to a remote setting. First, my introduction and onboarding into the museum were difficult within a remote setting. Without the benefit of time in the museum to meet with staff members, become familiar with the museum, and see the day-to-day operations, I initially felt overwhelmed. As many of us discovered over the pandemic, creating a sense of community remotely can be difficult but not impossible. Based on my experience, I would suggest inviting interns to an online meeting to meet key members of staff they will be working with. In addition, providing written materials with information on museum personnel, a short list of important contacts, and short descriptions of the various positions and their responsibilities within the museum was incredibly helpful in orienting me.

Another issue I encountered was working with physical collections in a remote setting. For one of my projects, I needed to track the history of an object from the moment of its acquisition by the museum. This required me to

go through old exhibition records, research requests, photographs, and original acquisition reports. All of this material was stored on site and not available for consultation remotely, due to the lack of collection software and a web-based platform.

Benefits

This unique approach to a museum internship offered many benefits in addition to its training in museum education and collections management. Having just finished my Masters programme, I was accustomed to scheduled class times and work hours. However, the hours I worked outside of scheduled meetings were largely left to my own preference and planning. This was a wonderful opportunity to develop my time-management skills. In combination with this process came many lessons in self-reliance as I was often working on my own. While my supervisors were responsive and helpful, the nature of working remotely or working in a museum with minimal personnel meant there were times when my supervisors were unavailable.

These moments encouraged me to get to know other members of museum staff who might be able to help me, become familiar with museum handbooks, and rely on my own judgment. This was a great experience as I was to begin my PhD programme soon after completing this internship. As I began my PhD research, I again found myself in a situation where I was required to manage my time without an established daily or weekly schedule. I was able to employ the skills and methods I had developed during the remote portion of my internship as I set aside time for different tasks, established personal goals and deadlines, and scheduled time for each portion of my research while approaching new tasks and projects.

Overall, completing a hybrid in-person and remote museum internship was beneficial in many ways. It prepared me for the independent nature of PhD research and studies. I grew immensely as my time-management and communication skills were tested and challenged. I was able to network with the museum's staff through weekly meetings or collaborative projects and became familiar with the different roles within the museum. The in-person hours built into the internship allowed me to experience the unique elements of working in a museum as well. This is a factor that could be built into many remote internships. Depending on distance, interns could be invited to come into the museum for a couple of hours each week or month, or if distance is a problem, a week could be set aside for interns to travel to the museum and spend some time in the collection. However, these in-person hours may not be essential for each type of internship. Much of the work I did with the education team was entirely remote and easily adapted to virtual work. Museums have a great opportunity to experiment with the remote platform to engage a wider range of interns and reach many who would have otherwise been unable to participate.

References

Agostion, D., Arnaboldi, M., & Lampis, A. (2020). Italian state museums during the COVD-19 crisis: From onsite closure to online openness. *Museum Management and Curatorship, 35*(4), 362–372. https://doi.org/10.1080/09647775.2020.1790029

Dunn, A. (2022). *Tips for hosting virtual museum internships*. American Alliance of Museums. https://www.aam-us.org/wp-content/uploads/2018/01/Hosting-Museum-Internships.FINAL_.pdf

Juarez, D., & Blackwood, E. (2022). Virtual undergraduate internships: One COVID-19 side effect that academic libraries should keep. *Portal: Libraries and the Academy, 22*(1), 81–91.

Part III

Creative Tensions

Bridging the Academic—Workforce Gap

8 Redefining the Museum Placement in a Post-pandemic World

Challenges and Opportunities Presented by the Virtual Model

Margaret McColl and Delia Wilson

Introduction

Workplace internships are established components of graduate programmes in museum studies. Not only do they enable students to apply their theoretical knowledge to practice-based contexts, but they also offer valuable opportunities for the expansion of professional networks in an increasingly competitive professional landscape. One graduate programme that offers a professional placement is the University of Glasgow's Master of Museum Education. This programme is offered on campus and online, but both models require a student placement to be completed with a museum or heritage organisation. In 2020, the COVID-19 pandemic accelerated a necessary shift to virtual learning for the university with a need to redesign curriculum and practice degree components. The MSc Museum Education teaching team had, until 2020, organised in-person placements, mainly in Scotland, for all students. The sudden closure of museums imposed by the pandemic meant that MSc Museum Education students were unable to complete the in-person placement element of the degree. To enable students to complete their studies and gain experience with a museum partner, virtual rather than in-person placements were organised. In line with the nature of the programme, all placement remits would focus on education with students taking responsibility for developing an innovative new aspect of museum learning centred around the museum's collections and thematic foci.

Securing these virtual placements required advance consultation with museum partners. A series of online meetings between university staff and museum partners allowed for remits, approaches, professional contact points, and collections' access to be agreed. Since the main challenge for students would be access to physical museum spaces and collections, it was decided that museum partners would meet online with students and guide them to and through online resources and virtual collections. Students undertaking placement are required to familiarise themselves with the professional demands of the museum world by attending staff meetings and supporting visitor workshops. They must also liaise regularly with placement mentors regarding their

DOI: 10.4324/9781003393191-12

progress. As will be discussed later, frequent and clear communication channels were integral to the success of the virtual placements discussed in this study.

The Purpose and Value of Museum Placement Internships in Higher Education

In its 2025 Strategic Mission, the University of Glasgow (UoG) committed to strengthening civic partnerships and working closely with communities (UoG, 2021). The university's desire to nurture these types of partnerships reflects the current civic direction of higher education institutions as noted by Hulme et al. (2022), who suggest that "community engagement through service learning is commonly used within narratives that support the civic mission of public universities" (p. 254). While serving strategic higher education goals, the inclusion of practicum experiences in the 21st-century degree is also high on the list of requirements for the discerning university applicant. Students today are seen as consumers, seeking "work-relevant (marketable) skills and attributes" (Hulme et al., 2022, p. 254). Conversations with students suggests this could well be how they see themselves. In addition to global institutional reputation, students often cite the inclusion of work placements and field visits as motivational aspects in deciding where to study. The 21st century student is network-savvy and keen to invest their finances and time in graduate study that will reap real-world dividends on graduation. When selecting a programme of study, the MSc Museum Education applicant views the placement as a key deciding factor, worthy of their financial and personal investment.

Notwithstanding the controversies surrounding unpaid internships (Holmes, 2007), 21st-century institutions are invested in approaches to teaching and learning that equip graduates to move quickly and seamlessly into the field of employment, whatever the discipline (Ashton & Noonan, 2013). The traditional type of internship undertaken by museum studies and museum education students involves the physical application of skills and knowledge in real-life museum and heritage settings. Virtual internships have tended to be adopted by higher education providers for students placed in technology sectors and to mitigate travel implications that might otherwise be a barrier to students being placed (Jeske & Axtell, 2014). However, with modern technological advances and an increase in hybrid working approaches, the virtual workplace is a modern-day reality. It is into this technologically charged, hybrid-working world that museum education graduates will emerge, and so a role for the virtual museum education placement seems a natural pedagogical progression for higher education institutions "as valid experiential learning opportunities to acquire professional skills and competencies" (Franks & Oliver, 2012, p. 274).

Virtualisation of Curriculum

To make a successful transition from higher education to the workplace, the 21st-century student must be flexible and equipped to adapt to an evolving technological landscape in a world where nothing is certain. According to Bowen (2020), students must become "autonomous, self-directed learners who are creative, resourceful, and agile" (p. 377). Technology offers a means by which students can operate effectively from a remote location to interact and engage productively with employers. Bowen (2020) suggests that students who develop the collaborative skills to operate effectively as part of a remote team will have "a competitive advantage in future work worlds" (p. 381). The aim of this study was to evaluate the success of virtual placements and to consider if such an approach would be a useful tool for museum education programs moving forward.

Materials and Methods

Study Design

The purpose of this study was to collect and analyse qualitative data that would allow museums who hosted virtual placements in 2020 to compare their experience of these with previous in-person placements, and allow the UoG Museum Education program staff to consider the viability of extending the use of virtual placements beyond the imposed remote period necessitated by the pandemic. We conducted the study via interviews using a semi-structured approach as suggested by Cohen et al. (2018). Using this design, we created a range of open-ended questions for discussion around specific themes, along with a series of possible probes that would allow for further clarification from the interviewees. We conducted the interviews in-person at the museums in which the virtual placements had been hosted.

In essence, the questions were designed to explore the following areas:

- What activities were the remote placement students able to contribute to in terms of the activities of the museum?
- How was communication with the students managed and were there particular difficulties that impacted the experience?
- What activities/contributions were enhanced/reduced with remote placements compared with in-person placements?

Participants

The participants were two museums in the United Kingdom who had each agreed to host a virtual placement for international students who were part-way through their online masters programme. Both museums already

had experience hosting face-to-face placements for students studying MSc Museum Education in partnership with the University of Glasgow. One museum was a national museum in the United Kingdom (Participant 1), and the other was a university museum in the United Kingdom (Participant 2). Participant 1 hosted one student, while Participant 2 hosted two students.

It is worth noting that in the initial data collection, the students themselves were included and given the opportunity to express their views. Indeed, two students participated in the Virtual Dialogue Symposium along with staff.

Tools for Data Collection

We collected data following successful completion of the placements using a semi-structured interview approach. Museum hosts were asked to consider areas such as communication, organising a remit, new skills gained by student, and benefits for the museum. These areas were explored in relation to:

1. Their experience of hosting face-to-face placements for students studying Museum Education;
2. Their experience of hosting virtual placements for students studying Museum Education;
3. Their view on comparing both approaches.

The participants were informed about the purpose of the study and a written consent was obtained. The research was approved by the University of Glasgow Ethics Committee (University of Glasgow, Online).

Data Analysis

We recorded data from interviews, transcribed these into written text and checked the transcriptions with participants to ensure accuracy before proceeding. We then used the thematic analysis principles as described by Braun and Clarke (2006) to interpret and make sense of the data. This approach involved the researchers carrying out the following steps:

1. Relistening to interviews and reviewing transcriptions to ensure researcher familiarity with the data.
2. Applying initial codes to the transcribed data which generated 35 codes.
3. Identifying themes which represented the codes. This generated 12 themes.
4. Reviewing and distilling the identified themes. This generated eight themes.
5. Selecting the final themes for discussion in the research paper.

Ethical Approval

The British Educational Research Association (BERA) provides a comprehensive set of guidelines that they suggest should provide the guiding principles of all studies related to research in education (BERA, 2018). These guidelines highlight the need for respect, integrity, and transparency in relation to all studies. We concur with all guidance provided by BERA and used these principles at all stages of the study. We sought and obtained ethical approval from the Ethics Committee of the University of Glasgow.[1]

Limitations

An obvious limitation of the study is the small number of participants whose views were sought and detailed here. However, as the initial virtual placement trial involved only two museums and appeared to be successful from anecdotal feedback, it was essential that the programme team explored this feedback in a formal way before applying virtual placements more widely within the degree programme. As the students themselves are no longer registered with the University of Glasgow, we were unable to obtain permission to include data that they had provided at the time of the *Virtual Dialogue* Symposium.

Remit

As previously stated, the remote placements had been organised to overcome the issue of museum closures due to the ongoing COVID-19 pandemic. It was therefore not surprising that both participant museums elected to provide a remit that either developed or improved digital resources, which they could utilise for online engagement. For the participant museums, the placements did appear to assist them in dealing with the issue of audience engagement due to museum closures during the pandemic.

Communication

From the outset, University Staff were aware that communication could become an issue if clear parameters were not identified at the start of the placement to ensure that regular communication channels were established and maintained throughout the placement. Therefore a virtual meeting involving the student, the museum supervisor, and the University placement lead was conducted before the start of the placement. At this meeting, it was agreed that the student would have a virtual check-in every week and could have regular email access at all times to assist in developing the remit. The museum supervisors would also invite the students to staff meetings and other virtual professional events with advance notice. If required, access to university staff could be by email or telephone during the placement weeks.

Table 8.1 Summary of Participants' Response on the Internship Experience

Area	Participant 1	Participant 2
Initial remit	Student was tasked with developing a series of films looking at toys and games of the past for both schools and with older adults.	Student A was asked to further develop a series of online resources for museum website which had been put together by staff hurriedly in response to Covid. Student B was tasked with developing a new series of online resources and activities based on one of the museum's collections. These were focussed on children aged 7–12 to help support home schooling during Covid.
Additional activities	• Student led an online workshop for a dementia support group associated with the museum. • Student created a set of digital films for the museum's YouTube channel.	• Students attended staff development events particularly focused on online engagement. • Student led staff presentation and Q&A session on development and use of digital resources.
Communication	Virtual meetings were scheduled on a regular basis. Further communication through email.	Regular virtual meetings via ZOOM and Teams. Some meetings involved both students and others one to one. Further communication by email and use of One Drive.
New skills gained by student	• Film editing. • Meeting the learning needs of specific groups. • Practical application of learning theories to resource production. • Enhanced presentation skills.	• Enhancement of existing digital skills. • Practical application of learning theories to resource production such as making digital resources more accessible and inclusive. • Enhancement of presentation. skills.
Benefits to host museum	Short term: • Student produced good quality digital resources which helped audience engagement during Covid.	Short term: • Resources produced by students helped the museum to support remote learning during Covid. • Students were adept at promoting new resources via social media platforms.

(Continued)

Table 8.1 (Continued)

Area	Participant 1	Participant 2
	Longer term:	Medium term:
	• The resources are still available on museum social media platforms and also through loan and handling box services. • The museum has subsequently looked at other digital content based on the work of the student.	• Resources are being used to support schools who wish to access the museum but cannot visit in person due to cost. Longer term: • Resources generated "Can extend the global reach of the organisation". • Some of the resources have been used in other outreach activities. • Digital content produced is likely to feature in the development of future resources. • Digital is a growth area so could be the main focus for future placements.
Identified challenges	The student could feel quite cut off from the team, so needed additional support. Did not get hands on experience working with groups or objects which would benefit them when looking for work. May miss out on social elements of being in the office. If they are in a different time zone then there can be challenges with timing meeting/activities.support, meetings etc.	Potential placement outputs are likely to be restricted as events and onsite engagements are generally ruled out. Identifying suitable work that can be exclusively remote. Technical glitches and wifi issues. Accommodating Time zones.

Both participant museums felt that virtual communication with the placement student had worked well and that sustained communication, verbal and written, via various platforms was essential for the remote placement to work effectively. However, Participant 2 did allude to some technical and timing issues with communication that arose due to time differences given the geographical location of the student.

New Skills Gained by Students

The key purpose of the placement is to enable the museum education students to experience the real-life workings of a busy museum workplace in its many contexts. As with all placements, our hope was that the virtual placement would offer opportunities to carry out specific tasks, have opportunities to engage with staff and to witness and to employ the theoretical knowledge gained in the University in a practical way in the museum setting, albeit in a virtual/remote context.

Both participants highlighted the students' application of museum education theory to real-life contexts as areas of development with a particular focus on increased accessibility for enhanced user engagement. Participant 1 observed that "meeting the learning needs of specific groups" as a newly acquired skill while Participant 2 commented that both students had advanced their skills in making digital resources "more accessible and inclusive."

The museums believed that all three students further enhanced their existing digital skills and gained opportunities to develop new skills in areas such as film editing, conducting virtual workshops as well as presenting to a virtual audience and to colleagues.

Participants in both museums strived to allow the students to observe the everyday working of the museum as would be the case for an in-person placement. This obviously came with a number of challenges due to the closure of the museums themselves. To overcome this and support networking opportunities, students were regularly invited to virtual staff meetings and encouraged to become involved in discussions. From these meetings, the students often contacted museum staff to discuss areas of interest which had been discussed at a general meeting. Students working with Participant 2 were afforded the opportunity to practice leadership skills when asked to lead a Q&A session with museum colleagues on their digital resource development journeys. In this way, both students had the opportunity to not only share some of the same experiences as those carrying out in-person placements, but also to recognise the virtual platform as a valuable means of facilitating staff development.

Benefits to Museum Host

Both museums spoke very positively about the digital resources the students created, which were still in use in a variety of ways. In the case of participant 1, the student had developed a set of activities and resources linked to their collections which enabled the virtual visitor to conduct a virtual visit to the museum and engage with collections. The museum felt that links to social media pages facilitated by the students further increased the volume of virtual traffic to the museum. Although museum staff were extremely interested in this approach, they did not have the necessary time or expertise to add social media to their already full workload. The input of the student was therefore extremely helpful.

Participant 2 commented that work that had been completed by staff as an initial response to Covid lacked consistency and coherence but after revision by the student, provided a valuable learning tool to support schools and learners during a period of school closures. Work by the second placement student had filled an engagement gap with school children that the museum had been aware of but had struggled to address due to staff work commitments.

Interestingly, in both cases—the placement process and the production and use of digital resources appeared to have influenced the longer-term thinking of the museum with respect to online engagement, as well as contributing to a short-term solution due to Covid.

Discussion

The Student Experience

While participants noted overall satisfaction with the virtual placement from the student perspective, they did identify advantages for students carrying out in-person placements that are unavailable to students interning online. These included "meeting staff in person and making connections, having a practical experience involving the use of museum objects, and seeing the day-to-day work of museums" (Participant 2).

Briant and Crowther (2020) who conducted their own study into remote pandemic internships as part of creative disciplinary degrees at the Queensland University of Technology suggest these desired features of the in-person placement inspire a sense of "belonging to a community" (Briant & Crowther, 2020, p. 623) a placement requirement they believe presents "one of the greatest challenges of on-line learning compared with an internship in the physical work place" (Briant & Crowther, 2020, p. 623). Participant 1 mentioned "fostering a greater sense of belonging, experiencing ad hoc work of museums through attending meetings, and fostering relationships with staff." However, both participants agreed that the ability to connect students with museums anywhere in the world and the flexibility afforded to the student via the virtual placement were highly desirable. The virtual placement facilitated excellent opportunities for students to extend their knowledge and develop practical skills in digital source creation, hugely valuable for a museum graduate in today's digitally connected museum world. As Khoreva et al. (2021) observe:

> In the context of widespread digitalization, the use of innovative remote technologies in organizing the activities in the sphere of creative services is one of the most productive approaches to promoting a museum product to the market.
>
> (Khoreva et al., 2021, p. 82)

Students utilized a variety of digital means to produce and enhance resources for pandemic audiences; their work either remains available to post-pandemic audiences or has influenced the on-going practices at both museums. Accessibility and inclusion were key factors for consideration during the production of these digital resources and the real-world context in which students worked made the need to address such factors all the more intense and motivational. Finances, which are often a source of worry and stress for students, were also impacted by the use of the virtual placement while the in-person experience brings certain advantages to the student, both participants noted that problems related to travelling to the museum, including cost, constituted a definite disadvantage for those involved with in-person placements.

Reflecting on the findings of their own study into virtual internships, organised in response to the Covid-19 Pandemic, Mark and Jones (2021) observed that interviews with student interns suggested they believed a similar skill set is required for physical and virtual internships (Mark & Jones, 2021, p. 185). Interestingly, students highlighted soft skills such as "patience, self-discipline, time-management, being organized, critical thinking, decision making, and working independently in virtual internships" (Mark & Jones, 2021, p. 185) as being important for successful experiences. Since the Glasgow students weren't directly involved in interviews for this study, it is not possible to ascertain if they felt similarly to the Tourism, Events, and Hospitality Education students interviewed by Mark and Jones; however the observations of the Glasgow participants indicate that these soft skills may well have been developed by their placement students.

The Host Experience

Both participant hosts noted that the virtual placement improved their ability to connect with audiences digitally through the use of new expertise brought by the student, including the development of digital resources. The placements generated the production of new and supplementary digital resources that reflected an awareness of specific audience needs associated with impaired memory and mental health. The students were able to devote considerably more time to the development of these digital resources than staff juggling the multiple demands of busy jobs in a daunting new pandemic climate. Participants' praise for the enhanced quality of resources that students produced through their established and developing digital skills and their intention to learn from the experience when designing future resources, demonstrates the strength of the mutually beneficial placement partnerships. The fact that Participant 2 entrusted a staff development Q&A session on digital visitor engagement to the students is testament to how much they valued the students' digital expertise and contributions. The flexibility afforded to the museum by University of Glasgow in engaging with the student was also mentioned as a positive by both participants. In contrast, problems that could

arise in relation to time zones for virtual placements and a sometimes challenging Wi-Fi connectivity were perceived as problematic.

The findings of this study very much chime with Briant and Crowther (2020). Reflecting on the outcomes of what they term remote "work-integrated learning" (WIL) experiences of students during the pandemic, the researchers concluded that:

> *Remote WIL is not just workplace-based WIL on-line, it has the potential to be accessed by more students, engage more industry partners, be flexible in time and space, align with good pedagogical practice, and encourage student autonomy and lifelong learning.*
>
> (p. 626)

Without doubt, the Glasgow study offered similar perspectives on the part of the Participants interviewed.

Conclusion

The aim of the study was to evaluate the success of two virtual placements carried out in museums in the United Kingdom by international students and to consider if the use of virtual placements was a viable option for MSc Museum Education Programs offered by the University of Glasgow. Having considered the responses from the two museum hosts (as well as those of the students themselves, which are not listed here), we consider that virtual placements are a viable option for programmes to adopt.

From the student perspective, there is no doubt that virtual placements are a useful tool in developing the "work-relevant (marketable) skills and attributes" described by Hulme et al. (2022, p. 254) and that students who complete virtual internships may in fact be better prepared for the 21st-century world of work as described by Bowen (2020). Graduates with practical knowledge and understanding of how to design engaging digital resources for a variety of audience needs would be an asset to any 21st century museum or heritage organisation, especially if they can simultaneously support colleagues to develop their digital engagement skill sets and lead the promotion of digital resources and activities through social media platforms.

Apart from the flexibility afforded by the virtual placement in terms of being able to work according to their own availability, there is also a cost saving issue in not having to physically travel to carry out the placement. Moreover, the prospect of being able to connect with prestigious museums worldwide is far more likely through a virtual placement than through an in-person placement.

However, it could be argued that there are certain core advantages in attending a placement in person that are lost in the virtual world, such as seeing the work of museums first-hand and meeting and working face-to-face

with museum professionals, affording opportunities for networking and possible employment. Similarly, from the perspective of the museum host, there are pros and cons to be considered. While both participants benefited from new skills and resources afforded by the virtual placement, Participant 2 did allude to the value in having "an extra pair of hands around" when the placement is carried out in person. This of course comes with a caution that in a landscape where budgets bring increasing pressure to museum managers, in-person placement students are not viewed as unpaid staff tasked with carrying out work that hard-pushed staff are unable to manage.

Overall, while the research was very small scale, we consider that the evaluation exercise has provided sufficient positive evidence to embed virtual placements within the suite of Museum Education graduate programmes at the University of Glasgow. Importantly, staff are satisfied that virtual placements offer excellent opportunities for the development of crucial 21st century museum education practice skills while they also accept a hybrid or in-person option as equally viable. Choice is key and going forward, staff should encourage students to adopt a global attitude towards the MSc Museum Education placement, recognising that geography need not be a barrier to a placement in the museum and country of their choice.

Note

1 Application no 400220142.

References

Ashton, D., & Noonan, C. (2013). *Cultural Work and Higher Education*. London: Palgrave MacMillan.

Bowen, T. (2020). Work integrated placements and remote working: Experiential learning online. *International Journal of Work-Integrated Learning*, 21(4, Special Issue), pp. 377–386.

Braun, V., & Clarke, V. (2006). Using thematic analysis in psychology. *Qualitative Research in Psychology*, 3, pp. 77–101.

Briant, S., & Crowther, P. (2020). Reimagining internships through online experiences: Multi-disciplinary engagement for creative industries students. *International Journal of Work-Integrated Learning*, 21(5), pp. 617–628.

British Educational Research Association [BERA]. (2018). *Ethical Guidelines for Educational Research* (4th ed.). London. https://www.bera.ac.uk/publication/ethical-guidelines-for-educational-research-2018 Last accessed on 2023 01-12 06:21:00

Cohen, L., Manion, L., & Morrison, K. (2018). *Research Methods in Education* (8th ed.). London: Routledge.

Franks, C.P., & Oliver, G.C. (2012). Experiential learning and international collaboration opportunities: Virtual internships. *Library Review*, 61(4), pp. 272–285.

Holmes, K. (2007). Experiential learning or exploitation? Volunteering for work experience in the UK museums sector. *Museum Management and Curatorship, 21*(3), pp. 240–253.

Hulme, M., Olsson-Rost, A., & O'Sullivan, R. (2022). Developing an online practicum in professional education: A case study from UK teacher education. In C. Hong & W.K. Will (Eds.), *Applied Degree Education and the Future of Learning.* London: Sage Publishing, pp. 165–178. Singapore, Springer pp. 253–271.

Jeske, D., & Axtell, C.M. (2014). E-internships: Prevalence, characteristics and role of student perspectives. *Internet Research, 24*(4), pp. 457–473.

Khoreva, L., Burina, A., & Gorgodze, T. E. (2021). Digital technologies in museum services: Innovation in a pandemic. In S. I. Ashmarina, V. V. Mantulenko, M. I. Inozemtsev, & E. L. Sidorenko (Eds.), *Global Challenges and Prospects of The Modern Economic Development, European Proceedings of Social and Behavioural Sciences* (Vol. 106, pp. 81–93).

Mark, M., & Jones, T (2021). Going virtual: The impact of COVID-19 on internships in tourism, events, and hospitality education. *Journal of Hospitality and Tourism Education, 33*(3), pp. 176–193.

University of Glasgow. (2021). *World Changers Together: World Changing Glasgow 2025.* https://www.gla.ac.uk/media/Media_792478_smxx.pdf

9 Digital Storytelling and Digital Skills in Museums

Anra Kennedy

Digital culture is noisy, fast-paced, and crowded. Voices jostle to be heard in competitive digital channels, often against toxic, negative undercurrents. Technologies and behaviours keep changing, and just as we catch hold of a new trend, it is gone. Stepping into that melee of digital spaces can be daunting. Organisations accustomed to carefully engineering the flow of in-person visitor experiences in their venues need to reframe their storytelling when it comes to more unpredictable digital spaces. In this chapter, I will explore the digital skills, literacies, and strategic understanding museum professionals need to create, disseminate, and track stories in digital channels for successful, relevant digital storytelling. These technologies are adaptive and can also be creatively introduced in the museum studies classroom to bridge academic and professional practices.

What Does Digital Storytelling Look Like?

Digital storytelling from and about museum collections, activities, and ideas takes many forms. Before delving into case studies, it is useful to appreciate that diversity of approach, medium, style, subject matter, scale, and scope. Some museums tell stories in shortform, at a micro-level in social media posts, such as Yorkshire Museum tweeting about Kevin Bacon and a meteorite[1]; Ashmolean Museum's #DogsofInstagram post[2]; Carnegie Museum of Natural History's TikTok mollusc jokes[3] from their stores; or The Somme Museum's Facebook post[4] about Christmas letters home in World War One. Topics covered in social posts range from the light-hearted to the profound.

At the other end of the spectrum, museums are creating longform content, such as Toronto's Myseum's "Derailed: The History of Black Railway Porters in Canada" digital exhibition[5]; livestreaming events and experiences, such as Museum of London's "Great Fire of London" series[6] for children and families; experimenting with gamifying collection items, like National Museum Scotland's "Dolly and the atom smasher"[7] game, built in a game jam with children and developers; using audio like Historic Royal Palace's innovative binaural "Lost Palace" audio trail[8] around the streets of Westminster;

DOI: 10.4324/9781003393191-13

and the "Museums 'n' That" podcast[9] from Leeds Museums. Plus, more rarely but interestingly, using immersive technologies to explore storytelling as in History Colorado's "Virgil Ortiz Revolt 1680/2180: Runners + Gliders"[10] exhibition incorporating augmented reality and "The Kremer Museum"[11]—a museum which exists only in virtual reality.

Museums' digital storytellers can be found across many roles and departments, from curators and learning and outreach specialists to digital staff, museum leaders, and volunteers. Communities of interest around the museum can also be digital storytellers, sometimes in collaboration with the organisation, often not. See this young railway enthusiast's (and museum volunteer's) YouTube channel[12], the Horniman Museum's commission of artist Harun Morrison on "Decolonising Natural History"[13]; the conversations happening amongst #museumlovers on Instagram;[14] and the museum visitor reviews on Trip Advisor[15].

Digital storytelling also opens up the range of target audiences. Removing the constraints of a building's physical spaces provides more opportunity for reaching and engaging multiple audiences with targeted, bespoke content strands. However, there are still capacity and resourcing constraints when it comes to digital work, despite those open-ended possibilities. Digital tools and channels therefore offer huge scope for sharing stories and engaging new audiences, but it is challenging work. While online and in-venue storytelling require the fundamental skills and qualities that so many museum staff and volunteers already possess around narration, interpretation, creativity, inclusivity, and empathy, the digital context adds a layer of distinct considerations. Successful, meaningful digital storytelling requires an additional and different set of skills and understanding. It also needs clarity of purpose—an understanding of why, how, and if digital storytelling is supporting the museum's mission, which in digital channels can be difficult to recognise and keep hold of.

What about the COVID-19 Pandemic?

When COVID-19 arrived in 2020 and up-ended so many everyday norms and expectations, digital communication and access were suddenly centre stage. Museum staff and volunteers found themselves running services from home, and digital storytelling took on a new urgency as digital channels became their only route to audience and community engagement. The pandemic put individual and organisational strengths and weaknesses into sharp relief for all of us. In some settings, people were able to try new ways of doing things, processes, and decision-making sped up; new equipment arrived; added strategic value was ascribed to digital engagement; and people developed new digital confidence and skills. In other settings, those things did not happen, and little progress was made.

While the pressures and strains of the times we were all living through were immense, I would argue that the digital skills and literacies needed for effective, relevant digital storytelling did not change during the pandemic and are still no different as things stabilise. The following case studies are therefore not specifically post-pandemic; they are examples of fit-for-purpose digital storytelling from or about museums and collections.

Victoria & Albert Museum's "ASMR at the Museum" Channel

My first case study is a hugely successful YouTube playlist, 15 videos called ASMR at the Museum.[16] Its understated strapline, "Experience our objects closer than ever before with this series of ASMR videos," gives nothing away to viewers who may not be familiar with ASMR, giving those in the know the feeling that this is an exclusive content strand. Definitions vary,[17] but essentially, ASMR or autonomous sensory meridian response describes a pleasurable, tingling feeling sparked in some people by quiet, slow-paced speaking and whispering and focused, often tactile activity.

The Victoria and Albert Museum (V&A) has tapped into the trend for ASMR on YouTube, creating films that focus on collection objects in minute detail, showing conservators, curators, and librarians working with and talking about objects in their care. Take their most recent video as an example— "Massaging hands with bath rasps from Iran." In the film, curator Fuchsia Hart shows several late 17th- and early 18th-century Iranian bath rasps, used for smoothing rough skin, unboxing and handling them, telling their stories, and sharing X-ray views. Two weeks after its publication on 27 December 2022, the 11.5 minutes-long film had close to 45,000 views.

The most viewed video on the playlist to date is "Conserving a Eurovision dress,"[18] which shows Senior Textile Conservator Susana Fajardo working on the dress worn by Sandie Shaw for her victorious performance of "Puppet on a String" at the Eurovision Song Contest in 1967. Again, the film uses high-quality imagery and sound recording and gives detailed information about the object.

These films cater to a trend and community of interest on a medium that lends itself perfectly to ASMR requirements, and they take museum collections to audiences in serendipitous ways. The films are technically and artistically innovative. The dress video, for example, uses ambisonic, or 360-degree, three-dimensional, sound recording techniques and was created in collaboration with Julie Rose Bower, a sound designer and performance artist. These two films, and the others in the V&A ASMR channel, illuminate collection and conservation techniques, giving viewers behind-the-scenes insights and letting individual objects shine, for a community who might not otherwise have sought out museum content.

@artlust, Seema Rao on TikTok

Seema Rao[19] has over 20 years' experience in strategy, content, and education at US museums, including the Akron Art Museum and Cleveland Museum of Art. Upon moving to the commercial sector, she began to create content on TikTok about art in her own time, outside of work. Rao's @artlust TikTok account[20] has 125.9K followers at the time of writing, and several of her most engaged-with posts have had hundreds of thousands of views.

Rao's "Vanderbilt Ball" TikTok[21] is her most popular to date with 1.2 million views, almost 230K likes, and over 1200 comments. Simply shot, the video shows Rao speaking directly to the camera, in front of a series of striking archive photographs, telling the story of the 1883 Vanderbilt Ball, an extravagant, Gilded Age costume party, in two minutes 22 seconds.

I deliberately chose this example of digital storytelling about collection objects and works of art because, despite Rao's career background, it comes from outside an arts institution. On TikTok, Rao switches topics from post to post, untied to organisational rhythms, exhibition calendars, content strategies, or brand guidelines. Her style is informal and opinionated, images and source material are only briefly flashed up, the editing often feels slapdash, and the subtitling is often imperfect. Those characteristics all fit TikTok's conventions perfectly. The engagement and interest shown in Rao's content should be a reality check for museum professionals. Audiences do not necessarily care about a museum brand. Museums are now competing for potential audiences with successful digital content providers who understand the norms of their platforms.

Transforming Practice, Science Museum Group

This third case study is an example of digital storytelling that encapsulates a reflective, collegiate, collaborative, and open approach to museum work. The "Transforming Practice" blog[22] is run by learning staff[23] at Science Museum Group[24] (SMG), a group comprising five of the United Kingdom's leading science museums.

Alongside the museum work they describe, such as research, teaching, resource creation, and interpretation of collections, the practitioners creating blog posts are reflecting on their processes, impact, planning, and strategies. Their target audience is clear: "Our blog is written by practitioners, for practitioners, to reflect on what research into STEM engagement means for our day-to-day practice." [25] The tone across the blog is collegiate, friendly, and informal, with a strong use of imagery and a multi-layered approach; there is always a link to follow for deeper or related content.

A post by Emilia McKenzie, SMG's Digital Manager, Learning, from 22 November 2022, entitled "WONDERLAB+: A user-centred design process for a website that is open for all"[26] illustrates the approach, detailing

the process her team went through in creating a new website for children. Another post, this time by Gabriela Heck, a Brazilian PhD student, entitled "STEM for all—reflections on capital and people with disabilities"[27] is written through a more personal lens yet discusses fundamental strategic issues with sector-wide relevance, such as the disparity in opportunities to create science capital for disabled people. This form of storytelling serves several purposes. It raises awareness for Science Museum Group's STEM engagement work; builds trust in those services, products, and the brand; builds skills; and creates and shares knowledge for both staff and readers.

One of the strengths of the Transforming Practice blog is that difficulties are detailed as well as successes. For example, assumptions McKenzie and colleagues made around user needs when designing new teaching resources were disproved in consultation with users, necessitating a change in approach. While still clearly positioned to share work from a positive perspective, there is an openness that gives the content credence.

What Do Successful Digital Storytellers Need to Have, to Know, and to Be?

In this concluding section, I will outline the skills, attributes, and conditions needed for effective digital storytelling in and about museums. The definitions of digital skills and literacies developed in the One by One[28] project by University of Leicester, Culture24, and partners[29] are fundamental here, breaking digital skills down into three types:

- **A competency** is action-orientated, the ability to use a digital tool or system.
- **A capability** is more contextual and achievement-orientated, knowing how to successfully apply that ability to a task.
- **A literacy** is more reflective, being able to evaluate the appropriateness of those competencies and capabilities, taking a holistic and strategic approach.

Each of the case studies demonstrates all three types of digital skills in action.

Fundamental digital competencies such as word processing, image sourcing and editing, and the ability to upload and edit digital multimedia content onto a range of platforms have long been basic requirements of work in museums across many roles. Whether the platforms are internal collections management systems or externallyfacing websites or social media profiles, museum people need a basic level of digital skills in order to do their jobs as well as to tell stories digitally.

The digital capabilities that successful digital storytellers need are more nuanced. They include an understanding of target audience needs, interests, behaviours, and motivations, on particular platforms or in particular

communities of interest. Digital storytellers need to understand how to tailor their content to their target audiences and how to package that content once created, such as tagging, categorising, and keywording to support discovery by users (including search engine optimisation). Crucially, they need the skills to make their digital storytelling accessible to all both intellectually and technically and to track engagement.

The Transforming Practice blog gives us an object lesson in the skills and attitudes required of museum practice in a digital world, not only in terms of the topics covered, which range from web design and interpretation to equity and organisational change, but also in terms of the writers' digital storytelling skills. Digital tools and channels have made knowledge exchange of the Transforming Practice kind more open, accessible, and inclusive than ever before. The approach is not exclusive to SMG and is not new, but it is becoming ever more integral to museum professionals connecting on social media, on email discussion lists, and via platforms such as Medium, Mighty Networks, and Substack to "think out loud" and build their profiles as well as learn and reflect.

Finally, the case studies are all underpinned by broad and deep digital literacies. The strategic decision to put museum resources into creating high production value ASMR videos demonstrates an understanding of the value to the V&A of stepping outside the "normal" collection stories model and of taking their collections to a new and highly engaged community of interest. Rao's TikTok is a prime example of effective digital storytelling that conforms to the norms of a platform yet at the same time plays with expectations, bringing "high" art to a platform often seen as lightweight and frivolous. Rao is putting many digital competencies and capabilities to use, but it is her digital literacy combined with her subject knowledge that has given her the confidence and ability to succeed on that platform.

Our future museum professionals do not need every distinct digital competency, capability, and literacy outlined here to tell engaging and relevant stories in digital spaces. They do not all need to be digital experts. However, they do need an understanding of the different kinds of digital skills museum work requires, and we as a sector need to recognise the need for those skills to be supported and valued across tasks, projects, teams, and organisations. The COVID-19 pandemic highlighted the role and value of digital storytelling in and about museums. It is now our responsibility to build on that momentum and to enable the next generation of museum professionals (and by extension, academics) to build and maintain the digital skills and literacies they need in order to do their work effectively.

Notes

1 https://twitter.com/yorkshiremuseum/status/1458441900130775044?lang=en-GB. [Accessed: 08 April 2024].
2 https://www.instagram.com/p/CmzJxS2OTzB/?hl=en. [Accessed: 08 April 2024].
3 https://www.tiktok.com/@carnegiemnh/video/7010102910918937861. [Accessed: 08 April 2024].

4 https://www.facebook.com/permalink.php?story_fbid=pfbid0LAL8pkHSpQX
 xFLDnRMRDTRA8G6W4Dz74seBREcaL67qjWUnySXPPaNdJgEEHEZ5Xl
 &id=100064813685643. [Accessed: 08 April 2024].
5 https://www.myseumoftoronto.com/collection/derailed-the-history-of-black-rail-
 way-porters-in-canada/. [Accessed: 08 April 2024].
6 https://www.museumoflondon.org.uk/families/great-fire-london-live-stream.
 [Accessed: 08 April 2024].
7 https://www.nms.ac.uk/flashcontent/dolly/dolly.html. [Accessed: 08 April 2024].
8 https://www.museumnext.com/article/making-lost-palace/. [Accessed: 08 April
 2024].
9 https://museumsandgalleries.leeds.gov.uk/podcasts/. [Accessed: 08 April 2024].
10 https://www.historycolorado.org/exhibit/virgil-ortiz-revolt-16802180-runners-
 gliders. [Accessed: 08 April 2024].
11 https://thekremercollection.com/. [Accessed: 08 April 2024].
12 https://www.youtube.com/@teescottageguyproductions/featured. [Accessed: 08 April
 2024].
13 https://www.horniman.ac.uk/story/artist-harun-morrison-is-awarded-the-decolo-
 nising-natural-history-commission/. [Accessed: 08 April 2024].
14 https://www.instagram.com/explore/tags/museumlover/. [Accessed: 08 April 2024].
15 https://www.tripadvisor.co.uk/Search?q=museums&queryParsed=true&searchSes
 sionId=BC0EDDB8F7EF96B8BC334FC5F38508D81674412225904ssid&sid=E7
 B1B02A2B124EB1818679601C2E18AA1674412249496&blockRedirect=true&g
 eo=1&ssrc=a. [Accessed: 08 April 2024].
16 https://www.youtube.com/playlist?list=PLe2ihXndm5jseo_RGEGeEbPy09z0nlmZE.
17 Wikipedia's ASMR page explores the varying definitions—https://en.wikipedia.org/
 wiki/ASMR. [Accessed: 08 April 2024].
18 https://youtu.be/4laKUaaIP-c. [Accessed: 08 April 2024].
19 https://www.linkedin.com/in/raoseema/. [Accessed: 08 April 2024].
20 https://www.tiktok.com/@artlust. [Accessed: 08 April 2024].
21 https://www.tiktok.com/@artlust/video/7187042879427153195. [Accessed: 08 April
 2024].
22 https://learning.sciencemuseumgroup.org.uk/blog. [Accessed: 08 April 2024].
23 https://learning.sciencemuseumgroup.org.uk/. [Accessed: 08 April 2024].
24 https://www.sciencemuseumgroup.org.uk/. [Accessed: 08 April 2024].
25 https://learning.sciencemuseumgroup.org.uk/blog/what-is-the-transforming-best-
 practice-blog/. [Accessed: 08 April 2024].
26 https://learning.sciencemuseumgroup.org.uk/blog/wonderlab-a-user-centered-
 design-process-for-a-website-that-is-open-for-all/. [Accessed: 08 April 2024].
27 https://learning.sciencemuseumgroup.org.uk/blog/stem-for-all-reflections-on-capi-
 tal-and-people-with-disabilities/. [Accessed: 08 April 2024].
28 https://one-by-one.uk/. [Accessed: 08 April 2024].
29 Research report: https://figshare.le.ac.uk/articles/report/Understanding_the_digi-
 tal_skills_literacies_of_UK_museum_people_Phase_Two_Report/10196294.
 [Accessed: 08 April 2024].

10 Immersive Digital Learning

Transforming an Onsite Simulation into a Powerful Virtual Learning Experience

Megan Gately, Colleen Hill,
Jessica Johns, and Anthony Pennay

Something is Happening…

It started slowly at first. A conscientious teacher called to let us know that they were monitoring the coronavirus and might have to postpone their planned field trip if the school or administration deemed it unsafe. Then, a few teachers began to request new dates, a couple of months down the line. Then schools began to cancel. Only a few at the beginning. We reacted swiftly to the challenge. As museum educators, responding to hiccups in the day was part of the job. Late buses, a sick kid, a wandering chaperone … we had seen it all. To be proactive to emerging COVID concerns, we invested in disinfectant sprays and wipes. We developed and shared with teachers our elaborate cleaning protocol for the rooms and devices. We rapidly became experts on CDC prevention protocols. Despite this, more schools cancelled or postponed. And then, on Friday, 13 March 2020, the President declared a national emergency. Overnight, every school, business, museum, public transportation … everything, it all shut down.

The Story of How We Did

At first, we focused on short-term adaptation. After all, our education team often adapted to any number of factors beyond the scope of our control. A bus arriving 30 minutes late due to an accident on the freeway, wildfires shutting down the museum or local schools, a class of unprepared students, even a school bus getting into an accident on the freeway, and our museum serving as a hub for emergency personnel to make medical assessments. You name it, we had seen it and adapted to it. We could adapt to this as well. We created lists of online museum resources and shared existing video tours and lesson plans to support classroom teachers who were shifting, over the course of a weekend, to an entirely new instructional model with no preparation or training. We reassigned every member of our team to a variety of remote ventures, finally getting around to a few of those long-term projects that were simmering on the back burner. We created and shared new content and tried to make the best of it.

DOI: 10.4324/9781003393191-14

After a couple of months, and with no clear timeline for reopening, the board decided to reduce staff and programming as most of the organisation's revenue streams disappeared. With no admissions or events, and no transactions taking place in the cafe or museum store, the majority of front-line staff who interacted with the public each day were furloughed. For the education team, this meant more than 70% of the team was let go, and our budget for programming was substantially reduced.

In addition to the challenges of adapting to COVID-19 and working from home, and the significant mental strain of the various external and internal threats, our primary professional challenges emerged as follows:

1. Our hallmark in education had always been hands-on, immersive civic learning. How could we possibly provide immersive and empowering civic learning without the physical space of the museum?
2. Studies show that remote learning poses many challenges for educators. (Larkin et al., 2016) discovered that online instruction frequently results in disengaged students. Another study (DePaepe et al., 2018) revealed that there is a dearth of training and resources to prepare teachers for online instruction, that motivating students to engage during lessons is difficult, and that students are far less likely to effectively collaborate in online environments. Despite these challenges, we wanted to be sure that any programme we offered during the pandemic rose to the high standard of engaged learning upon which we had always prided ourselves.
3. Given the financial situation of the organisation, we wanted to develop online programmes that could, at the very least, be self-sustaining and ensure the continued employment of our team. In fact, we hoped we would be able to generate enough interest and revenue to quickly get our colleagues back to work.
4. We wanted our programme to be fun.

To summarise—we had to adapt a highly successful onsite programme to an online environment, and with just a fraction of our team, adopt a new revenue model, and ensure the programme was highly engaging in an online environment, with no experience doing such a thing, and no budget. What follows is the story of *how we did.*

The Stage

The Ronald Reagan Presidential Foundation and Institute is "dedicated to the preservation and promotion of the legacy of Ronald Reagan and his timeless principles of individual liberty, economic opportunity, global democracy, and national pride." (Reagan Foundation, 2023) We are the non-profit side of the Reagan Library, opened in 1991. In an average year, our museum hosts over

400,000 visitors, making it one of the most visited presidential libraries in the country since its opening. (National Archives, 2015)

Our education department is an integral part of the museum, with its commitment to cultivating the next generation of citizen leaders. Through a number of programmes, it serves over 60,000 students during a school year. Unfortunately, like hundreds of thousands of businesses, schools, and other museums, we had to close in March 2020 because of the COVID-19 pandemic.

Programme Description

The crown jewel of the education department is the Reagan Leadership Center. The Center offers an award-winning immersive simulation that uses game-based logic to build leadership, communication, and informed decision-making skills for over 25,000 fifth-grade through high school students per year on average. This programme is aligned to state standards, so teachers and administrators can easily justify time at the library and integrate the programme into their curriculum. Under the Common Core State Standards, students have been challenged to not just give answers, but also to provide supporting evidence, "Quote accurately from a text when explaining what the text says explicitly and when drawing inferences from the text" (Common Core State Standards, 2023). Our in-person and virtual field trips require students to demonstrate their proficiency and use their communication skills (written, oral, and listening), which are included in many of the standards (Figure 10.1).

Figure 10.1 Megan Gately Advises a Student Taking on the Role of President during a Simulation.

Prior to the impacts of COVID-19, a typical year meant that the programme was offered only in-person. Students arrived at the museum and were divided into three groups. They were assigned to the replica (one-third scale) of the White House's Oval Office, a military command/intelligence centre, or the replica of the White House Press Room. Students take on the roles of the people in each of those rooms and recreate a high-pressure simulation based on actual events that occurred during President Reagan's administration. Students use historical information to discuss and make informed decisions within a limited amount of time, manufacturing the stress of a historic crisis. As they proceed through a series of decisions, the tension levels rise. Then, as actually happens in the real event, members of the press release news of the planned, top-secret US military operation. Each student shares with the president their recommendation for what course of action the president should take and reasons that support their advice at each of the four decision points in the programme. The president listens to advisors and can ask questions before making the final decision on how to move forward.

As a wrap-up, all students meet in the press room and take part in a presidential press conference. They discuss the roles of the president and the executive branch, the military, and the press and discuss the tension that sometimes exists between National Security and Freedom of the Press, two foundational American concepts. Often this leads to an engaging debate between the students. What is more important? Security or Freedom? What do we do when these come into conflict? What happens when there is not an easy or clear right answer? We conclude by telling students this debate has been going on in the United States since our founding as a country and continues today. We urge them to keep thinking about this debate and talking about it in class, with their friends, and at home. We often hear from teachers that these debates continue on the bus ride home. Students want to be a part of these discussions, and ultimately our goal is to prepare the next generation of engaged and informed citizens. The simulation helps them practice for their most important role: that of citizen.

COVID 19 Reality—Now What?

When the pandemic closed our museum and our education programmes came to a standstill, our team knew it was time to innovate, and fast. We were experts in immersive, hands-on, place-based learning, and the world had shifted to a version of learning that was remote, detached, and situated at home, an environment not always conducive to learning. We had no experience with remote learning, no technological expertise, and no budget to adapt. Like the rest of the world, we were learning on the fly. As the pandemic lingered, we wanted to not only offer online resources for teachers and classrooms, but a digital version of the experience that had long been a hallmark of our programming.

From what we had both heard from our teacher partners and observed as parents of students learning in online classrooms, one of the biggest challenges teachers faced was being able to engage students. Most classes had shifted to Google Classroom, and used a version of a live lecture, posted materials, and independent time to complete assignments. Many teachers taught to entire "classrooms" of students whose cameras were off. There was very little interaction in class or with peers. Coupled with many attendant challenges of pandemic learning, including, "severe staff shortages, high rates of absenteeism and quarantines, … students and educators … struggle(s) with mental health challenges,… and concerns about lost instructional time" (Kuhfeld et al., 2022), this presented quite a challenge for our museum educators as we designed our virtual experience.

As we worked on the adaptive redesign, we grounded ourselves in our highest team value: the experience must be engaging. Despite the challenges of remote learning, students must be able to speak up and participate. Even remotely, democracy is a participatory sport, so every aspect of the virtual experience design needed to be based on student interaction with each other, our team, and history itself.

Building a New Programme

We knew the in-person experience, but we weren't sure how the timing and objectives of the in-person simulation would translate online. Testing consisted of a whole lot of trial and error and practice, practice, practice. First, we had to select the right technology. We needed a programme that would allow us to embed videos from our in-person programme and add anything needed—including information and subtitles—to ensure accessibility for all learners. We found the combination of Google Slides and Zoom to be the best solution. Google's interactive interface enabled our team to work collaboratively and simultaneously to create slides with the information, prompts, images, and videos we needed to give experiential context to the students. We enabled player agency through Google's programme features so that student choices had immediate and visible consequences in our virtual environment. In this way, the slide deck allowed us to virtually manage and shape a customisable adventure experience for the students.

Once we felt the slide decks were ready, we practised for months. We were able to balance the use of videos and slides with screen sharing against live facilitation and discussions without it so students and staff could see each other and interact. We created an environment similar to our in-person experience, where students share their recommended action and rationale with someone playing the role of the US President at each of the four decision points. By limiting the Zoom rooms to 12–15 students, the President was able to listen to their advisor in an intimate environment and ask questions before making the final decisions via the Google slide deck.

We also used Zoom's closed captioning function while people were talking; YouTube, where we embedded our videos, allowed us to change the language of the closed captioning when we had students who did not speak English. In addition, we optimised Zoom's chat feature. One staff person was dedicated solely to promoting chat interactivity. Staff posts also served as Breaking News and made sure that all action in the simulation was shared and clear in real time through the chat. Team members reacted to students' posts and questions immediately. Students having audio difficulty participated by typing their thoughts into the chat. Behind the scenes, the staff used the messaging app Slack to communicate and troubleshoot. These tools helped keep engagement possible, even when inevitable technical challenges arose.

The virtual simulation concluded with a wrap-up discussion in each Zoom room, during which students deliberated the conflict between freedoms and national security and explored how best to balance the two. Often this discussion connected in a deeper and more relevant way to students' own lives as we explored the complicated nature of how individual freedoms and the common good conflicted during a major international public health crisis. We stressed that there were no wrong answers, and that the students' input demonstrates how to practice engaged democracy. Everyone's input was valued. We taught that the diversity of ideas gave the group opposing perspectives, and allowed for all points of view to be considered (Figure 10.2 and Figure 10.3).

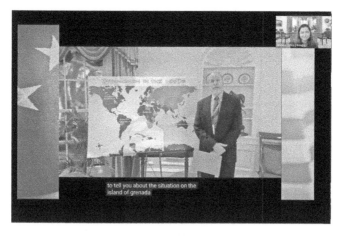

Figure 10.2 Educator Will Donley Plays the Role of Oval Office Advisor during a Virtual Simulation, while Facilitator Jessica Johns Looks on. Screenshot from the Museum Studies International Symposium *Virtual Dialogue* Hosted by South Dakota State University, 16–19 November 2021.

Figure 10.3 Participants Use Primary Source Material to Simulate Critical Decision-making during an International Crisis. Screenshot from the Museum Studies International Symposium *Virtual Dialogue* Hosted by South Dakota State University, 16–19 November 2021.

New Programme, Just Add Students

Once we had a virtual programme designed and our staff had time to practice and make modifications, we opened up registration in the fall of 2020. We limited our number of available sessions to two sessions a day, three days a week. After some tough discussions, we landed on a price to charge schools that could afford the fee and continued to waive any fees for Title 1 schools or schools and communities that could demonstrate financial need. Many of us were not sure how this budgetary decision of a struggling department would be received in our community. We reached out to our educator network that had supported this programme in years past through emails and open communication. Within one week, almost all of our sessions were filled. From October 2020–December 2020, we were able to serve almost 800 students. We were blown away by the support and motivated teachers looking for something to help their students feel excited about learning again. This interactive field trip was a welcome break for teachers and students. They missed connecting with each other and opened their hearts up to us with their smiles and joy.

In December 2020, we paused booking further sessions of our simulation field trips in order to reflect and evaluate our staffing and budgets. Teachers started contacting us, worried we might not continue to offer this engaging field trip. We had responded to our community quickly and were able to serve as a community resource even without the four walls of the library's physically immersive environment. In January 2021, the Reagan Leadership Center

opened registration through May 2021. Within a few days, once again, almost all of our available sessions were booked. Almost 1,500 students had the opportunity to learn about leadership and develop skills because of the light of our programme during the darkness of COVID-19.

Serving Our Audience

We modify the content of the simulation slightly for our various audiences. The elementary content uses more basic language and the decisions to be made are simpler. The middle and high school versions provide much more depth of information and ask questions that require higher levels of critical thinking. The programme is always evolving to respond to the learning needs of students. After each experience, teachers fill out a survey. Of the 50 teachers who filled out the surveys during our pilot season, 100% said we met or exceeded expectations. Given our goal of ensuring an engaging online learning experience, we were eager to see if our programme had met the mark. Teachers who provided feedback complimented the high interactivity of the programme, the decision-making process shaped to be experienced by their students and their empowerment to have a voice, the training on problem-solving skills, the balance between different media. Likewise, students appreciated being engaged throughout the programme, their empowered to make decisions and the amount of learning.

Finale—Our Story and Yours

This programme helped to cultivate the next generation of citizen leaders by requiring all students to share their opinions, listen to each other without judgment, and relate their experience to the world today. As online classes replaced in-person schooling, we created a virtual field trip that required students to get out of their comfort zones, communicate, and interact with each other in ways that often surprised and impressed their teachers. This virtual programme was so successful that it remained an option for schools, even when the museum reopened and resumed offering the in-person experience. In addition, the virtual programme allowed us to serve classrooms from across the country and around the world with an award-winning leadership development programme (Figures 10.4 and 10.5).

This was the story of how we were able to face the challenges of COVID-19 and through hard work, experimentation, and engagement with teachers and students from across the country, we were able to create a solution that solved the immediate and pressing challenges of pandemic learning in our museum. We were able to connect with students, offer an engaging learning programme, develop a new revenue stream for the organisation, and support the development of essential civic skills, even when it seemed impossible. We

Figure 10.4 Students Consider Primary Source Material during a Simulation of Operation Urgent Fury.

Figure 10.5 Students and Staff at the Completion of an Online Version of the Operation Urgent Fury Simulation.

hope this story showed that even during the most trying of times, to borrow from the plaque on Ronald Reagan's desk, "It can be done." Let our story be a part of your story. Regardless of the challenges before us as a country and as a field, we believe we can leverage our talents and museum resources to support our future leaders, to build better communities, and to foster better citizens.

References

De Paepe, L., Zhu, C., & Depryck, K. (2018). Online language teaching: Teacher perceptions of effective communication tools, required skills and challenges of online teaching. *Journal of Interactive Learning Research, 29*(1), 129–142.

Larkin, I., Brantley-Dias, L., & Lokey-Vega, A. (2016). Job satisfaction, organizational commitment, and turnover intention of online teachers in the K–12 setting. *Online Learning, 20*(3). https://doi.org/10.24059/olj.v20i3.986

The Ronald Reagan Presidential Foundation and Institute. (n.d.). *About Us.* The Ronald Reagan Presidential Foundation and Institute. Retrieved January 5, 2023, from https://www.reaganfoundation.org/about-us

California Department of Education. (n.d.). Common Core State Standards. California Department of Education. Retrieved January 5, 2023, from https://www.cde.ca.gov /re/cc/index.asp

(2015, February 22). Presidential library museum attendance in the past 40 years. *Washington Post.* Retrieved January 5, 2023, from https://www.washingtonpost .com/local/education/presidential-library-museum-attendance-in-the-past-40-years /2015/02/22/7da8b778-bb0d-11e4-b274-e5209a3bc9a9_graphic.html

Kuhfeld, M., Soland, J., Lewis, K., & Morton, E. (2022, March 3). The pandemic has had devastating impacts on learning: What will it take to help students catch up? *Brookings.* Retrieved July 5, 2023, from https://www.brookings.edu/articles/ the-pandemic-has-had-devastating-impacts-on-learning-what-will-it-take-to-help -students-catch-up/

11 Collaborative Conservation E-Course across Borders

Interpretation and Presentation of an Uncomfortable Heritage Site in Berlin

Alexandra Skedzuhn-Safir, Katelyn Williams, Steven Cooke, and Iain Doherty

Museums have always been globally networked institutions, at times for the worse. The collection and display of material cultural acquired, often illegally, through colonial expansion and violence (Turnbull, 2020a; Vawda, 2019), the motivations for the holding of and participation in imperial exhibitions and world fairs from the 19th century onwards (Bennett, 1995), and the continued flow of curatorial knowledge and objects through exchanges between museums (Paterson & Witcomb, 2021) were predicated on unequal global systems of knowledge and exchange. More recently, decolonising approaches in museum theory and practice (Schorch & McCarthy, 2019), debates over the repatriation of artefacts and human remains (Curtis, 2006; Turnbull, 2020b), and the focus on transnational approaches to history (McCarthy, 2018; Paisley & Scully, 2019), which attempt to decentre the nation-state, pose new challenges for cultural heritage and museum professionals to not only understand the histories of the institutions in which we work, but also how to address the ongoing legacies of these "difficult heritage" sites (MacDonald, 2009, p. 2).

Within this context, the importance of a transnational cultural heritage and museum studies education has never been more relevant. For some, the museum sector is a global workplace with an increased emphasis, within many higher education contexts in Australia and perhaps to a lesser extent in Germany, on supporting graduates to be workplace-ready through work-integrated learning and "authentic assessment" that replicates activities students might undertake in the workplace. Thus, how we include practical skills and theoretical concerns, as well as the possibilities of enhanced cross-cultural understanding and the reformulations of the benefits of cooperation between museums (Li & Ghirardi, 2019), will inform our pedagogical approaches. At the same time, the revised International Council of Museum's (ICOM's) definition of a museum affirms that museums are in the service of society,[1] foregrounding the need for self-reflective practitioners who engage critically with global systems of knowledge and practice and for the exchange of approaches to addressing the politics of the past in the present, which continue to unsettle.

DOI: 10.4324/9781003393191-15

Background to the Collaborative Conservation e-Programme

Since 2015, Brandenburg University of Technology Cottbus—Senftenberg (BTU) in Germany and Deakin University (DU) in Australia have collaborated on a dual award postgraduate master's programme linking the World Heritage Studies (WHS) and Cultural Heritage and Museum Studies programmes, respectively. The dual award programme is funded by the German Academic Exchange Service (in German, Deutscher Akademischer Austauschdienst or DAAD), an association of German higher education institutions and student bodies whose aim is the international exchange of students and researchers.[2] The dual award programme is based on a reciprocal recognition of a prior learning agreement through which five students from each institution study concurrently over two years and graduate with two master's degrees. The programme brings together the different academic strengths of the partner institutions. Throughout the development and implementation of the dual award, both universities laid the foundation for co-teaching and blended mobility by developing a conversion table and establishing a procedure for the exchange of grades. The benefits to students and staff of diversifying the student cohort, providing increased exposure to international theoretical and practical approaches in cultural heritage and museum studies, as well as enhanced work-integrated learning opportunities through fieldwork projects, was recognised through the renewing of funding through the DAAD since 2014. The current funding will run until 2026. The programme also received the DU's Vice Chancellor's Award for Outstanding Contribution to Global Experiences in 2016.

However, due to the required physical mobility and limitations of funding, the dual award programme is only open to a limited number of students each year. Therefore, colleagues at BTU and DU explored other options of bringing the benefits of the dual award—such as international education, cross-cultural approaches to cultural heritage and museum studies, and the specialisations of the respective degree programmes—to a greater number of students.

This became even more urgent during the COVID-19 pandemic. With the closing of many international borders and repeated lockdowns preventing students from attending physical campuses, many universities had to start developing or expanding their online teaching capabilities. It also became necessary to incorporate these approaches within international university cooperation frameworks. Thus, the DAAD called for project proposals in the northern hemisphere to be delivered during the spring semester of 2020 under the umbrella of the "International Virtual Academic Collaboration (IVAC)" grant programme (DAAD, 2020).[3]

BTU and DU jointly developed a proposal that focussed on bringing together the respective strengths of the programmes.[4] The proposal was designed to allow students from BTU and DU to work collaboratively on

a conservation and interpretation project on one of many sites of "difficult heritage" in Germany: the Berlin Wall. The Berlin Wall is symbolic of the Cold War, and is relevant beyond the more recent German history. Traces of the Wall can be found in numerous places throughout the city, although many of them are somewhat unnoticed. Funding provided the opportunity to further expand the existing cooperation between the two partner universities. The World Heritage Studies Masters Programme offered at BTU is designed to be taught on campus. Up until the COVID-19 pandemic, none of the modules of this programme made use of e-learning elements, apart from access to e-learning materials, such as study guides and library resources. The e-learning team of the Competence and Service Centre for Digitalisation in Learning and Teaching (MMZ) at BTU had, however, already implemented concepts and services so that educational technology could be integrated into didactically coherent teaching and learning scenarios. Yet neither an entire study programme nor an individual module offered for the World Heritage Studies Programme had been designed in an online format.

With the onset of the pandemic, the entire degree programme at BTU was temporarily converted to an online format. It became apparent that the lack of teaching experience in e-formats presented considerable challenges, such as holding online meetings and delivering lectures or presentations, not to mention designing online tasks or tests. Lecturers, as well as students at BTU, were thus at a disadvantage compared to universities with many years of experience in e-learning. DU, on the other hand, has integrated e-learning formats into their programme for many years and has extensive experience in designing success-ful modules for Australian and international students. The impetus for developing distance education was one of access and equity, providing students with the flexibility to study at a time and place that suits them. One of the outcomes of the collaborative project was, therefore, that BTU would profit from DU's experience in the design of e-modules in which the interaction with content and the didactic method are designed for the virtual space.

While the focus of the World Heritage Studies programme at BTU lies on the UNESCO World Heritage Convention, site management, cultural man-agement, and architectural conservation, DU has traditionally taken a holistic approach to cultural heritage and museum studies but with specialisation in heritage interpretation, curatorial practice, intangible heritage, and commu-nity engagement. Of particular interest for teaching at BTU is the module on Digital Interpretation offered at DU, while the methodological approach to architectural conservation taken at BTU is not included in the curriculum at DU. By combining architectural conservation with heritage interpretation in a collaborative online format, the newly designed and offered course repre-sented an interface of the two disciplines and thus filled a gap in the respective study programmes.

For some time now, scholars have been dealing with difficult heritage in Germany, first and foremost with National Socialism (Macdonald, 2009)

and the Holocaust, the Cold War and the resulting division of Germany (Feversham & Schmidt, 1999; Klausmeier et al., 2004; Schlusche et al., 2021), and the genocide of Nama and Herero in present-day Namibia (Sarkin, 2010). As the majority of those enrolled at DU and BTU are international students, a German case study dealing with the topography of the Cold War, in particular with an element of the Berlin Wall Memorial Site, posed a particularly challenging example for heritage interpretation.

Pedagogical Approach

It has already been noted that DU has a 40-year experience in the e-learning space in the delivery of both fully online teaching and blended teaching, where students learn both on campus and online. In the context of teaching and learning at Deakin, this experience includes a focus on best practice pedagogy, with technologies being used to support excellence in teaching and learning.

In terms of leading the sector in e-learning, Deakin University partnered with FutureLearn in 2017, thereby becoming the first university in the world to use a Massive Open Online Course (MOOC) platform to offer fully online postgraduate courses.[5] DU built on its experience and learnings from FutureLearn with what was referred to as a CloudFirst project. This project brought together a CloudFirst team of instructional designers and digital technology experts to transform strategically important courses at Deakin through working with academics, in alignment with best practice pedagogical principles for teaching and learning online referred to as CloudFirst principles for teaching and learning.

DU has continued to innovate in the sector through initiatives to provide lifelong learning opportunities in the form of "taster units" for students who want to explore their interests in a particular subject area, micro-credentials as stand-alone units of study, and stackable short courses that enable students to develop knowledge and skills in an immediate area of need, while also providing study credit towards a qualification. This innovative work recognises that there are learners with diverse needs, ranging from those who want to know a little more about a subject, to professionals who want to upskill in the workplace, and on to learners who want to work towards a formal qualification but without committing to it as a whole.

More recently, DU has developed nine principles for teaching and learning that have built upon the aforementioned CloudFirst principles developed in the context of DU FutureLearn work. These nine principles significantly align with and support the pedagogical approach that underpinned this collaborative project.[6] Learning design at DU creates educational experiences that are holistic, authentic, active and collaborative, integrated, digital, course-wide, inclusive, feed-back focused, and relational. Focussing on some key principles for this project, the learning design aimed to create authentic, collaborative, and relational learning experiences designed to connect students to their

discipline, to one another, and to the space/place where they were studying through a flipped classroom approach. The project also aimed to make purposeful use of digital technologies to support students in their learning and skillset development.

While each of these learning design principles is important, the digital component was fundamental in enabling this project. Deakin's extensive experience in online and blended learning meant that the DU learning designer was well prepared to work with BTU on this aspect of the project. Digital technologies were incorporated during an iterative design process that placed an emphasis on ensuring that DU and BTU students had an equitable learning experience and were enabled to come together to learn with and from one another. Thus, the use of digital technologies had a particularly strong alignment with the relational principle for learning design. Deakin's approach to making use of digital technologies is now captured in a resource that enables academics to search for technologies either by the name of the tool, if known, or by the sort of teaching and learning activity they want to design.[7]

The final lens that we put on the learning design work for this project was that of Deakin's Graduate Learning Outcomes (GLOs).[8] These outcomes describe the knowledge, skills, and capacities that Deakin students will have developed and demonstrated by the end of a course. The outcomes are mapped across the course into the units of study, to ensure that students develop the knowledge and skills across their studies. Even though we were working on a single unit, the outcomes were nonetheless important in focussing us on key outcomes beyond discipline knowledge. For example, the GLO for Digital Literacy informed our perspective on making authentic and purposeful use of digital technologies for teaching and learning. The GLO for Teamwork focused us on ensuring a collaborative learning experience in which students learned with and from one another. Finally, the GLO for Global Citizenship put a focus on students developing a world view based on local and international perspectives.

Overview of CoCo Project

The course developed for this project, titled "Conservation & Communication: Interpreting the Subtle Traces of the Berlin Wall" (CoCo), began in April of 2021, with 14 students participating from various locations, including Germany, Iran, and Australia. As the students were in vastly different time zones, one of the biggest challenges was selecting a format for the course that would present the least number of obstacles for meaningful engagement with learning materials and discussions. It was determined that a flipped classroom format—a mix of self-study materials and live follow-up sessions—was the most effective solution.

The first half of the semester entailed students' theoretical exploration of the core concepts of architectural conservation and heritage interpretation. Learning materials such as pre-recorded lectures, readings, and exercises were

uploaded to the learning management platform Moodle, so that the students could engage with them on their own time. This was followed up with live online sessions at a time that was reasonable for all the students—not excessively early or late—during which we addressed any questions they had about the course materials and delved deeper into the topics at hand together. We used the online collaborative whiteboard platform Miro to serve as a workspace for the students, both for general class exercises and for their group projects. Svenja Hitschke designed the course Miro board, so that it would serve as a bridge and a visual connection between the real-world case study and the theoretical exploration conducted in the first half of the semester.

The second half of the semester was focused on practical work, with the students working in groups to develop their own interpretive tools for the semester's case study: the Günter Litfin Memorial. Günter Litfin was the first victim of the border regime of the German Democratic Republic (GDR) after the erection of the Berlin Wall. Litfin was shot and killed while trying to flee to West Berlin on 24 August 1961. Following the fall of the Wall, his brother, Jürgen Litfin, initiated the transformation of a former command post watchtower close to the site of Günter's death into a memorial to his brother.[9] The watchtower was recently brought under the management of the Berlin Wall Foundation. While the foundation has an established interpretive strategy at the Berlin Wall Memorial at Bernauer Strasse, at the time of the course, they had not yet developed extensive interpretive infrastructure for the Günter Litfin Memorial, presenting an excellent opportunity for the students to step in and develop interpretive tools that could potentially fill this gap (Figure 11.1).

The students' task was to use Lisa Brochu's 5-M Model for interpretive planning to develop an appropriate interpretive project for the Günter Litfin

Figure 11.1 The Watchtower Embedded within Today's Urban Context has Become One of the Sites that are Managed by the Berlin Wall Foundation and Is Known as the Günter Litfin Memorial (Sophia Hörmannsdorfer, 2018).

Memorial. The 5-M Model argues that there are five factors that need to be considered for effective and holistic interpretive planning: The message, management, mechanics, markets (audiences), and media (Brochu, 2003). Several students had never been to Germany, and even those who were in Germany for their studies were unfamiliar with the Günter Litfin Memorial and the Berlin Wall Foundation. It was thus very important for all the students to gain an understanding not only of the site itself but also of the existing interpretive infrastructure at other sites managed by the Berlin Wall Foundation, including the Berlin Wall Memorial, so that the tools that they developed for the watchtower would fit within the style and tone of what is already there.

We planned an experimental hybrid excursion in May 2021. As some of the students were located in or around Berlin, they were able to walk the path between the Berlin Wall Memorial and the Günter Litfin Memorial and participate in an in-person tour of the watchtower led by a staff member of the Berlin Wall Foundation. However, we needed to ensure that students unable to participate in person would not only have an equivalent learning experience but also one that would enable them to contribute meaningfully to later group work, as the excursion was meant to serve as a springboard for the development of their final projects. Thus, in addition to virtually travelling the path between the two sites using Google Earth, those who were not in Germany were tasked with exploring the existing online interpretation, including the Berlin Wall Foundation's websites and multiple digital tours. They shared their observations and screenshots from their "digital" excursion on the course Miro board.

During the excursion, Sebastian Rau from BTU's MMZ video-recorded the tour, which he then uploaded to a private YouTube page for the students who could not attend in person. Rau also captured footage that enabled the MMZ to design a 360-degree tour of the watchtower. The students were encouraged to develop an interpretive project that could be integrated into the 360-degree tour in close cooperation with the MMZ. In a subsequent live session with students in the course and staff members of the Berlin Wall Foundation, the parameters for the development of the tools were set and project groups were formed around the various concepts brought forth in a brainstorming session. The students then worked in their groups for the remainder of the semester to first create a fully formed project proposal and then to implement their ideas to the extent that was possible with the time and resources available. They met with the course lecturers on a weekly basis for consultations.

The final projects included three that were incorporated into the 360-degree tour and were designed to fill different thematic gaps, and two that were stand-alone tools. One group created an introductory video for the 360-degree tour that provided an overview of the history of the Berlin Wall as well as the story of the Litfin brothers. Another designed a virtual scavenger hunt for high school-aged students that allowed them to explore the watchtower looking for clues they could use to delve further into the story of the Litfin brothers. The third group conducted extensive research in order to create a 3D rendering of

Figure 11.2 The Image Depicts a 3D Rendering of the Watchtower of Today's Günter
Litfin Memorial (Sabra Saeidi, 2021).

the watchtower as it would have looked in the 1980s and used it to share the experiences of the border guards who worked at the site, a perspective that had been missing in the existing interpretation (Figure 11.2).

The two stand-alone projects took the form of an audio tour designed in the storytelling platform izi.TRAVEL that leads users from the Berlin Wall Memorial to the Günter Litfin Memorial, pointing out the traces of the wall hiding in plain sight along the way. The final project took the form of a concept video and written proposal for an augmented reality app that would take users from the Günter Litfin Memorial to the site of his death about 1.3 kilometres away. Students filmed the walk to give an impression of a possible AR experience, superimposing quotes from Jürgen Liftin's book, *Tod durch fremde Hand: Das erste Maueropfer in Berlin und die Geschichte einer Familie* (*Death at the Hands of a Stranger: The First Berlin Wall Victim and the Story of a Family*) on meaningful sites along the way. As the previous group's audio tour connected the Berlin Wall Memorial with the watchtower, this group aimed to make the final, necessary connection between the watchtower and the site of Günter Litfin's death. However, they also aimed to allow users to engage with the personal pain of Jürgen Litfin and his family and to connect this pain with the wider story of the Berlin Wall .

Conclusion

Throughout the process of designing and implementing their CoCo projects, the students successfully navigated the challenges of interpreting a difficult heritage site, while attuning their work to the needs and goals of the managing organisation. Feedback from students and the Günter Litfin Memorial attests to the value of the project. Several students pointed to the hands-on interpretation project as a highlight of the course, indicating that it was both a challenging and fruitful experience. In addition, the teaching team refined and developed their approach throughout the semester. This was helped by the established, long-term relationship between the institutions and the complimentary academic specialities of the two master's programmes.

A number of other factors contributed to this success and could be incorporated into future projects. The use of free or low-cost digital technologies allowed the teaching team to experiment with different approaches and to work out which was the most effective in allowing flexible, synchronous, and asynchronous engagement with and among students. This was particularly important as building effective modes of collaboration and cooperation between the students was key, especially given the time differences. It was beneficial to have some students physically on site at the Günter Litfin Memorial who could share their experiences with students in different parts of the world who did not have the opportunity to visit. Conversely, the online-only students brought a specific approach. Experiencing the site only digitally and through conversations with their colleagues in Germany gave them a particular perspective on developing effective digital interpretation. The circumstance, initially perceived as an obstacle, in which the DU students neither knew nor could visit the Litfin Memorial, resulted in a creative tension—whereby interpretive content and presentation could be adapted to make up for the lack of their physical access and experience of visiting the site.

The project has also enabled the learning team at DU to reflect on the learning activities in the Cultural Heritage and Museum Studies programmes. Visits to museums and heritage sites have always been a popular aspect of DU's pedagogic approach. This has benefitted on-campus students who have had the opportunity to engage with the staff and site in a way that was not possible for online students. With more students studying online at DU, the CoCo provides a model for new ways of collaborative learning among students in campus and remote settings. This form of learning and researching is now implemented in seminars and study projects, allowing for students to participate in contents that would otherwise not be possible due to the inability to travel. Furthermore, the interpretative devices explored during the CoCo project are currently employed for another study project.

While the differences in funding postgraduate study in Australia and Germany may mean that similar collaborative projects are unlikely to be run on a regular basis in the future, the programme has generated tangible outcomes for both programmes that have benefitted student learning, staff development, industry engagement, and broadened and deepened the existing collaborative relationship between DU and BTU.

Acknowledgements

The authors would like to express their gratitude to Sophia Hörmannsdorfer and Sabra Saeidi for the provision of their illustrations and photos.

Notes

1 ICOM (2022).
2 DAAD (n.d.).
3 The IVAC programme has continued to call for new projects after its initial launch in 2020.
4 The applicant of the project was then the Acting Professor Dr phil Alexandra Skedzuhn-Safir, with academic assistant and lecturer Katelyn Williams and assistant Svenja Hitschke, Chair of Architectural Conservation (BTU), Project Manager Boguslaw Malys, with Franziska Weidle, PhD, and Marie-Theres Augsten at the Multimediazentrum/ Informations-, Kommunikations- und Medienzentrum (MMZ/BTU). The DU partners were Associate Prof Dr Steven Cooke, then Associate Head of School (International and Partnerships), Faculty of Arts and Education, and Dr Iain Doherty SHSS Arts & Education, Deakin University. The project was funded from 1 November 2020 until 31 August 2021.
5 https://www.futurelearn.com/partners/deakin-university (accessed 14 December 2022).
6 https://www.deakin.edu.au/students/studying/deakindesign-principles-and-practices (accessed 14 December 2022).
7 https://tl-tools-guide.deakin.edu.au/ (accessed 14 December 2022).
8 https://www.deakin.edu.au/about-deakin/vision-and-values/teaching-and-learning/deakin-graduate-learning-outcomes (accessed 14 December 2022).
9 Berlin Wall Foundation (2021).

References

Bennett, T. (1995). *The birth of the museum: History, theory, politics.* Routledge.
Berlin Wall Foundation. (2021). Günter Litfiin. Available at https://www.stiftung-berliner-mauer.de/en/guenter-litfin-memorial/historical-site/guenter-litfin. Accessed 2 September 2023.
Brochu, L. (2003). *Interpretive planning: The 5-M Model for successful planning projects.* The National Association for Interpretation.
Curtis, N. G. W. (2006). Universal museums, museum objects and repatriation: The tangled stories of things. *Museum Management and Curatorship, 21*(2), 117–127. https://doi.org/10.1080/09647770600402102

DAAD. (2020). IVAC – International Virtual Academic Collaboration funded projects, funding period: 1st September 2020 –30th September 2021. Available at https://static.daad.de/media/daad_de/pdfs_nicht_barrierefrei/infos-services-fuer -hochschulen/projektsteckbriefe/2020-10-21_funded_projects_eng.pdf. Accessed 22 November 2022.

DAAD. (n.d.). The DAAD. Available at https://www.daad.de/en/the-daad/. Accessed 15 November 2022.

Feversham, P., & Schmidt, L. (1999). *Die Berliner Mauer heute: Denkmalwert und Umgang / The Berlin Wall today: Cultural significance and conservation issues.* Bauwesen.

ICOM. (2022). ICOM approves a new museum definition. Available at https://icom .museum/en/news/icom-approves-a-new-museum-definition/. Accessed 15 November 2022.

Klausmeier, A., Schmidt, L., & Haspel, J. (2004). *Wall remnants – Wall traces: The comprehensive guide to the Berlin Wall.* Westkreuzverlag.

Li, C., & Ghirardi, S. (2019). The role of collaboration in innovation at cultural and creative organisations: The case of the museum. *Museum Management and Curatorship, 34*(3), 273–289. https://doi.org/10.1080/09647775.2018.1520142

Macdonald, S. (2009). *Difficult heritage: Negotiating the Nazi past in Nuremberg and beyond.* Routledge.

McCarthy, C. (2018). Museums in a global world: A conversation on museums, heritage, nation and diversity in a transnational age. In S. Watson, A. J. Barnes, & K. Bunning (Eds.), *A museum studies approach to heritage* (pp. 179–194). Routledge.

Paisley, F., & Scully, S. (2019). *Writing transnational history.* Bloomsbury Academic.

Paterson, A., & Witcomb, A. (2021). "Nature's marvels": The value of collections extracted from colonial western Australia. *Journal of Australian Studies, 45,* 197–220.

Sarkin, J. (2010). *Germany's genocide of the Herero: Kaiser Wilhelm II, his general, his settlers, his soldiers.* UCT Press.

Schlusche, G., Bernhardt, C., Butter, A., & Klausmeier, A. (2021). *Die Mauer als Ressource: Der Umgang mit dem Berliner Mauerstreifen nach 1989.* Ch. Links Verlag.

Schorch, P., & McCarthy, C. (Eds.). (2019). *Curatopia: Museums and the future of curatorship.* Manchester University Press.

Turnbull, P. (2020a). Collecting and colonial violence. In C. Fforde, C. T. McKeown, & H. Keeler (Eds.), *The Routledge companion to indigenous repatriation: Return, reconcile, renew* (1st ed.). Routledge. https://doi.org/10.4324/9780203730966

Turnbull, P. (2020b). International repatriations of Indigenous human remains and its complexities: The Australian experience. *Museum and Society, 18*(1), 6–19. https:// doi.org/10.29311/mas.v18i1.3246

Vawda, S. (2019). Museums and the epistemology of injustice: From colonialism to decoloniality. *Museum International, 71*(1–2), 72–79. https://doi.org/10.1080 /13500775.2019.1638031

Part IV

The Impact of Space and Architecture in Transforming Museum Studies

12 Mapping Memories and Making Meaning

Community-Engaged Heritage Studies and Research

Hannes Engelbrecht and
Martina Jordaan

Introduction

The case study in this chapter explores a collaborative approach taken to enhance community-university collaboration in heritage studies.[1] It encompasses the outcomes of two research projects—including their integration into a module course—and reflects on advances in education and heritage studies. The larger of the two research projects is an Erasmus+ co-funded research project entitled, "Strengthening university-enterprise cooperation in South Africa to support regional development by enhancing lifelong learning skills, social innovations and inclusivity" (SUCSESS). It started in February 2020, with the goal to increase graduate employability. The project comprises six partner universities from South Africa, Finland, and the United Kingdom.

With the onset of COVID-19 shortly after its inception, the SUCSESS project teams had to adapt to significant challenges brought on by the pandemic. A sudden shift to online and hybrid learning meant delays in implementing some project outcomes, a shift in approaches to others, and changing priorities in the form of hybrid and technological skills development. This meant a greater focus on digital skills.

The primary focus of this chapter is a community-engaged research project that included 16 students enrolled for the BSocSci Honours[2] Heritage and Cultural Tourism (HCT) programme in the Department of Historical and Heritage Studies (DHHS) at the University of Pretoria (UP), South Africa, as well as four members of the Historical Society of Mamelodi (HSM). The HSM project aimed at capturing the history and heritage of Mamelodi on a virtual platform, ArcGIS StoryMaps, and required the collaboration of community members and students. Although the focus on digital histories was not exclusively the result of the COVID-19 pandemic, the accelerating demand for virtual museum exhibits and online engagement brought by the pandemic (Choi and Kim, 2021) contributed to the course design and to the rationale behind its combination within a heritage studies course. The goal of the HSM project was to inspire inclusive development of community members by

DOI: 10.4324/9781003393191-17

uplifting a marginalised community's history and heritage and, in so doing, to amplify previously peripheral voices within the historical landscape of South Africa. Collaborative approaches to history with non-academic partners fundamentally envision history as for and with the public (Babal, 2010).

Collaborative and community-engagement practices have become a central theme and critical aspect in the lexicon of heritage studies (Harrison et al., 2020; Landorf, 2009; Peters, 2020). A particularly seminal statement contained in the Budapest Declaration on World Heritage in 2002 "acknowledge(s) the role of partnerships in sustainable heritage management" (Landorf, 2009, p. 498). Simultaneously, educational research posits "service learning that integrates service projects with relevant coursework" as a pedagogical approach that can develop work-readiness skills and civic responsibility by creating "opportunities for students to take an active role in giving back to their community" (Valencia-Forrester et al., 2019, p. 31). The case study in this chapter reflects the symbiosis between collaborative heritage management practices and service learning with community-engaged research activities as its nexus.

Context, Stakeholders, and Collaborative Approach

The Community Engagement Research offices at UP's Mamelodi Campus acted as facilitators for the HCT students and the HSM. The Mamelodi Campus is one of UP's seven campuses and is situated within a local community. The HSM is a community-based organisation established by retired residents. Mamelodi is a township community located next to Pretoria in South Africa, established during the apartheid era in 1953, when black citizens were forcefully removed from the suburb of Lady Selborne in the city centre of Pretoria and relocated to Mamelodi (Ralinala, 2002).

The BSocSci HCT three-year degree in the DHHS is a multidisciplinary, intradisciplinary, and transdisciplinary degree that merges disciplines such as history, geography, museology, tourism studies, and archaeology. The undergraduate degree explores various perspectives on heritage (tangible, intangible, natural, and cultural) as both separate concepts and processes, and as an interconnected whole. The degree follows an inquiry-based learning approach that requires students to engage with various topics and debates related to heritage and tourism studies, such as meaning-making, heritage management, sustainability, and stakeholder engagement. At honours level, the approach is markedly shifted to skills development through more application-based learning, work-integrated learning, service learning, and practical, real-life projects.

In 2020, at the SUCSESS project's inception, participating lecturers from South Africa were required to implement new teaching approaches, such as work-integrated learning in various HCT module courses as outcomes of the

project. As one such implementation, the HSM project was integrated into the curriculum of an HCT honours module as a real-life service-learning pilot project in the second semester (August to December) of 2022, in alignment with the SUCSESS project's objective of "enhancing community development and prosperity due to modern development tools gained in knowledge triangle activities" (SUCSESS Project, n.d.). The collaboration between higher education, community, and students to develop and distribute knowledge about a previously marginalised community's history and heritage provided a fertile environment to share and co-create knowledge.

Since the late 1970s, "traditional" top-down techniques in the management of heritage resources have been criticised for divorcing cultural heritage from its natural counterparts (Harrison et al., 2020, p. 6), tangible heritage from its intangible meanings (Landorf, 2009, p. 500), and heritage from the communities it represents (Peters, 2020, p. 6). Consider, for example, a medicinal plant traditionally classified as a tangible natural heritage specimen. However, its medicinal use by a particular community carries with it both intangible and cultural associations that add to its value as a heritage object. A more holistic and integrated heritage management approach can be followed if we consider all aspects of a heritage object instead of the separate taxonomies. Consequently, it is widely recognised today that decision-making regarding the evaluation, interpretation, and conservation of heritage should include active participation by various stakeholders and communities in every part of the decision-making process (Harrison et al., 2020; Landorf, 2009; Peters, 2020). Moreover, Harrison et al. (2020) describe "heritage studies as a study of future-making or worlding practices" (p. 6). Therefore, training future heritage practitioners in inclusive practices is no longer discretionary, rather it becomes a critical practice for the inclusive development of such future worlds and heritage landscapes.

Additionally, collaborative approaches to higher education, in which all partners are considered co-creators of knowledge, can foster empowerment, engaged learning practices, and transformative experiences (Peters, 2020; Unger and Polt, 2017; Valencia-Forrester et al., 2019). HCT students and HSM community members were required to take leadership and ownership of their stories, and lecturers became facilitators of learning. Community members possess cultural competencies and understand the dynamics of their society, and as such, they can assist students in identifying people of interest to interview. As co-creators and co-curators of the stories, community partners played a central role in the execution of the project. This approach empowers community members, who make decisions regarding the histories recorded and the intangible heritage to safeguard. For their part, the tech-savvy HCT students could quickly adapt to using the cloud-based ArcGIS StoryMaps software. The project provided a rich learning environment with multiple opportunities for students to learn from real-life scenarios, innovate,

develop various professional skills, enhance their sense of civic responsibility, and practically broaden their knowledge of heritage-related topics.

A critical aspect of this type of collaboration recognised by Peters (2020) and Valencia-Forrester et al. (2019) is communication through reflection and dialogue. Throughout the process, students were required to reflect on their learning and engagement with community members. As stated by Valencia-Forrester et al. (2019), "Reflexivity plays a central role within a wise practice approach and requires knowledge and understanding of both ethics and values, along with historical knowledge, cultural knowledge, social knowledge, self-knowledge, and communication skills" (p. 32).

As a result of societal transformations exacerbated by the COVID-19 pandemic and consequent lessons in new learning modalities, lecturers created a hybrid environment to facilitate interaction during the project. Technological tools such as Google Drive and WhatsApp groups facilitated communication, dialogue, and exchange of ideas. Furthermore, the students and community members could work on the project through the shared space of the Digital Capability Laboratory on UP's Hatfield Campus (Figure 12.1). The lab was launched in November 2022—once full in-person teaching resumed on campus—as an output of the SUCSESS project to provide an environment for "digital collaborative learning" to "equip students with the necessary digital, technical, management, and people skills required in the world of work" (University of Pretoria, 2022).

Figure 12.1 Students and Community Members Working in the Digital Capability Lab.

The ArcGIS StoryMaps Software

Esri's ArcGIS StoryMaps is an online software that combines interactive maps with content, including text, photographs, videos, and 3D models to tell the story of a place, event, issue, or pattern within a geographic context. The maps can zoom in and out to assist the viewer in understanding different spatial scales (Walshe, 2016; Alemy, Hudzik, and Matthews, 2017). The final StoryMaps can be shared with the broader community as a web page. ArcGIS StoryMaps has proven to be an effective digital engagement and educational tool in several projects (Antoniou et al., 2018; Cope et al., 2018; Howland et al., 2020; Kallaher and Gamble, 2017; Strachan and Mitchell, 2014). An example of a similar community engagement project addressing a historical event using ArcGIS StoryMaps, *Mapping Greenwood*, was a project focussing on the Tulsa Race Massacre of 1921. This project was created by a team and advisory board consisting of historians, librarians, archivists, digital humanities scholars, and GIS researchers with diverse expertise in local history, black history, business history, archival practices, and technologies; it also included students from different classes and semesters guided by the Tulsa Community College Faculty members. The project is a virtual tour that was developed out of the events culminating in the Tulsa Race Massacre and included an examination of the current sites of commemoration. The tour also focusses on how the Greenwood community continues to rebuild (Maloney, 2021; Tulsa Community College).

ArcGIS StoryMaps has a user-friendly interface, wherein content can be edited to match the finished output. Knowledge about coding or web page design is therefore not necessary to develop the story map. The adaptable format allows StoryMaps to be easily updated. Users can seamlessly manipulate the interactive maps on ArcGIS StoryMaps by zooming in and clicking on different features to open pop-ups. The pop-ups can be customised to include text, video, photographs, and other StoryMaps. The format allows users to create multiple layers of hypermedia content (Howland et al., 2020). It is, therefore, not necessary to use expensive field recordings to create a compelling StoryMap.

The Project

For the first meeting between the HSM and HCT students, the community members visited the Hatfield Campus and described the existing general aim of the HSM to the students. As Peters (2020) states, the "process starts by examining the present context and its concrete situations, and should reflect the aspirations of all groups involved" (p. 20). During this session, a staff member from the Department of Geography, Geoinformatics and Meteorology (DGGM) introduced the students and community members to the functionality of the ArcGIS StoryMaps software. Each community member partnered with a group of four students, and the community members and students then discussed and identified four topics related to the community

of Mamelodi that they would address in their StoryMaps together, including famous people, important historical sites and events, education, and daily life.

For the second meeting, the students visited Mamelodi with the HSM members as the fieldwork component of the class project. The HSM members conducted a tour that included important sites in Mamelodi, such as the Solomon Mahlangu Square, Moretele Park, the Mamelodi Rondavels, and the Mothong African Heritage Site. The Solomon Mahlangu Square is situated at the western entrance of the township as the main focal point of a twice-life-size bronze statue of the freedom fighter Solomon Kalushi Mahlangu, that was executed on 6 April 1979 by the then Apartheids Regime (Khanyile, 2014, p. 75). Moretele Park is situated in the northern part of the township: with the many events it hosts, including jazz concerts, it is a family-friendly place (City of Tshwane). The Mamelodi Rondavels are not only the oldest known buildings in Mamelodi, but they were established when the Pretoria Bantu Normal College started in the late 1940s (Bakker, De Jong, and Matlou, 2003). At the Mothong African Heritage Site, medicinal plants and herbs are cultivated (Ntuli, 2020).

At their third meeting, the students and community members received further training from the DGGM members on developing a StoryMap using ArcGIS software. The StoryMap had to consist of at least five reference points on the map, and the students had to conduct at least one video interview with a community member. From this point, it was left to the students and community members to organise, brainstorm, arrange interviews, conduct research, and complete their StoryMaps (Figure 12.2). The community members were part of every aspect of the project and were credited in the students' StoryMaps as co-authors.

Figure 12.2 Extract from HCT Student StoryMap, Education in Mamelodi, Mamelodi Rondavels.

Throughout the course of the project, the student-community group that worked on the StoryMap about Education in Mamelodi, for example, worked together in sharing sources via WhatsApp and GoogleDrive, decided on sites such as the Mamelodi Rondavels as one of the most important to feature in the StoryMap, discussed interview questions, and arranged an interview with a retired ex-headmaster to gain more insight into the history and meaning associated with the heritage site. Community members then accompanied the students on the interview. The interview explored the complex relationship between the rondavel as a unique architectural style of African heritage and the specific conditions of the particular site's establishment as an apartheid-era symbol of separate education.

The students presented their final StoryMap for assessment to the lecturers and community members. Projects were evaluated based on lecturer and community input, student self-reflection, and peer assessment. The criteria used for assessment related to specific skill sets and learning outcomes, such as teamwork, communication, fieldwork, research, innovation, time management, and engagement with heritage topics. This approach de-hierarchises "knowledge or expertise" (Peters, 2020, p. 21) and "encourages more holistic engagement" (Valencia-Forrester et al., 2019, p. 34). The students also presented the outcome of their learning experience at the UP-SUCSESS seminar that the community members attended.

Reflection on the Project

The students reflected on the wealth of knowledge gained regarding the history of Mamelodi and on the communication, teamwork, time management, and technical skills they developed through the project. One of the students indicated that they developed tacit knowledge that enabled them to use the software in the workplace and illustrated an awareness of the critical role of working with community members on local history and heritage projects.

The community members found interacting with the students exciting and enjoyed being part of the process. The project supported the aim of the HSM to make the stories and history of Mamelodi available to the broader public. One community member expressed an appreciation for the symbiosis between the abilities of students to adapt to the new technology and the local knowledge and information provided by community members. Another community member reflected that he enjoyed the interaction with the students and found it an enriching experience to be part of the project.

The project was not without its challenges. Lecturer facilitators experienced difficulties in "striking a balance between space for innovation and structure," similar to a project by Cempellin (2012, p. 80). Initially, the project was left unstructured primarily to allow students space to innovate regarding project timelines and outcomes. Later on, as the project was taking shape,

the lecturer-facilitators provided more structure in the form of a timetable for completing specific tasks. At times, students found it challenging to reconcile their schedules with those of the community partners, and community partners found it difficult to understand what they perceived as the students' tendency to procrastinate.

Conclusion

With some adaptations, this project will continue to be offered as a more permanent feature of the postgraduate module. Future course iterations will incorporate additional theoretical and practical elements, in the form of reading materials on oral and digital histories and archival work, as well as a more structured approach that requires students to submit planning documents in phases to manage their time more effectively.

The interaction between community members and students created a fertile environment for innovation. Involving three departments of UP added a transdisciplinary component to the project. Students developed critical work-readiness skills and competencies that prepared them for the future, especially adaptability. Community members gained agency in the narratives of their own history as co-developers in capturing their communities' stories. The StoryMaps software added value to these stories and made them visually attractive historical narratives for sharing with the broader public. The completed StoryMaps are shared on social media and on the University of Pretoria's, the Mamelodi campus's, and the Historical Society of Mamelodi's websites.

The aim is to make local history more accessible and to encourage greater engagement with cultural heritage by students and community members. ArcGIS StoryMaps is a user-friendly and valuable tool for visually representing spatial data (Walshe, 2016). The end-user can easily navigate through the content, making StoryMap software useful for broader community access and involvement. Moreover, StoryMap software enables the mapping of stories to tangible landscape features, codifying landscapes as dynamic heritage objects. This dynamism allows for the elevation of community voices in retelling history. The combination of interaction between various roleplayers, transdisciplinary thinking, and the accessibility of StoryMap software in this project transforms how we do heritage and challenges a traditional historical narrative written by a few elites.

Notes

1 This study involving human subject research was submitted to the Ethics Committee at the University of Pretoria, was approved, and assigned protocol no. EDU054/22.

2 In South Africa, as in the United Kingdom, an honours degree designates a level of education higher than a bachelor's degree. It includes an additional fourth year of study before qualifying for a master's degree.

References

Alemy, A., Hudzik, S., and Matthews, C.N. (2017) 'Creating a user-friendly interactive interpretive resource with ESRI's ArcGIS story map program', *Historical Archaeology*, 51, pp. 288–297. https://doi.org/10.1007/s41636-017-0013-7

Antoniou, V., Nomikou, P., Bardouli, P., Lampridou, D., Ioannou, T., Kalisperakis, I., Stentourmis, C., Whitworth, M., Krokos, M., and Lemonia, R. (2018) 'An interactive story map for the Methana Volcanic Peninsula', in C. Grueau, R. Laurini, and L. Ragia (eds), *Proceedings of the 4th international conference on geographical information systems theory, Application and management* (pp. 68–78). Science and Technology Publications. https://doi.org/10.5220/0006702300680078.

Babal, M. (2010) 'Sticky history: Connecting historians with the public', *The Public Historian*, 32(4), pp. 76–84.

Bakker, K.A., De Jong, R.C., and Matlou, A. (2003) 'The "Mamelodi Rondavels" as place in the formative period of Bantu Education and in Vlakfontein (Mamelodi West)', *South African Journal of Cultural History*, 17(2), pp. 1–22.

Cempellin, L. (2012) 'A service-learning project: Linking an art museum, honors students, and the visual arts', *The Journal of Effective Teaching*, 12(1), pp. 78–94.

Choi, B., and Kim, J. (2021) 'Changes and challenges in museum management after the COVID-19 pandemic', *Journal of Open Innovation: Technology, Market, and Complexity*, 7(2), pp. 148. https://doi.org/10.3390/joitmc7020148

City of Tshwane. *Moretele Recreation Resort*. Available at: https://www.tshwane.gov.za/?page_id=5003 (Accessed: 25 September 2023).

Cope, M.P., Mikhailova, E.A., Post, C.J., Mark A.S., and Carbajales-Dale, P. (2018) 'Developing and evaluating an ESRI story map as an educational tool', *Natural Sciences Education*, 47, pp. 1–9. https://doi.org/10.4195/nse2018.04.0008.

Harrison, R., DeSilvey, C., Holtorf, C., Macdonald, S., Bartolini, N., Breithoff, E., Fredheim, H., Lyons, A., May, S., Morgan, J., Penrose, S., Högberg, A., and Wollentz, G. (2020) *Heritage futures: Comparative approaches to natural and cultural heritage practices*. UCL Press. https://doi.org/10.2307/j.ctv13xps9m

Howland, M.D., Liss, B., Levy, T.E., and Najjar, M. (2020) 'Integrating digital datasets into public engagement through ArcGIS StoryMaps', *Advances in Archaeological Practice*, 8(4), pp. 351–360.

Kallaher, A., and Gamble, A. (2017) 'GIS and the humanities: Presenting a path to digital scholarship with the Story Map app', *College and Undergraduate Libraries*, 24, pp. 559–573. https://doi.org/10.1080/10691316.2017.1327386

Khanyile, N.V. (2014) *A critical examination of the nature of the public participation process: A case of Solomon Mahlangu Freedom Square* [Unpublished doctoral dissertation, University of Witwatersrand, Johannesburg]. https://wiredspace.wits.ac.za/

Landorf, C. (2009) 'A framework for sustainable heritage management: A study of the UK industrial heritage sites', *International Journal of Heritage Studies*, 15(6), pp. 494–510. https://doi.org/10.1080/13527250903210795

Maloney, B. (2021, 24 May) *The burning of greenwood, The Tulsa race massacre, 1921*. Available at: https://storymaps.arcgis.com/stories/1d3f89365f024504961b35df7d94b094 (Accessed: 25 September 2023).

Ntuli, C. (2020) 'Mamelodi's Mothong Heritage Site a university of nature for local schools', *Pretoria News*, 23 September. Available at: https://www.iol.co.za/pretoria-news/news/mamelodis-mothong-heritage-site-a-university-of-nature-for-local-schools-741ba946-a055-42da-9b18-301b6befa2c2 (Accessed: 25 September 2023).

Peters, R.F. (2020) 'Conservation and engagement: Transforming and being transformed', in R.F. Peters, I.L.F. den Boer, J.S. Johnson, and S. Pancaldo (eds), *Heritage conservation and social engagement* (pp. 6–29). UCL Press.

Ralinala, R.M. (2002) *Urban apartheid and African responses: Aspects of life in Mamelodi township, 1953–1990* [Unpublished doctoral dissertation, University of Cape Town]. http://hdl.handle.net/11427/8793

Strachan, C., and Mitchell, J. (2014) 'Teachers' perceptions of Esri story maps as effective teaching tools', *Review of International Geographical Education Online*, 4, pp. 195–220.

SUCSESS Project. (n.d.) *Objectives.* Available at: https://www.sucsessproject.co.za/ (Accessed: 25 September 2023).

Tulsa Community College. (n.d.) *TCC remembers: Greenwood projects & events.* Available at: https://www.tulsacc.edu/greenwood/events (Accessed: 25 September 2023).

Unger, M., and Polt, W. (2017) 'The knowledge triangle between research, education and innovation – A conceptual discussion', *Foresight and STI Governance*, 11(2), pp. 10–26.

University of Pretoria. (2022) 'UP launches digital lab to develop future-fit employable students', 1 November. Available at: https://www.up.ac.za/news/post_3112051 -up-launches-digital-lab-to-develop-future-fit-employable-students (Accessed: 25 September 2023).

Valencia-Forrester, F., Patrick, C.J., Webb, F., and Bakchaus, B. (2019) 'Practical aspects of service learning make work-integrated learning wise practice for inclusive education in Australia', *International Journal of Work-Integrated Learning*, 20(1), pp. 31–42.

Walshe, N. (2016) 'Using ArcGIS online story maps', *Teaching Geography*, 41(3), pp. 115–117.

13 Re-Imagining Museums from the Screen

The Challenges and Opportunities of Pandemic Learning

*Dalia Habib Linssen and
Martina Tanga*

The worldwide COVID-19-induced pause not only forced museums into a new digital realm but also prompted a radical rethinking of typical museum studies methodologies. While museums came to an important inflection point—under pressure from the recent global pandemic, economic crisis, and renewed calls for social justice—so were students' motivations growing to tackle major institutional questions. A course in museum studies requires training for the next generation of museum practitioners to respond to the recent and systemic challenges facing museums. Both content and delivery needed to be reconsidered. The classroom, therefore, became a place for pedagogical experimentation and reimagining of cultural institutions.

In spring 2021, we remotely taught Museum Practice Today at Boston University. Amongst a myriad of challenges and uncertainties, we had to design a course where the majority of—if not all—interactions with our students would be online. Museum studies, as a dialogical form, is deeply grounded in site, space, and the physical institution; how could we translate that learning method from the physical space into a completely virtual world? From the beginning, we saw this challenge as an opportunity to pursue activities that students could complete remotely using rapidly and ever-growing digital content. We embraced the possibilities of "armchair" museum studies where students could visit virtually and think critically about sites and spaces far beyond their current geographies. Moreover, through digitally oriented assignments and virtual class discussions, students would explore how museums were transitioning to digital platforms to connect to audiences and communities.

Central to the course was focusing on the museum field's current challenges. Preparing the next generation of museum practitioners meant equipping them to envision tomorrow's cultural institutions. Topics included museum mission and ethics, governance and transparency, collections and hierarchies, exhibitions and authority, audience development and programming, community and digital strategies, and budgets. Offered as a seminar with ten students enrolled, all sessions were conducted synchronously and

DOI: 10.4324/9781003393191-18

remotely. Classes were structured through a blend of instructor-led content and student-focused discussions. We regularly integrated short video segments produced by museums to manage screen fatigue and tap into how museums responded to the pandemic's effects. In addition to typical course readings, the regularly unfolding shifts related to COVID-19, and its impact on art museums, provided a consistent source of newsworthy discussion.

This essay highlights two topics: a critical analysis of museum architecture as a typology of space and the examination of online programmes through DEI (Diversity, Equity, and Inclusion) perspectives. These two topics, in particular, provided new opportunities, given the increase in museum-generated digital content. Adapting these topics to a digital modality resulted in a huge increase in available case studies and the possibility for students to explore what was out there in the digital realm beyond our classroom discussion to find museums and programmes that complemented their interests.

Museum Sites

A discussion of land, architecture, and buildings came early in the semester to show students that so much of the experience of being in a cultural institution is dictated by how that space is constructed. Buildings are never just buildings; they are physical manifestations of the ideologies they serve. Western museums have legacies rooted in imperialism and colonialism, and their architecture often supports these origins. Denied the opportunity to physically visit one museum space, walk around, and go through its galleries, we visited several through the screens that have become our portals. We could "travel" from California to Spain in one lecture and experience two architectural tours: a typical docent-led tour of the Getty Museum in Los Angeles and an artist critique of Frank Gehry's Guggenheim Bilbao in Spain. We compared two post-modern museum buildings that were products of late-capitalist societies and that self-consciously thought about the visitor experience in their design.

The Getty tour was shot by a visitor filming a tour guide walking around the building that Richard Meier completed in 1997. In class, we watched a selected 15-minute segment, but we encouraged the students to tune in to see the entire tour on their own time. The tour guide explained that the main idea for the Getty was its position on two naturally occurring ridges by overlaying two grids along these axes. These grids define the campus space: one axis for galleries and another for administrative buildings. The guide described the entire campus's 30-inch square primary grid structure. More impressive, many of the façades are of travertine, sourced in Italy, and around 1,200,000 square feet of it were used! The guide offered a tactile connection to the building that would have been missing from photographs. Through this virtual experience, students could project themselves as being there physically. In our discussion, we talked about the Getty as ensconced on the hill, separate from the city, and how its positioning reinforces its identity as an elite research center instead of an arts space in the community.

Also built in 1997, the Guggenheim Bilbao boasts eye-catching architecture that reinforces capitalist ideologies. Art historian Julian Stallabrass (2006) called this the "Bilbao Effect," whereby art museums become agents for cultural reinvigoration at best and cultural colonization at worst (95). In Bilbao specifically, the museum brought an economic resurgence to a city hit by declining shipping and steel industries—but the post-war contemporary culture it imported is the leading hegemonic voice of Western modernism. Indeed, the original Guggenheim mission was to affirm abstract art's spiritual and intellectual values. In class, we discussed the role museums play in the culture industry and how they can support tourism and the global economy, but this can come with a global flattening of cultural specificity. Importantly, architecture plays a major role in shaping these forces.

Contemporary artist Andrea Fraser, in her piece, *Little Frank and His Carp*, from 2001, performs the experience of being a visitor at the Guggenheim Bilbao, taking her cues from the institution's official audio guide available at the front desk. Fraser listens to the guide in the space, which we can also hear. She follows the guide's instructions closely, her emotions visibly changing— in an exaggerated fashion that suggests satirical intent—in response to what she hears. Told that modern art is "demanding, complicated, bewildering," she appears anxious, but when the guide tells her, "the museum tries to make you feel at home," she immediately seems reassured and happy (Fraser, *Little Frank and His Carp*, audio). She is also instructed to touch the limestone-clad pillar, which she does in an intimate manner. The sexual aspects of Fraser's performance are an ironic response to the erotic language often used to describe the Guggenheim building—the audio guide talks of its "powerfully sensual" curves—as well, perhaps, as an allusion to notions of power and potency frequently invoked in critical assessments of male architects and artists such as Frank Gehry and Richard Serra. As Fraser intended, the students were caught off-guard by her performance but were eager to engage with the why and how. Ultimately, Fraser's *Little Frank and His Carp* indicates that the art space is a consumer venue that seeks to create and guide our emotions and ultimately control our bodies and imaginations.

After this lecture, the students' assignment was to visit museums in person, mostly from the outside—as museums in Boston in February 2021 were still negotiating reopening plans—and examine their buildings critically. They had the chance to apply what we had learned in class to actual museum buildings and evaluate their architecture and its effect on how we consider museums' function, mission, and experiences. Along with the independent site visit, there was a research component as students were asked to look at the institutions' histories, audiences, and missions and relate these aspects to the architecture. Students not based in Boston visited a museum close to their location. In effect, this physical exercise could be completed anywhere at any time, but it was crucial following the lecture, as it gave students the conceptual framework to consider why and how institutional space influences perceptions and actions. Building on students' understanding of the relationship

of architectural design to institutional identity, the class went on to explore how and to what extent museums adapted their programming to maintain value within the broader cultural realm.

Audiences and Online Programmes

The course's session on Audience and Community Engagement centered on how museums cultivate meaningful audience experiences in a digital realm. We explored how museums, as institutions rooted in colonial histories and white-dominant narratives, have long grappled with which audiences to prioritise, a problem amplified by pandemic-induced closures and worldwide social protests. Confronted with physical spaces made vacant, staffing reductions, and increasingly limited resources, how were art institutions balancing their public-facing missions while intentionally engaging specific audiences, many of whom have been historically marginalised from museum spaces? But before they could evaluate these issues happening in real-time, students had to build an understanding from their own experiences and prominent museum leaders.

Following personal reflections on moments they had felt connected, seen, and moved in an art museum, students discussed why glimmering buildings often fall short of fulfilling a museum's desire for more diverse audiences. We questioned what types of leadership are needed to institute meaningful engagement, antiracist practices, and authority-sharing with communities. Video segments from two museum leaders offered important perspectives. In a 2012 TED talk, Nina Simon, then director of the Santa Cruz Museum of Art and History, discussed how participatory programmes where visitors create and share collaboratively helped meaningfully advance engagement and cultural relevance. As sites of personal reflection, discovery, and even delight, Simon reasons, museum spaces can help catalyse and deepen social connections. And yet, while participatory strategies may result in higher levels of engagement, for some visitors, museums represent sites of longstanding intergenerational emotional harm.

In her 2016 TED talk to an audience of museum professionals, Cinnamon Catlin-Legutko, then director of the Abbe Museum in Bar Harbor, Maine, suggested that understanding the colonial underpinnings of today's museums is critical for working intentionally with marginalised audiences. Through her work with Wabanake people, she identified three hallmarks of decolonizing practices: collaboration with Indigenous advisors throughout a project, prioritizing Native perspectives that broaden narratives, and valuing truth-telling that allows a full measure of history to be told. When we work deeply with communities and share authority, in Catlin-Legutko's view, we uphold the museum's role as existing in the public trust.

Finally, to highlight a local perspective, we invited Rosa Rodriguez Williams, the Museum of Fine Arts, Boston's inaugural Senior Director of Belonging and Inclusion, to share her vision for inclusive visitor engagement. Specifically, Rosa discussed establishing the *Think Inclusion Grant Programme* open to all MFA staff and designed to support the Museum's efforts to build the needed awareness, attitudes, knowledge, and skills to facilitate an inclusive experience for all visitors. Doing so would ultimately support the Museum's commitment to becoming a museum for all of Boston. While these speakers offered insights into how museums are reshaping what it means to work with audiences, the challenge for students, then, was to consider what happens when these forms of engagement, both expansive and deliberate, were no longer possible in physical form.

The assignment asked students to evaluate programmes offered digitally at any art museum to explore how institutions affirmed a sense of personal identity, decentered whiteness, and addressed museum privilege. Doing so would reveal not only how museums demonstrate their stated values but also how they engage audiences unbound by geographic restrictions. Students attended virtual programmes from New York and Boston to Singapore, Paris, and Australia; others focused on online collections searches and digitally-presented exhibitions. Students were motivated by a range of interests, from geography and previous familiarity with certain institutions in some cases to specific interests related to language, culture, or accessibility in others.

By comparing online programmes, students observed a number of innovative interventions responsive to audience needs. The Whitney Museum of American Art's Verbal Description Online, a Zoom- or phone-based live programme, for example, offered detailed verbal descriptions of artwork against key conceptual frameworks. While, as a consequence of COVID-19, many institutions focused simply on highlighting existing digital assets, suddenly facing no geographic limitations, some were also beginning to reimagine audience engagement through the digital realm. Separately, exploring databases from New York's Metropolitan Museum of Art and Washington, DC's National Gallery of Art to the Musée d'Orsay in Paris, revealed a stark lack of attention to language regarding artist identities, a topic currently under review by the Association of Art Museum Curators. This type of inquiry reflects the kind of systems-oriented critiques proposed by Cinnamon Catlin-Legutko. The class came to the conclusion that much like architectural space, digital interfaces serve as complex sites of knowledge that shape social perceptions.[1]

Completed during a time of physical closure, this research revealed how a museum's digital space can extend beyond simply delivering content to inviting transparency into an institution's priorities and values. Through these assignments, students explored audience engagement methodologies that advance the kind of inclusive community engagement regularly called for in the field.

Conclusions

These two topics and assignments—museum architecture and programmes—exemplify how students capitalised on remote learning *and* looked critically at major issues facing museums today. Through engaging different sources, such as readings, digital tours, online talks, and live programmes, students examined current museum practices in ways that would not have been available or even conceivable in a pre-COVID-19 context. With the proverbial walls having come down, students could investigate a global range of museum spaces to consider how architecture creates frameworks for shaping knowledge and how museums were redefining audience engagement through intangible digital spaces. These assignments not only uncovered longstanding issues such as physical space and audience engagement, but they also helped prepare students to reshape art institutions of the future.

What might we carry forward from this entirely digital experience? We reflected on the enormous quantity of material now available to students by thinkers and practitioners in museums, academia, and other creative spaces that will be useful for future teaching. Still, as these resources have not been vetted or undergone peer review, students will, guided by faculty, continue cultivating a critical awareness of sources and perspectives. Ultimately, students are learning in increasingly dynamic ways, and integrating digital technologies will be just one of the methods in our pedagogical toolbox. Let us hope that our students continue to push us as educators to be responsive and agile and that they enter the field with imagination and a willingness to experiment.

Note

1 Association of Art Museum Curators, AAMC Foundation Best Practices Guide for Artist Demographic Data Coordination, 19 April 2023. https://issuu.com/artcurators/docs/aamc_bestpractices_final_singlepages.

References

Catlin-Legutko, C. (2016). *We Must Decolonize Our Museums*. https://youtu.be/jyZAgG8--Xg Accessed: November 9, 2021.

Stallabrass, J. (2006). *Contemporary Art—A Very Short Introduction*. New York: Oxford University Press.

Simon, N. (2017). *The Art of Relevance*. https://youtu.be/NTihl739w4?si=uukQCvf2l KU28EXP Accessed November 9, 2021.

Simon, N. (2012). *Opening Up the Museum*. Opening up the Museum: Nina Simon @TEDxSantaCruz. https://www.youtube.com/watch?v=aIcwIH1vZ9w. Accessed November 9, 2021.

14 From Streets, to Galleries, to Internet

Defining "Contemporary Museum Space" in Chinese Art Exhibitions Pre- and Post-Pandemic

Shaoqian Zhang

Since the opening of the Chinese market in 1978, Chinese experimental art sought alternative exhibition venues that were outside the official art establishments.[1] (Wu, 1999) . Unconventional spaces provided platforms for artists to showcase their work in a more independent and experimental manner, free from rigorous censorship and bureaucratic constraints. In the late 1970s, the streets surrounding the National Art Museum of China became a notable phenomenon within the art scene. Later, the entertainment galleries in prominent Chinese cities such as Beijing and Shanghai assumed a vital role as platforms for exhibiting contemporary Chinese art. The emergence of Covid-19 in 2020 presented significant challenges yet opportunities for exhibiting Chinese art, not only in traditional gallery spaces but also in unconventional venues such as streets, markets, and public parks.

The shifting of the exhibition space in China demonstrates a continuous adaptation process influenced by evolving domestic politics, market demands, and, ultimately, the challenges posed by the COVID-19 pandemic. The questions raised in this essay are: what is the relationship between grassroot contemporary Chinese art and official-conventional Chinese exhibition spaces? Did the COVID-19 pandemic empower or impede the Chinese government in exerting greater control over art exhibitions? What changed in exhibition space before and after the pandemic? To answer these questions, this essay discusses a few types of exhibition space before, during, and after the pandemic. I will focus my study on the National Museum of China (NAMOC), the top official Chinese art museum, whose main mission is to serve as a national-level art museum dedicated to displaying, collecting, and researching the modern and contemporary artistic works of China ("Brief Introduction to the NAMOC," 2023). We will explore the physical space in and around it as well as its virtual space for art exhibition after the pandemic.

DOI: 10.4324/9781003393191-19

The NAMOC versus Its Surroundings: A Controversial History

Funded by the Ministry of Culture, the National Art Museum of China (NAMOC) plays a crucial role in shaping, documenting, and validating the Chinese government's official narrative of modern contemporary Chinese art ever since its debut in 1962 (Fan, 2013, pp. 3–5) (Figure 14.1).

Its primary building spans an expansive floor area of 18,000 square metres, comprising five floors and 21 exhibition halls. The NAMOC's own collection showcases artworks by influential painters who have had a profound impact on traditional Chinese painting during the 20th century. ("Brief Introduction to the NAMOC," 2023). However, as the premier official exhibition venue, the NAMOC has a complex relationship with contemporary Chinese art.

On 27 September 1979, a remarkable scene unfolded at the NAMOC. While inside the museum, the "National Fine Arts Exhibition for the 30th Anniversary of the Founding of the People's Republic of China" was taking place, outside the museum in the streets, the metal fences were hung with oil paintings, ink paintings, and woodcuts as part of the first art exhibition by the Stars Group (*Xingxing huahui*). These artworks, featuring artistic expressions remarkably unfamiliar to the audience, captured the attention of numerous visitors who were initially heading to the museum to view the exhibition.[2] Eventually there were more visitors in the streets than the museum (Gao, 2016, p. 20). Two days later the street exhibition was closed by the police. Yet, on 20 November 1979, the Stars Group was granted official permission by the Chinese government to continue the "Stars Art Exhibition" at the

Figure 14.1 The National Art Museum of China (NAMOC), Photography by Tian Gao.

Huafangzhai Pavilion in Beihai Park. This park exhibition lasted ten days and attracted a huge number of visitors as well as intensive media attention (Gladston, 2014, p. 16). In time, the First Stars Art Exhibition, which made innovative use of street and park spaces, gained recognition as the origin of contemporary art in China.

After successfully experimenting with non-official exhibition spaces, the Stars Group made a transition into traditional art museums. They achieved this by hosting the "Second Stars Art Exhibition" at the NAMOC from 24th August to 7 September 1980, to showcase the works of selected members. However, this exhibition did not result in the integration of contemporary art into the institutional framework of art museum exhibitions. Instead, it concluded with the end of the exhibition, without establishing a lasting presence for contemporary art within the museum space of the Chinese government. (Wang and Wu Hung, p. 12) Nevertheless, in 1989, the NAMOC hosted another atypical exhibition focussing on contemporary Chinese art. This landmark exhibition, titled "China/Avant-Garde Exhibition," was curated by independent art critics Li Xiande, Gao Minglu, and Peng De. (Lincot, 2004). However, it was shut down a mere two hours after its opening when artist Xiao Lu used a pellet gun to shoot her own artwork, a gesture considered too controversial and dangerous in the conventional space of the NAMOC.

As the market continued to open, contemporary Chinese art found more opportunities for exhibition in privately owned museums, galleries, and collections. The 1990s witnessed a rapid rise of contemporary Chinese art on the global stage through commercial venues in big cities. (Wang, 2014, p. 2)

Notably, several commercial galleries within Beiijing's 798 Art District, including Ullens Center for Contemporary Art, Long March Space, Tang Contemporary Art, Taikang Space, and others, have evolved into influential Chinese contemporary art institutions. These galleries are magnets for independent contemporary Chinese artists who firmly believe that their artistic creations are integral to contemporary Chinese culture and should draw inspiration from Chinese realities. Meanwhile, many contemporary Chinese artists have begun to express growing criticism towards non-Chinese curators, accusing them of adopting an "orientalist" mindset (Wang, 2014, p. 3). Motivated by this perspective, these artists have taken the initiative in organising and funding their own exhibitions. However, they continue to encounter challenges in gaining full acceptance from official art exhibition venues, which encompass state-run art museums and university galleries.

Another a milestone for the NAMOC occurred on 19 August 2008, with the opening of "Cai Guo-Qiang: I Want to Believe," marking the first large-scale solo exhibition by a Chinese contemporary artist at an official China art museum. Furthermore, the launch of the "Extending Life: Media China 2011—International Triennial of New Media Art" exhibition on 26 July 2011 introduced a new branded exhibition. ("The Birth of Art Museums," 2013.) Overall, 1978–2019 witnessed a dual dynamic in the Chinese art world.

Exhibitions in "unofficial" spaces assumed a prominent role in exhibiting contemporary Chinese art. Simultaneously, the officials in the Ministry of Cultural Affairs and the Ministry of Propaganda diligently worked towards diversifying and enhancing the appeal of their own exhibitions, aligning with China's rebranding efforts.

The Impact of the Covid-19 Pandemic: A Turning Point for the Chinese Government?

In 2020, the Chinese government implemented aggressive measures to effectively contain the spread of the coronavirus. As a result, museums in China were initially closed following the Wuhan lockdown and remained shut until March or April 2020 (An, 2021, p. 553). During this period, museums across the country adapted swiftly by organising over 2000 online exhibitions, as reported by the Ministry of Culture and Tourism (Xiao, 2021, p. 118). After a brief hiatus, in-person art shows in Beijing and Shanghai placed Chinese artists at the forefront (Xiao, 2021, pp. 118–119).

Demonstrating their confidence in effectively managing the virus, the NAMOC promptly responded in late March 2020 by mobilising artists to create artworks centred around the theme of combating the pandemic. The exhibition titled "Sculpting for the Anti-Epidemic: Selected Works from the National Art Creation Group of the National Art Museum of China" showcased the initial collection of 21 sculptures to the public (Shao, 2020, p. 4). A few months later, the Chinese National Museum in Beijing's Tian'anmen Square hosted a large exhibition commemorating the country's fight against Covid-19. On view from August through October 2020, this exhibition showcased nearly 200 art pieces of a variety of media, which were selected from a total of 75,147 works of art, created in the context of combating the Covid-19 pandemic ("The Unity of the People," 2020).

Alongside ongoing exhibitions in traditional venues under certain restrictions, the Ministry of Culture also actively promoted online exhibitions and educational initiatives. During the period from 1 February–3March 2020, approximately 300 online exhibitions were introduced by state-owned museums. These included 130 online interactive exhibitions, 138 digital panoramic exhibition halls, and 13 sets of digital displays showcasing cultural relics. (Yuan, 2020, p. 63) The quantity of these digital forms corresponded to the advancement and maturity of technology while being inversely related to the associated costs. An important event occurred on 17 July 2020, when the Ministry of Culture and Tourism convened a teleconference, highlighting the importance of embracing the opportunities presented by the digital economy, prioritising online development, and leveraging the support of the digital industry for the cultural and tourism sectors. ("Opinions of the Ministry of Culture and Tourism

on Promoting the High-Quality Development of the Digital Cultural Industry," 2020) While the pandemic has posed challenges to China's economy, it has also brought about new opportunities in promoting the government's agendas through technology. In March 2020, the director of the NAMOC, Wu Weishan, proclaimed, "One screen is equivalent to an art museum." As expected, the NAMOC quickly adapted to this trend, by utilising its website and WeChat platform to introduce a range of online exhibitions and artwork appreciation, many of which encompassed political themes (Xiao, 2021, p119).

During the pandemic, state-owned museums experienced vibrant scenes with both in-person and online exhibitions. However, the challenge of exhibiting "controversial" contemporary Chinese art persisted, and concrete data on such exhibitions is difficult to obtain. It is evident that the Covid-19 situation provided the Chinese government with increased authority to curate politically-themed and propaganda-orientated exhibitions. The extent of control has notably broadened, with a strong focus on virtual domains. The Great Firewall, a comprehensive Internet censorship and control system established by the Chinese government, remains as robust as ever in exercising stringent authority over online content and curbing the dissemination of politically sensitive information.

Conclusion

As contemporary Chinese art continually pushes the boundaries of artistic definitions, the exhibition spaces themselves challenge the authority of established physical spaces found in traditional museums and galleries. However, when exhibiting their artworks within China, whether in esteemed institutions like the NAMOC or commercial galleries, or even the city streets and parks, contemporary Chinese artists have to delicately navigate the fine line between expressing critical viewpoints and adhering to the boundaries established by the government. (Ruiz, "Ai Weiwei," 2020)

While online exhibitions in China offer a digital platform that enables artists and audiences to engage beyond geographical and physical limitations, they encounter similar constraints and regulations as traditional exhibitions. In general, virtual exhibition spaces function as mirrors of physical architectural spaces. Therefore, it would be incorrect to assert that the rapid growth of online exhibitions, driven by the Covid-19 pandemic, has inherently provided more opportunities for the diversification and advancement of contemporary Chinese art. Nevertheless, during the pandemic, Chinese museums have facilitated unprecedented access through 3D tours and online programmes, and online exhibitions offer individuals the freedom to engage with art regardless of geographical and financial barriers. It is likely that this accessibility and convenience will persist even after the pandemic subsides.

Notes

1 The term "experimental art" was first brought up by art historian Wu Hung in his book *Transience: Chinese Experimental Art at the End of the Twentieth Century.*
2 Most members of the Stars Group received no formal art training and were not affiliated with any official art institution. The group's early activities included private discussion sessions and informal art shows. It was initially organised by Huang Rui, Ma Desheng, Zhong Acheng, Qu Leilei, Wang Keping, Yan Li, Bo Yun (Li Yongcun), Li Shuang, Mao Lizi, Yang Yiping, and others.

References

An, L. (2021) "Hou yiqing shidai bowuguan shuzi jishu yingyong de chubu guancha yu sikao [Observations and Reflections on the Preliminary Application of Digital Technology in Museums in the Post-Pandemic Era]." *Kexue jiaoyu yu bowugua* 7, no. 6, pp. 532–539.

"Brief Introduction to the NAMOC." Available at http://www.namoc.org/jljy/wggk/jj/ (Accessed on June 12, 2023).

Fan, D. (2013) *Zhongguo meishuguan: Meishuguan ren de jiyi [The National Art Museum of China: The Memory of Museum People].* Beijing: Zhongguo meishuguan.

Gao, M. (2011) *Total Modernity and the Avant-Garde in Twentieth-Century Chinese Art.* Cambridge: MIT Press.

Gao, M. (2016) *Lichang. Moshi. Yujing – Dangdai Yishu Shuxie [Position, Model, and Context: Writing Contemporary Art History].* Beijing: Zhongyang fanyi chubanshe.

Gladston, P. (2014) *Contemporary Chinese Art: A Critical History.* London: Reaktion Books.

Lincot, E. (2004) "Contemporary Chinese Art Under Deng Xiaoping." *China Perspectives*, 53 (3), pp 1–9.

Lv, P. (2014) *Zhongguo dangdai yishushi [History of Contemporary Chinese Art].* Shanghai: Shanghai renmin chubanshe.

Ma, S. (2020) "Opinions of the Ministry of Culture and Tourism on Promoting the High-Quality Development of the Digital Cultural Industry."Available at https://www.mct.gov.cn/whzx/zcjd/202012/t20201225_920097.htm (Accessed on June 17, 2023).

"Meishuguan dansheng ji: 'nanchan' de yishu baoku [Birth of Art Museums: The Difficult Birth of Art Treasure Troves]." Available at http://www.bjnews.com.cn/feature/2013/06/19/268961.html (Accessed on June 16, 2023).

Ruiz, C. (2020) "Ai Weiwei: If You Do Not Question Chinese Power, You Are Complicit With It." Available at https://www.theartnewspaper.com/2020/09/01/ai-weiwei-if-you-do-not-question-chinese-power-you-are-complicit-with-itthat-goes-for-art-organisations-too (Accessed on May 15, 2023).

Shao, X. (2020) "Wei kang 'yi' er su de xin shidai yishu jingshen Zhongguo meishu guan guojia zhuti meishu chuangzuo zu zuopin jiexi [The Spirit of New Era Art Shaped for the Fight Against the 'Epidemic': An Analysis of the Artworks by the National Thematic Art Creation Group of the National Art Museum of China]." *Art Panorama* 33 (02), pp. 4–15.

Unknown Author. (1989, February 10) "Special Editions on China Avant/Garde Exhibition." *Beijing Youth Daily*. Section 4, 5.

Wang, P. (2014) "Making and Remaking History: Categorising "Conceptual Art" in Contemporary Chinese Art." *Flash Art* 25, no. 162, pp 2–17.

Wang, P. and Wu Hung, eds. (2010) *Contemporary Chinese Art: Primary Documents*. New York: MoMA.

Wu, H. (1999) *Transience: Chinese Experimental Art at the End of the Twentieth Century*. Chicago: The Smart Museum of Art of the University of Chicago.

Xiao, Y. (2021) "Hou yiqing shidai bowuguan shehui jiazhi daoxiang de zuoyong, yi guoneiwai bowuguan xinmeiti zaixian yunyong de chenggong jingyan weili [The Role of Social Value Orientation in Museums in the Post-Pandemic Era - Taking the Successful Experience of New Media Online Application in Domestic and International Museums as an Example]." *Dongnan wenhua*, 57 (01), pp. 118–123.

Yuan, W. (2020) "Woguo bowuguan wangshang zhanlan qingkuang ji sikao - Yi xinguan feiyan yiqing qijian guojia wenwuju guanfang wangzhan tuichu de liupi wangshang zhanlan weili [The Situation and Reflections on Online Exhibitions in Chinese Museums - Taking the Six Batches of Online Exhibitions Launched on the official Website of the National Cultural Heritage Administration During the COVID-19 Pandemic as an Example]." *Zhongguo zhanlanguan yanjiu* (Second), pp. 63–67.

"Zhongzhi chengcheng——kangyi zhuti meishu zuopin zhan kaimu [The Unity of the People — Exhibition of Artworks on the Theme of Fighting Against the Epidemic Grand Opening]." (2020). Available at https://www.mct.gov.cn/whzx/zsdw/zggjbwg/202008/t20200806_873885.html (Accessed on July 1, 2023).

Conclusion

Ready for Change: The New Resilient Cultural Heritage Professional in the Post-Pandemic Era

Leda Cempellin and Pat Crawford

The concept for this anthology originated from the Museum Studies International Symposium *Virtual Dialogue: Museum Academics and Professionals on Challenges and Opportunities in the Post-COVID World*, organised and broadcast via Zoom by the co-editors at South Dakota State University on 16–19 November 2021. We extended an invitation to academic institutions offering Museum Studies undergraduate and graduate programmes that we were able to identify across five continents (North America, Europe, Australia, Asia, Africa). The responses received, and the finalised essays included in this anthology, largely mirror the concentration of programmes in the United States and the United Kingdom. These programmes often adopt a Eurocentric perspective, focussing on collection management, preservation, exhibition design, and educational programming.

In the finalised anthology, we succeeded in documenting a transnational collaboration between Europe and Australia and we managed to include a contribution from Africa. Regrettably, Asia and South America are not represented. Museum Studies programmes outside of a Eurocentric framework often envision cultural heritage institutions as catalysts for social change, thereby emphasising community engagement. This approach is reflected in the contribution by the University of Pretoria included in the anthology. Programmes in Asia, such as the one at the University of Calcutta, often highlight site-specific cultural heritage. This focus is especially prominent as an effort to counterbalance the dominant Eurocentric narrative and to reflect a more complex and inclusive global narrative. It is important to note that the absence of essays from certain regions of the world in this anthology does not diminish the value or importance of their perspectives and practices in Museum Studies; hopefully, their efforts will be captured in future contributions.

The abstracts received as part of the original submission suggested an organisation for the symposium around six broad themes: human connections and engagement, trends in practice; cultural influences, collaborations, leadership and mentoring, and inclusions and exclusions (Figure 15.1 and 15.2).

DOI: 10.4324/9781003393191-20

PROGRAM OVERVIEW

DAY 1: Tues, November 16: 8:30am CST: Welcome by Symposium hosts,
Dr. Pat Crawford and Dr. Leda Cempellin
School of Design

8:40am CST	9:00am CST	10:15am CST	11:30am CST
Symposium's official opening by Dean of the AHSS College. **Dr. Lynn Sargeant**	**Keynote address** **Donna Markt**, Director South Dakota Art Museum (1 hr. keynote including questions + 15 min. break)	Roundtable moderated by **Anthony Penney** (1 hr. including questions + 15 min. break)	Presentation **Dr. Peter Ride** (20 min. presentation + 10 min. questions)

12:00noon–1:00pm CST: LUNCH BREAK

OPTION A: Virtual exploratory activity (provided by Anra Kennedy, Culture24)

OPTION B: Improvised breakout rooms to continue the conversation

1:00pm CST	1:45pm CST	2:30pm CST	3:00pm CST
Presentation **Martha Schleeter** (20 min. presentation + 10 min. questions + 15 min. break)	Presentation **Dr. Dalia Habib Linssen and Dr. Martina Tanga** (20 min. presentation + 10 min. questions + 15 min. break)	Presentation **Dr. Lea Davidson and Dr. Leticia Pérez-Castellanos** (20 min. presentation + 10 min. questions)	Concluding greetings by Symposium hosts

DAY 2: Wed, November 17: 8:50am CST:

8:50am CST	9:00am CST	10:15am CST	11:00am CST
Welcome by Symposium hosts	**Keynote address** **Phyllis Hecht,** Johns Hopkins University (1 hr. keynote including questions + 15 min. break)	Presentation **Dr. Miriam Posslack** (20 min. presentation + 10 min. questions + 15 min. break)	Discussion Group Part I - Virtual Experiences moderated by **Dr. Laure-Blythe S. Coleman** (1 hr. Including questions)

12:00noon–1:00pm CST: LUNCH BREAK

OPTION A: Virtual exploratory activity (provided by Anra Kennedy, Culture24)

OPTION B: Improvised breakout rooms to continue the conversation

1:00pm CST	1:45pm CST	3:00pm CST	3:30pm CST
Presentation **Olivia Reyes** (20 min. presentation + 10 min. questions + 15 min. break)	Roundtable moderated by **Adriana R. Dunn** (1 hr. including questions + 15 min. break)	Presentation **Jenna Coplin** (20 min. presentation + 10 min. questions)	Concluding greetings by Symposium hosts

Wide discussion topics emerging from the program:
- human connections and engagement
- trends in practice
- cultural influences
- collaborations
- leadership and mentoring
- inclusions and exclusions

NOTE: The Zoom link or links to access the symposium will be shared with the registered participants ahead of the event. Limited seats available, contact Dr. Leda Cempellin: Leda.Cempellin@sdstate.edu

Figure 15.1 Museum Studies International Symposium *Virtual Dialogue*, Hosted via Zoom by South Dakota State University, 16–19 November 2021. Programme Overview. Graphic Designer: Bev Krumm. Sponsored by the FUNd for Museum Studies.

Each participant touched on one or more of the six overarching themes, thus forming a network of interconnections among the various projects' foci, scales, and approaches. The different pedagogical approaches ended up being condensed into four broad areas, but the essays' approaches are inextricably tied to each other since they respond to common fundamental needs that we try to preserve, no matter the challenges encountered.

The contributions within this anthology also represent divergent points. Across a large spectrum of classrooms, cultural heritage sites, and communities, our authors have demonstrated that there are many ways to see the same issue: within the newly discovered online and hybrid educational experience, one course redesign can focus on the structural and organisational component, another can emphasise the socio-emotional aspects of learning, while another can be centred on collaborative processes and practices. Once students leave school and join our cultural institutions, these approaches will mix and form new pathways for innovation. All the skills summarised by Crawford and Fink

Figure 15.2 Museum Studies International Symposium *Virtual Dialogue,* Hosted via Zoom by South Dakota State University, 16–19 November 2021. Programme Overview. Graphic Designer: Bev Krumm. Sponsored by the FUNd for Museum Studies.

(2020), namely, communication, decision-making and problem-solving, self-management, teamwork, professionalism, experiences, leadership (p.4), are involved in dealing with meaningful change: this volume is focused on providing various cross-sectional forays into this complex and multidimensional process.

The degree of uncertainty brought about by a massively disruptive event, such as the 2020 pandemic, has enabled the adaptive exploration of emerging technologies that have modified our daily working habits. It is the ambiguity offered by the situation and the potential solutions that have created the perfect setting for the innovative approaches presented in this volume. Designers Andrea Small and Kelly Schmutte (2022) have recently explained that uncertainty and ambiguity is the place where multiple possibilities coexist (p. 23). Our authors come from a multitude of contexts, so each team works with pathways unseen by others; the virtual dialogue of our symposium was meant to capture those intersecting points so that new directions can be seen and built together.

The unique experience bonded groups into interdependent virtual and networked teams, whether within the classroom or across institutions, navigating uncharted territories and brainstorming solutions, as they explored the innumerable possible intersections among classroom, cultural heritage institutions, and community dimensions. The collaboration between students and faculty in shaping the teaching and learning process under the new circumstances, facing risks and unknowns, has enabled a cooperative investment and ownership of change, which then becomes more authentic, effective, and lasting (see Cameron & Green, 2015, p. 333).

Learning to collaborate across space and time boundaries requires the development of skills in self-management, professionalism, communication, and problem-solving. Students and faculty strive to build professional relationships when the room's temperature cannot be read, body language has disappeared, and written feedback can be misconstrued or magnified. Living in two different time zones – one in person and one in Zoom – within the same day requires the reconciliation of parallel lifestyles. Faculty navigate uncertainties with their students and show that successes come from seeing failures as growth opportunities.

Before entering the workforce, students who have witnessed a major change through the adaptive lenses of their course instructors and professional mentors have learned to discover the socio-emotional dimension involved with learning and thus developed their emotional intelligence. This skill represents the perfect match for tackling the ongoing challenges presented by subject matter that is sometimes uncomfortable or controversial.

Students will also be capable of managing and adapting to other changes that they will experience in the workplace as technology evolves. Resilient professionals working in teams will know that contextual analysis will determine the choice of the best solution among a vast realm of possibilities, and that their rejected idea has served as a stepping stone towards building a stronger solution together. Students, who move past the individual gratification of the course grade towards thinking at the wider team or organisational well-being, will make a successful transition into the new workplace (see Crawford & Fink, 2020, p. 11).

Cultural heritage sites are increasingly adopting "management and governance strategies associated with enterprise culture" and shift their focus from collections to the visitor experience (Rodney, 2019, p. 17). The "new museology" is becoming more service-orientated as it reduces its cultural elitism and increases its attention towards matters of inclusion (p. 26). After experiencing the more egalitarian Zoom real estate in the virtual classroom, the former student is now becoming the new cultural heritage professional. This professional will lead the ongoing transformation, which has been occurring within the field since the turn of the millennium, from the traditional transmission mode of cultural content to a more constructivist, collaborative, and inclusive mode of meaning-making (pp. 20–22).

The future cultural heritage professional, having learnt strategies to integrate content, technology, empathy, and professional relationships, will be equipped to invite the patrons to become active participants in the construction of multi-layered meaning within the "new media culture." This culture, according to Zsófia Ruttkay & Judit Bényei (2018), includes a participatory component, "creative self-expression," content creation and sharing, mentorship, and the "emergence of informal and formal social networks and protocols" (p. 103).

The interdisciplinary virtual learning environment, built on mentorship, guest speakers, and project collaborations across institutions, will enable future cultural heritage professionals to overcome the challenges of the traditional siloed mentality; they will view their tasks within a wider context, respecting, communicating, and working with professionals from various backgrounds to design increasingly complex experiences.

We hope that the new work models, spurred by pandemic-driven changes, will contribute to the emergence of a flexible and resilient cultural heritage professional, who sees the classroom, the cultural heritage institution, and the community as integral to the appreciation of cultural heritage. For Museum Studies students, the close observation of faculty and professionals as they navigated uncertainty has been a leadership lesson, for "The illusive leadership capacity is built on a series of uncomfortable learning moments, events, and experiences, and in that situation, we were all witnessing leaders in the making." (Sutherland, 2022, p. XVII). The emphasis on both structure and empathy in teaching museum studies during a post-crisis adaptation will help the future professional achieve well-rounded leadership, capable of balancing a wide range of approaches depending on the situation: the new leaders will in turn become capable of managing healthy disruptions that promote change.

References

Cameron, E. & Green, M. (2015). *Making Sense of Change Management*. London and New York: Kogan Page.

Crawford, P. & Fink, W. (2020). From Academia to the Workforce: Navigating Persistence, Ambiguity, Change and Conflict in the Workplace. *APLU Series on Employability Skills in Agriculture & Natural Resources*. https://www.aplu.org/wp-content/uploads/from-academia-to-the-workforce-navigating-persistence-ambiguity-change-and-conflict-in-the-workplace.pdf

Rodney, S. (2019). *The Personalization of the Museum Visit: Art Museums, Discourse, and Visitors*. Abingdon, Oxon: Routledge.

Ruttkay, Z. & Bényei, J. (2018). Renewal of the Museum in the Digital Epoch. In Bast, G., Carayannis, E.G., & Campbell, D.F.J. (Eds.), *The Future of Museums*. Cham, Switzerland: Springer 101–116.

Small, A. & Schmutte, K. (2022). *Navigating Ambiguity: Creating Opportunity in a World of Unknowns*. California and New York: Ten Speed Press.

Sutherland, D. (2022). *The Business of Ambiguity*. Austin, TX: River Grove Books.

Index

Page numbers in **bold** indicate tables, while page numbers in *italics* indicate figures.

accessibility 15, 23, 27, 40, 52, 58, 62–63, 70, **82**, 84, 86
adaptability 54, 97, 101
"Alice: Curiouser and Curiouser" exhibit (Victoria and Albert) 57–58
ambiguity 146
American Alliance of Museums (AAM) 1, 40, 50
Añoveros, Paloma 39–54
ArcGIS StoryMaps 123, 125–26, 128
architecture 132–34
artist identities 135
Art of Gathering: How We Meet and Why It Matters (Parker) 18
@artlust 93, 95
Arts Administration & Museum Leadership (AAML) graduate programme 56–57
"ASMR at the Museum" 92, 95
Association of Art Museum Curators 135
asynchronous/synchronous content combinations 10, *11*, 111–12
augmented reality 56, *57*
Australia 9, 108

Badley, K. 10
Banki, S.R. 13
bath rasps 92
Become The Monuments That Cannot Fall exhibition *44*

Bénye, Judit 148
Berlin Wall collaboration project 4, 109
Berlin Wall Foundation 113
Berlin Wall Memorial 113, *114*
"Bilbao Effect" 133
Birnbaum, Paula 39–54
BLM protests 32, 52
Boston University 131–32
botanical gardens 23–25; *see also* McCrory Gardens
Bowen, T. 79, 87
Bower, Julie Rose 92
Bradford, Lorena 33
Brandenburg University of Technology (BTU) 108, 116; Competence and Service Centre for Digitalisation in Learning and Teaching (MMZ) 109; World Heritage Studies Masters Programme 109
Braun, V. 80
Briant, S. 85, 87
Brigham Young University Museum of Peoples and Cultures 72
British Educational Research Association (BERA) 81
Brochu, Lisa 112
Budapest Declaration on World Heritage (2002) 122
Bushfires activity *14*

California Academy of Science (CAS) 40
Canvas 10
capabilities 94
care 3, 9, 13–15
Catlin-Legutko, Cinnamon 134
Cavanagh, Sarah Rose 32
Cempellin, Leda 1–5, 127, 144–48
China 4, 137–40
Chrysalis exhibition 42, *43*
civic learning 98
Clapp, Edward 34–35
Clarke, V. 80
classrooms 2; *see also* virtual classrooms
CloudFirst projects 110
Clouser, Lynn 58
Cohen, L. 79
Coleman, Laura-Edythe 56–63
collaboration 3, 79, 111, 147–48; and communities 123; and heritage studies 122; student enthusiasm for 47, 49; virtual reality project 61; for virtual tours 17, 20
collections management 46–47, 53–54, 70, 72–73
colonialism 107, 133–34
Common Core State Standards 99
communication 81
communities, and collaboration 123
community-building: in live seminars 13–15, 41–42; through participatory programs 134; via omnidirectional mentorship 34
competencies 94
conferences 60–62
connections: as element of projects or exercises 20; value of 9–10
"Conservation & Communication: Interpreting the Subtle Traces of the Berlin Wall" (CoCo) 111, 115
Cooke, Steven 107–16
COVID-19 65–66, 70, 95, 97; and the Boston University Museum Practice Today course 131–32; and China 137, 140–41; and classroom space 4; and the

digital expansion 1; and digital storytelling 91–92; and the online internship course 51–53; professional challenges of 98
Crawford, Pat 1–5, 144–48
critical reflection, and research 2
Crowther, P. 85, 87
cultural heritage institutions 2–3, 147
cultural heritage professionals 147–48
Curatorial Studies Practicum 44

De, Peng 139
deaccessioning, policy changes concerning 54
Deakin University (DU) 108–11, 115–16
democracy 101
Deutscher Akademischer Austauschdienst (DAAD) 108
DiCindio, Carissa 3, 17–22
digital content: China's focus on 140–41; incorporating into lectures 12, 42
digital culture 90
digital environment, and inter-institution collaboration 4
digital literacy 111
digital skillsets 3, 70, **82–83**, 84, 87, 92; lab time for 48; Museums and Technology Practicum 48; One by One project 94; postcards 46; and the SUCSESS project 121; virtual tour project 21
digital storytelling 90–91, 94–95; @artlust 93, 95; "ASMR at the Museum" 92, 95; "Transforming Practice" blog 93–95
distance learning accommodations 56
Doherty, Iain 107–16
Drexel Founding Collection 58
Drexel University: Arts Administration & Museum Leadership (AAML) graduate programme 56; Virtual Reality & Immersive Media (VRIM) programme 56, 58, 61–62
Dunn, Adriana R. 65–73

e-mail communications, and
predictability 11
emotional intelligence 147
emotions 32, 52
engagement/communication cycles *11*
Engelbrecht, Hannes 4, 121–29
European Network of Cultural
Administration Training Centres
60–61
Eurovision dress conservation 92
exercises: creating kits for 46–47;
freewriting 33; National Gallery
internship 36; postcards *45*, 46

Fairbairn, Cannon 65–73
Fajardo, Susana 92
family heirlooms, used for
collections management
exercises 47
Feldman, Valentina 58
Felten, Peter 32
filming, requirements for 61
Fink, W. 145–46
First Stars Art Exhibition 139
5-M Model 112–13
flexibility 3, 9, 12–15, 51, 71, 86–87
flexible pedagogy,
reconceptualizing 12
forums *see* online discussion boards
Fraser, Andrea 133
Fraser, Karen 39–54
freewriting exercise 33
FutureLearn 110
The future now 44

games, Would You Rather 37
gardens 23, 27; student assignments
concerning 25, *26*; *see also*
McCrory Gardens
Gately, Megan 97–105
Gehry, Frank 133
geographical barriers 3–4; and guest
speakers 15
German Academic Exchange
Service 108
Germany 109–10, 113
Getty Museum 132
Gillman, Derek *57*, 58–60

Girnus, Bridget 36–37
Google Classroom 101
Google Drive 124
Google Slides 101
Gregory, Neecole A. 65–73
guest speakers: and geographical
barriers 15; and the USF museum
studies program 40, 48
Guggenheim Bilbao 132
Günter Litfin Memorial *112*, 113,
114, 115

Harrison, R. 123
Hart, Fuchsia 92
Hatchie River Region collection
70–71
Hatfield Campus 125
Heck, Gabriela 94
heritage resource management 123
heritage studies 123
Hill, Colleen 97–105
historical societies 52
Historical Society of Mamelodi
(HSM) 4, 121–23, 128
Hoffman, Lauren 58
Hoodooism exhibit 68–69
Huang, R.H. 12
Hulme, M. 78, 87
hybrid learning models 49

Ikpeze, C.H. 13
imagination 25
inclusion 86
Inclusive Museum conferences
60–62
inquiry-based teaching 25
International Council of Museums
(ICOM) 107
"International Virtual Academic
Collaboration (IVAC)" grant
programme 108–09
interns: curatorial 67;
and mentors 35, 37;
supporting 34; tasks
for **82–83**
internship curricula, relevancy of
51–53
internship questionnaires 50

internships 31, 49–50, 52–53,
 65–66, 68; challenges of 72–73;
 compared to virtual internships
 79, 85, 87–88; educational
 programming 67–68; non-
 museum 50; professorial support
 getting 50–51; purpose of 32, 78,
 84; questions about 79; *see also*
 virtual internships
interpersonal skills, pandemic
 restrictions impacts on 31
izi.TRAVEL 114

Johns, Jessica 97–105
Johnson, Amanda Hunter 46–47
Jones, T. 86
Jordaan, Martina 4, 121–29

Kennedy, Anra 3, 90–96
Khoreva, L. 85
Kremer Collection 58
Kunstmatrix 45

Lawrenson, Anna 3, 9–16
learner-centered educational
 strategies 12
learning: and emotions 32;
 reflective 33
lectures: pre-recorded 111–12;
 rethinking 12, 42
Lemon, N. 13
Linssen, Dalia Habib 4, 131–36
literacies 94
Litfin brothers 113–14
Litfin, Günter 112
Little Frank and His Carp
 (Fraser) 133
Lu, Xiao 139
Luebbers, Leslie 65–73

Mamelodi 125, *126*, 127
Mapping Greenwood 125
Mark, M. 86
Marotz, Lisa 3, 23–27
Massive Open Online Course
 (MOOC) platforms 110
McColl, Margaret 4, 77–88
McCrory Gardens 23

McCrory Gardens Explorer app
 24–25, *26*, 27
McKenzie, Emilia 93–94
McLaughlin, Heather 56–63
medicinal plants 123
Meier, Richard 132
mental health challenges, of the
 global health crisis 18
mentorship models 34–36
Metropolitan Museum of Art 135
mindfulness, and virtual reality 61
mindfulness exercises 33; at the
 Rubin Museum 52
Minglu, Gao 139
MiReBooks 57
Miro 2, 112
Moodle 2, 111–12
Moon, Jennifer A. 33
multimodal learning 21
Musée d'Orsay 135
Museum and Heritage Studies
 (MHST, University of Sydney)
 9; MHST6904 Museums and
 Heritage: Objects and Places *14*;
 MUSM7035 Ethics of Cultural
 Property 10, *11*, 12–15;
 pre-COVID-19 10
museum closures 17, 65, 81,
 97–100, 131
museums 73, 107, 147; adaptability
 of 97; and audiences 134–35;
 in China 140; and the culture
 industry 133; decolonialisation
 of 107, 134; and face-to-face vs.
 virtual internship placements 80,
 85, 87–88; locations 132; and
 social media *69*, 71; storytelling
 by 90–91; and student-created
 digital resources 84–86; using
 VR 57
Museum Studies programs 1, 63,
 131, 144, 148; classrooms
 1–2; and decolonisation 107;
 Eurocentrism of 144; role of 2;
 at South Dakota State University
 24; *see also specific programs*
museum tours 18; *see also*
 virtual tours

Namibia 110
National Art Museum of China 137
National Gallery of Art 31, 135
National Museum of China
(NAMOC) 137, *138*, 141; "Cai
Guo-Qiang: I Want to Believe"
139; "China/Avant-Garde
Exhibition" 139; "Extending
Life: Media China 2011—
International Triennial of New
Media Art" 139; "National Fine
Arts Exhibition for the 30th
Anniversary of the Founding
of the People's Republic of
China" 137; "Second Stars Art
Exhibition" 139
Neecole 68–70
networking 15, 17, 21, 32, 34, 36, 78
Next Evolution in Museum Studies
educational materials 56
Night Kitchen Interactive 58
notebooks 32–33

object handling *57*, 58–60
omnidirectional mentorship 34–35
online discussion boards 12–13
O'Reilly, Chiara 3, 9–16
Orsini, Marie-Louise 34

Padlet *14*, 15, 19
pandemic history exhibition 43
Parker, Priya 18
participatory learning 21
passive education tools 23
PastPerfect 65, 69
peer socialization 15, 36
peer support: through mentorship
36; and Zoom 13
Pennay, Anthony 97–105
Pennebaker, James 33
personal reflection for professional
development 32–33
Peters, R.F. 125
Plank, Kathryn 23–27
Plasencia, Javier 39–54
Postcard for Quarantine
Connections *45*
postcards *45*

predictability 3, 9–12
pre-pandemic assignments,
modifying 41–42
preservation questions 47
professional networking 21
protests, BLM 32, 52

Queensland University of
Technology 85

Rao, Seema 93, 95
Rasmussen, Briley A. 3, 17–22
Rau, Sebastian 113
Reagan Foundation 3–4; online
version 101, *102–03*, 104, *105*
Reagan Leadership Center *99*,
100, *105*; virtual simulation *99*,
100–101, *102–03*, 104, *105*
real/virtual space gaps 4
reflective learning 33
reflexivity 124
Related Tactics *44*
remote education 56, 66, 98, 101,
108, 131, 136; DEI perspectives
on 132
remote "work-integrated learning"
(WIL) experiences 87
research, traditional 2
ResumeBuilder.com 31
Robinson, H.A. 10
Ronald Reagan Presidential
Foundation and Institute 98–99
Rubin Museum (New York City) 52
Ruttkay, Zsófia 148

Sampson, Scott 40
San Francisco, Bayview
neighborhood *44*
Schloetzer, Martha M. 31–37
Schmutte, Kelly 146
Schultz, S.M. 13
Scotland 77
self-awareness 32
Serra, Richard 133
service learning 122
Shahar, Eyal 39–54
Shaw, Sandie 92
Shorofsky, Karren 39–54

Simon, Nina 134
Skedzuhn-Safir, Alexandra 107–16
Skin and Bones app 57
Small, Andrea 146
Smithsonian National Museum 57
social/emotional learning 31–32, 37
social engagement, lack of 41
social justice 47; USF focus on
 39–40, 53–54
social media *69*, 70–71, 84–85, 90, 95
soundtracks, for virtual tours 19
South Africa 125–26
South Dakota State University 24,
 27n2; *see also* McCrory Gardens
staff, and instability 9
Stallabrass, Julian 133
Stars Group (*Xingxing huahui*)
 138–39, 142n2
StoryMaps 125, *126*, 127
storytelling *see* digital storytelling
"Strengthening university-enterprise
 cooperation in South Africa to
 support regional development
 by enhancing lifelong learning
 skills, social innovations and
 inclusivity" (SUCSESS) project
 121–23, 127–28
student artwork exhibitions 42, *43*
students 78–79; communication
 expectations 81; and instability
 9; new skillsets for 46, **82–83**,
 84, 86, 147; program support for
 40–41; at the Reagan Leadership
 Center *99*, 100–101, *102–03*,
 104, *105*
Suparak, Astria 44

Tanga, Martina 4, 131–36
teaching styles 41
technology: and cultural institutions
 47–48; humanising power of 3
TED talks 134
Thacher Annual exhibition 42, *43*
*Think Inclusion Grant
 Programme* 135
3M EcoGrants 24
TikTok 93, 95
time management skills 71, 73

time zones 21, **83**, 87, 111, 115, 147
Tourism, Events, and Hospitality
 Education students 86
"Transforming Practice" blog 93–95
trauma, of the global health crisis
 18, 40–41
Tulsa Race Massacre project 125
Tulsky, Steven 39–54

uncertainty 146
unconventional exhibition venues 137
University of Glasgow: Master of
 Museum Education 77, 87–88;
 Strategic Mission (2025) 78
University of Memphis 65; Art
 Museum 69; Interdisciplinary
 Graduate Certificate in Museum
 Studies 65–66
University of Pretoria (UP)
 121–22, 128; Digital Capability
 Laboratory *124*
University of San Francisco 39; Art
 History and Museum Studies
 programme (undergraduate)
 42, *43*; capstone paper/project
 53–54; Collections Management
 course 46–47; Museum Studies
 MA Programme 39, 46; online
 internship course 51–53
US State Department, Virtual
 Student Federal Service
 programme 31

Valencia-Forrester, F. 124
Victoria and Albert Museum 57–58;
 "ASMR at the Museum" 92, 95
virtual classrooms 3, 66, 131, 147–
 48; and accessibility 63; and lab
 time 48–49; *see also* classrooms
virtual collections 77
*Virtual Dialogue: Museum
 Academics and Professionals on
 Challenges and Opportunities
 in the Post-COVID World*
 symposium 144, *145–46*
virtual events: increased accessibility
 of 40; Reagan Foundation 101,
 102–03, 104, *105*

virtual internships 31, 51–53, 65, 67–72, 77–78, **82–83**, 84, 86–87; *see also* internships
virtual outreach *69*; student assessments of 135
virtual reality 56, *57*, 58; equipment *60*, 62; using personal mobile devices 62
virtual tours 17, 20, 22, 132–33, 136; Berlin Wall 113–15; project components *19*; Reagan Foundation 101, *102–03*, 104, *105*; soundtracks for 19; *see also* museum tours

watchtowers *112*, *114*
Weishan, Wu 141
West Tennessee Delta Heritage Center (WTDHC) 66–68, 70
WhatsApp 124
Whitney Museum of American Art 135
Williams, Katelyn 107–16
Williams, Rosa Rodriguez 135

Wilson, Delia 4, 77–88
Wilson, Rachel 65–73
WONDERLAB+ 93–94
working environments 71
work placements 78
World Heritage Studies Masters Programme 109
writing exercises 19

Xiande, Li 139

YouTube 92

Zhang, Shaoqian 4, 137–42
Zoom 2, 101, 147; breakout rooms 13–15, 37, 41–42; difficulties with time zones 21; for discussing projects 20; and group activities 37, 49; and peer support 13; and the Reagan Foundation 101, *102–03*, 104, *105*; screen sharing 25; tied to asynchronous content 12–13